CW01019443

RULING DEVOTION

SUNY series, Studies in the Long Nineteenth Century

Pamela K. Gilbert, editor

DEBORAH SUTTON

∼ Ruling Devotion ∼

The Hindu Temple in the British Imperial Imagination

SUNY
PRESS

First published by Permanent Black D-28 Oxford Apts, 11 IP Extension, Delhi 110092 INDIA, for the territory of SOUTH ASIA. First SUNY Press edition 2024. Not for sale in South Asia.

Cover image: *The Kanheri caves on the island of Salsette, near Bombay, Maharashtra.* Colored aquatint by Thomas and William Daniell, 1800, Wellcome Collection.
Cover design by Anuradha Roy

Published by State University of New York Press, Albany
© 2024 Deborah Sutton

All rights reserved
Printed in the United States of America

No part of this book may be used or reproduced in any manner whatsoever without written permission. No part of this book may be stored in a retrieval system or transmitted in any form or by any means including electronic, electrostatic, magnetic tape, mechanical, photocopying, recording, or otherwise without the prior permission in writing of the publisher.

Links to third-party websites are provided as a convenience and for informational purposes only. They do not constitute an endorsement or an approval of any of the products, services, or opinions of the organization, companies, or individuals. SUNY Press bears no responsibility for the accuracy, legality, or content of a URL, the external website, or for that of subsequent websites.

For information, contact State University of New York Press, Albany, NY
www.sunypress.edu

Library of Congress Cataloging-in-Publication Data

Names: Sutton, Deborah, author.
Title: Ruling devotion : the Hindu temple in the imperial imagination, 1800-1946 / Deborah Sutton.
Other titles: Hindu temple in the imperial imagination
Description: [Albany] : [State University of New York Press], [2024] | Series: SUNY series, studies in the long nineteenth century | Includes bibliographical references.
Identifiers: LCCN 2024000343 | ISBN 9781438499208 (hardcover) | ISBN 9781438499222 (ebook)
Subjects: LCSH: Hindu temples--India--History. | Art and architecture. | India--History--British occupation, 1765-1947. | Imperialism.
Classification: LCC BL1243.74 .S88 2024 | DDC 294.5/35095409034--dc23/eng/20240226
LC record available at https://lccn.loc.gov/2024000343

to my mother
ANN SUTTON
and my daughter
MAY NAZ FLETCHER

Contents

Images

(between pp. 74 and 75)

Introduction

Chapter 1

Chapter 2

Chapter 3

Chapter 4

Chapter 6

Abbreviations

BoR	Board of Revenue
C.C. Procs	Chief Commissioner's Proceedings
Collr	Collector
D.C.	Deputy Commissioner
Dy C.C. Procs	Deputy Chief Commissioner's Proceedings
DSA	Delhi State Archives
ERC	Eastern Records Centre
NAI	National Archives of India
OIOC	Oriental and India Office Collections, British Library
PMA	Philadelphia Museum of Art
RAA	Royal Academy Archive
RIBA	Royal Institute of British Architects
SAO	State Archives of Orissa
TNSA	Tamil Nadu State Archives
VAMA	Victoria and Albert Museum Archive
WIA	Warburg Institute Archives

Glossary

abadi	land officially allotted for public purposes)
adālat	the court
apsara	celestial nymph
ashtabandhanam	rituals accompanying the installation of an idol
bargi	horse-mounted Maratha soldiers
cadjan	palm manuscript document
*carnum/karanam*s	temple accountants
*chela*s	disciples
choultry	guest house; rest house
chowkidar	guard
chukrum	a unit of currency
coil/koil/covil	temple (Tamil)
darshan	seeing and being seen by deity
devasthanam	abode of the gods
dharamshala	guest house
dharmacurtah	temple manager
dubash	translator or spokesman
garbhagriha	central sanctum of temple
hartal	a mass strike/withdrawal
inaam/inām	gift or award

javab navis	clerk or writer
jheer	senior priest
kacheri/cutcherry	office of district collector
Mahabharat	Hindu epic
mahasnana	a purification ceremony
mandapa	hall adjacent to temple
mandir	temple
murti	idol
mutth	religious institution; monastery
navagraha	nine (*nav*) astral bodies or divinities
nazul land	state-owned land
pagoda	umbrella term for any active temple in the eighteenth and nineteenth centuries
peishkar	temple manager appointed by collector
peishkash	portion of revenue; tribute
pindis	a form of murti that has emanated rather than been sculpted
piao	drinking-water stall
prachīn	ancient
pran pratistha	consecration ceremony
puja	a devotional act or prayer ceremony
pujari	priest
sabil	drinking-water stall
sadhu	ascetic devotee
sanad	a document under the government's seal
satyagraha	Gandhian mode of protest premised on acts of conscience
sevaks/sebaks	devotional volunteers
shastras	scriptural tradition generally relating to religious instructions

shastric	relating to the authority of the shastras
Shaivism	denomination of Hinduism that prioritises Shiva as the supreme deity
shivling/shivaling	physical representation of the god Shiva
shikhar/sikhara	spire above a shrine
*silpa*s	artisans; craftsmen
Star Pagoda	unit of currency
*sthānattār*s	directors
*swayambhu*s	divine emanations of a shivaling
thakurdwara	temple (Lord's dwelling place)
upadesam	an instructional document understood to be a document of succession
Vaishnavism	denomination of Hinduism that prioritises Vishnu as the supreme deity
waqf	property held in trust for an Islamic institution
zillah courts	district civil courts

Acknowledgements

THIS BOOK has been a labour of love for a decade. A number of other projects emerged while I researched its very loose limbs taking me on a number of fascinating tangents. It was enriched by other work, in particular by my six years as editor of a wonderful journal, *South Asian Studies*. I also owe a large debt of thanks to my students at Lancaster University for their work and commitment to South Asian history.

The book has benefited from access to a variety of archives and I would like to extend a sincere thanks to archivists and research officers who extended generous and informative support. In particular, I would like to thank Lalatendu Mohapatra of the Eastern Records Centre in Bhubaneswar who facilitated my work so generously. Research for this book was supported by a British Academy Small Grant (2010) and a Leverhulme Trust Research Fellowship (2012–13).

A number of scholars, friends, and scholarly friends have generously commented on proposals, papers, and drafts that formed the basis of the chapters and arguments in this book. In particular, I would like to thank Aparna Balachandran, Darrelle Mason, Michael Meister, Katherine Baxter, Will Glover, Anubhuti Marya, Rohan D'Souza, Naomi Tadmor, Sria Chatterjee, Sarah Turner, Andy Tate, Steve Legg, David Smith, and Daud Ali. Conversations with the late Kavita Singh, who was brilliant, helped me understand Stella Kramrisch and frame her better in this book.

Many very good friends have provided patient support. Aparna Balachandran, Farhana Ibrahim, Tanuja Kothiyal, and Swati Shresht – thank you for the friendship and laughter in Delhi and in-between. Thanks also to my wonderful friends and colleagues Corinna Peniston-Bird and Sarah Barber for the lunches and sorority.

A huge number of friends have supported this work: Bhavani Raman, Clare Anderson, Anita Balachandran, Siddhartha Chatterjee, Rashmi Misra, Anna Hopkins, Fiona Cecchi, Indra Sengupta, Crispin Bates and Aya Ikegame, Yu Sasaki, Malavika Kasturi, Rochelle Pinto, Prashant Kidambi, Nagraj Adve, Majid and Naz Siddiqi. I found the opening quotation in the fifth chapter while my daughter and I were staying with Uma and Mohan Raman in Chennai and I would like to thank them for their generous hospitality and their excellent P.G. Wodehouse collection. I owe my Dad a huge thanks for repeatedly asking me where the book is. It's here! Thanks to him and to Sue for their love and support. Thanks also to James, Sarah, Isobel, and Freya for all the holidays.

I owe particular thanks to Anita Sharma who suggested I approach Permanent Black as a potential publisher, when I wouldn't have presumed. Working with Rukun Advani has been an absolute privilege and I cannot thank him enough for his advice, support, meticulous editing, and help in placing this book for copublication with James Peltz at SUNY Press, New York.

Thank you to the kind, tolerant, and patient devotees, officials, pujaris, police, and residents of the Kalkaji Mandir in Delhi who answered questions, gave me chai, and allowed me to take photographs.

None of my research would be possible without the support of family and friends. My mother, Ann Sutton, allowed this book to be researched and written by caring for my daughter; I owe her an unpayable debt of thanks.

Finally, to my daughter, May, for putting up with my grumps and for being her brilliant self and an endless source of fun.

A version of Chapter 4 was published in *Modern Asian Studies*, vol. 47, no.1 (2013), 135–66, as "Devotion, Antiquity and Colonial Custody of the Hindu Temple in British India".

Introduction

> [The] Black Pagoda stands [as] a symbol for all of India,
> a symbol of its mystery, of its impenetrability to the
> Western eye. The things I remember best of India are the
> things I could not understand. – Lowell Thomas,
> *India: Land of the Black Pagoda*

PUBLISHED IN 1931, Thomas' description of the "Black Pagoda" – now more commonly called the Sun Temple – at Konarak in the eastern Indian state of Odisha, is an apogee of Anglophonic representations of the Hindu temple.[1] His account presents the Hindu temple as emblematic and incomprehensible; the temple was a lens through which the kaleidoscope of India can be both contained and encountered. This book will attempt to tell some of the histories through which the temple became an emblem of India in the Western, and in particular the British, imperial imagination.

Temples have a varied, and often peripheral, significance in anthropological, literary, philosophical, and sociological studies of Hinduism. In the words of one evocative formulation, temples provide merely "the hardware" for the more significant philosophies and devotional practices of Hinduism. Many Hindus actively prefer to offer devotion in private domestic shrines.[2]

Temples have been the fulcrums of particular political, social, and religious movements – for example, the Temple Entry movements from the 1920s onwards which contested restrictions

[1] Thomas, *India: Land of the Black Pagoda*, 272.
[2] Waghorne, *Diaspora of the Gods*, 4.

placed on the entry into temples of particular caste groups. Hindu temples have provided a focus for medieval archaeological and architectural scholarship. Their extraordinary sculpture has been distilled many times over into richly illustrated coffee-table books.

This book pursues a different tack. It brings together the histories of a range of diverse structures – from those of splendid medieval temples to small emergent shrines – in order to explore how, in a variety of times and places, the colonial state in India interacted with temples. It presents histories of the Hindu temple – as an idea, a form, an architecture, and a place – across 150 years of colonial governance. It explores the creation of the idea of the Hindu temple in the colonial imagination as one aspect of the complex imperial history of Britain and South Asia, tracing the ways in which the temple took shape in imperial governance and culture as a site of enviable wealth, compelling depravity, architectural wonder, political sensitivity, and aesthetic appeal.

The chronological arc of this book, from the late-eighteenth to the mid-twentieth century, encompasses the establishment, transformation, and eventual collapse of colonial authority in India. The Hindu temple was a place and an idea where the colonial state met and was tested by Indian society. These encounters took the form of physical conquest, revenue administration and taxation, surveillance and documentation, physical refurbishment and destruction, and scholarly abstraction. In some of these engagements, the temple became entirely the creature of a colonial imagination and was used to delineate the differences between a defining European hand and an Indian subject. In others, the gaze of the colonial state was caught and its interventions were resisted, manipulated, or rejected. The Hindu temple, I argue, was most obedient when it was a distant referent, the subject of scholarly schematics and policy formulation. However, as a living place of worship and site of popular devotion, the temple became a subject far less amenable to colonial governance.

Temples have never wholly curtailed or contained the divinity of Hindu gods and represent only one means by which the divine

can be encountered. In Hinduism the gods are never far away and a variety of human relationships with the divine – showing veneration, affection, opportunism, dependence, service, and even indifference – will be explored in what follows. However, as the site of pilgrimage, patronage, wealth, landholding, and contestation the temple did provide the form in which the Hindu divine had its most potent public presence. In this book, the divine inhabits the space of the temple in a variety of forms: as a sculpted form, as energy manifest, as sovereign, and, when necessary, as legally recognised subject. The relationship between the deity and the temple is constant and dynamic; the divine is either present or an imminent possibility. I explore that imminence of the divine as a source of considerable potency, and of agility in negotiations and contestations with the colonial state over 150 years or so. Only at the temple's convenience did the colonial state and its successors find the temple amenable to a relationship with bureaucratic and political authority.

What was "a Hindu temple", and why did it both compel and baffle Europeans? Despite the certainty with which the term has been used in English texts over the last two centuries, there is no *stable* living object, place, or structure to which it refers. The term encompasses in fact a bewildering range of devotional places and possibilities. The "Hindu temple" can describe a hand-held miniature, a simple roadside shrine, and a religious complex stretching across hundreds of acres. This physical variation is matched by historical, devotional, and organisational diversity. Temples can be dedicated to a huge variety of deities, including the devotional and philosophical schools of Vaishnavism and Shaivism, as well as local cult deities. All such devotional traditions are dynamic, and the dedications can change over time. The inception and construction of temples have been driven by institutional, monastic, or individual consecration, and dedicated to existing and innovative devotional practices.

Moreover, the word "temple" shelters a multiplicity of terms deriving from a number of languages used across India to describe a place

of devotion: for example, Devālaya, Prāsāda, Mandir, Gṛha, Devā-yatana, Covil, and Thakurbari. One encyclopaedia of Hindu architecture observes the breadth of terminology that can be equated with the term "temple" – "No especial word has yet been created to signify a peculiar structure in which the Indian placed the images of their Gods."[3] The term "pagoda", used extensively in the nineteenth century to describe a building for Hindu devotion, was probably borrowed from a Portuguese transliteration. This connotation of the word had fallen into disuse by the beginning of the twentieth century, simultaneously migrating eastwards to become associated with Buddhist structures.[4] The term "pagoda", along with "caste", was one of several that an evangelical commentator in 1811 deemed to have been drawn into usage among the British in India – evidence of the Company pandering to Hindus, and of the failure of the Company's government to reform Hindu society.[5] In the present book, "temple" and shrine are the principal terms used to describe Hindu architectural structures, the former denoting a larger established edifice, and the latter generally a more modest devotional structure.

This book is about the Hindu temple, not about Hinduism. It is not a contribution to the scholarly literature that has emerged in the last three decades to explore colonial transformations of local religious beliefs and behaviour.[6] The effects of colonial intervention on the breadth of conviction and practices described by the term "Hinduism" were wide-ranging and fundamental, and my book benefits from a host of historical work that situates particular lineages – theological, material, textual, social, political – through which the varieties of Hinduism were incanted during the period

[3] Nagarch, *Encyclopaedia of Indian Architecture*, 134.

[4] For an etymology of the term, see Ahmed, *Muslim Political Discourse in Postcolonial India*, 57, fn10.

[5] Roberts, *Hindu Infanticide*, 183.

[6] See Davis, *The "Bhagavad Gita"*; Reddy and Zavos, "Temple Publics", 241–60.

of study.[7] The nineteenth century saw projects of translation and publication, the emergence of new organisations and new structures of representation, and the assertion of a huge corpus of texts that articulated variant versions of what it meant to be, among other things, Hindu and Indian. But my book does not deal directly with these various political, devotional, and philosophical initiatives through which Hinduism was rethought and remade. Instead, it explores the Hindu temple as an idea and structure that was concocted and made coherent within white colonial governance from the turn of the nineteenth century until the mid twentieth.

The Government of India tried repeatedly but failed to formulate legislation that would fix the temple at some known and definite distance from itself. Each new set of rules formulated by the colonial authorities modified those made by their predecessors. The 1863 Religious Endowments Act replaced earlier presidency- and province-level Acts that required revenue authorities to supervise religious institutions. Instead, the 1863 Act required the formal recognition of mediating trusts between the temple and the state. In theory, the 1904 Ancient Monuments Protection Act harmonised with the 1863 legislation, but in practice it drew the colonial state into new encounters with the temple. In the case of living temples, these trusts would undertake the obligations required by the Act. Where no divine sovereignty existed, the state would take full control of the temple. The Act, however, precipitated the return of divinity into Hindu temples that had been reserved as monuments.

The temple returned to local governance with the passage of the Montagu–Chelmsford reforms after 1919. These reforms were driven in part by post-War austerity and replaced the costs of central supervision with the economies of local autonomy. The

[7] For an excellent bibliographic overview on the "invention" of Hinduism in the nineteenth century, see Lorenzen, "Who Invented Hinduism?" Histories of nineteenth-century reformism include Basu, *Religious Revivalism*, and Weiss, *The Emergence of Modern Hinduism*.

principle, as opposed to the convenience, of local supervision was strengthened by the Government of India Act in 1935. The popular ministries established, briefly, in the elections after the 1935 Act, gave rise to a political will to effect an organised reform of religious institutions. This determination resulted, after independence, in the Hindu Religious and Charitable Endowments Act of 1951. This Act established a government institution to exercise control over "the 'public' institutions of the Hindu community".[8] Over a century and a half, therefore, governance of the temples passed from being a state responsibility to a central responsibility and back again.

This book traces that emergence and various instantiations of the "Hindu temple" as an exemplary exotica in the Anglophonic colonial world – a world characterised by racialised orders of social, devotional, and civilisational difference. The arc of the chapters moves from money to metaphysics; from the attempts made in the early nineteenth century to regulate and profit from the wealth of the Madras Presidency temples, to esoteric art histories created in the inter-War period. Some chapters explore the attempts made by colonial officers to draw revenue, extract information, and impress their authority on the temple. Others examine scholarly attempts to categorise and manage the temple as a visual and physical resource.

Of equal importance are the many acts of resistance and divergence explored in this book. The temple was never a passive subject of the governing imagination. Resistance took many forms. The colonial state's uncertainty and mistranslations created opportunities for local actors to assert their own interests. After the rebellion of 1857, the colonial state was especially nervous about becoming embroiled in questions connected with religious sensitivity, a hesitation that provided the agents of Hindu divinity considerable latitude to counter, manipulate, or refuse

[8] Mudaliar, *The Secular State and Religious Institutions in India.*

interference from the Government of India. The Hindu temple, whether understood as a source of revenue, artefact, or incursion, was always inhabited. A recurring theme of this book is the capacity of the divine, through the agency of devotees, to compromise or thwart the presumptions – and presumptuousness – of imperial authority.

The Temple in Imperial Culture

Temples featured in some of the earliest European accounts of India and were, by the second half of the nineteenth century, familiar points in both touristic and vicarious textual encounters with India. Railway tours in the 1890s featured visits to temples.[9] Collections of lithographs and, later, photographs, such as Deen Dayal's *Famous Monuments of India* (1888), featured compositions that set the temple within a verdant oriental landscape or foregrounded architectural form.[10] Stereoscopes, a medium made popular by Queen Victoria's enthusiasm for their display at the Great Exhibition in London in 1851, presented the temple in immersive, three dimensional scenes. (Image i.1.) By the twentieth century, the Hindu temple was at once a familiar visual signifier of the exotic and a medium that communicated a set of immutable associations about India and Indianness: wealth, eroticism, peril, profusion, and an indistinct spirituality.

The temple entered the Anglophonic textual realm as a place of explicable, if unfamiliar, practices. At the end of the seventeenth century, Jean de Thevenot described the temple at Multan:

> [A] Pagod of great consideration because of the affluence of People, that came there to perform their Devotion after their way; and from all places of *Multan, Lahors*, and other Countries, they come thither in Pilgrimage. I know not the name of the Idol that is worshipped

[9] Review of Hope, "The Rationale for Railways in India", *British Architect*, 15.

[10] Dewan and Hutton, *Raja Deen Dayal*.

there; the Face of it is black, and it is cloathed in red Leather. It hath two Pearls in place of Eyes; and the *Emir* or Governor of the Countrey, takes the Offerings that are presented to it.[11]

Thevenot emphasised the presence in the Multan temple of "a great many precious Things". Temple wealth was to become one of the most compelling and enduring themes in Western accounts, even if Thevenot's admiration for living temples was subsequently diminished by the weight of Protestant disapproval of iconography and devotional wealth.[12] By the end of the eighteenth century, the East India Company governments established in different parts of the subcontinent were drawn to the possibilities presented for the organised taxation of both the assets and the revenues of temples that fell within conquered territories.

As the territories claimed by the East India Company governments grew during the first two decades of the nineteenth century, pressure was exerted by Anglicists, within Company service and beyond, for the imposition of "moral" governance over an "immoral" populace. The temple was deployed to situate the mythologised, and abhorred, practices of Hinduism. Texts and images proliferated in which sati (widow immolation), slavery, phallic worship, and sacrifice were demonised to feed this imagination, deftly combining titillation and indignation. The extravagance of the violences reported and re-reported in evangelical literature ranged from the general scandal of priapic worship to accounts of the amputation of noses and the sacrifice of children to crocodiles.[13] The Scottish Missionary Claudius Buchanan concocted in some detail the supposed obscenities and violence of Hindu devotion for an Anglophonic public. In his accounts, temples were theatres for debased devotional practices and the seats of a corrupt and corrupting priesthood whose influence had degraded Hinduism

[11] Thevenot, *The Travels of Monsieur de Thevenot*, 55–6.

[12] Ibid., 59.

[13] William, *Hindu Infanticide*, 227–70; Buchanan, *Two Discourses Preached &c*, 244.

over three millennia.[14] Buchanan's extravagant accounts were recognised and criticised as stemming from the evangelical and political desire to rein in the corporate Company's sovereign power. Despite their questionable veracity, their tone and principal motifs created a durable set of associations with the temple in the British imagination.

In the early nineteenth century, the Orientalist imagination separated the temple from text-based understandings of Hinduism. The "pure and wise" doctrine contained in Sanskrit texts was distinguished from "those vulgar superstitions which are constantly presented to the traveller's eye in their [the Hindus'] numerous temples." The latter were deemed as remote from the former as "the mummeries sanctioned by the Roman Catholic priesthood are from the purity of those doctrines promulgated by the chosen ministers of the Christian Lawgiver."[15] The temple was a harbour for "the poorer and more ignorant classes," those most susceptible to "all the absurdities of idolatry."[16]

The materiality of Hinduism unnerved a Protestant sensibility that was ill at ease with material mediations of devotion. Comparisons between Hinduism and Roman Catholicism were widespread and most pointed in early-nineteenth-century literary and missionary writings. Sectarian accounts sceptical of Catholicism said that the "comparative success" of Roman Catholic missionaries in India was explained by the materialism of both faiths.[17] In clerical accounts, the temple was a stronghold of superstition casting a hypnotic control that might occasionally be reordered to redeem devotees as congregants. In 1844, Reverend Pope recounted the case of a temple rededicated as a church in the village of Santharagiri in the Tinnevelly District of the Madras Presidency. After the idol had been evicted and thrown down the village well, "[t]he

[14] William, *Hindu Infanticide*; Buchanan, *Two Discourses Preached &c.*, 265.

[15] Caunter, *The Oriental Annual or Scenes in India*, 223–6.

[16] Ibid., 1.

[17] Anon., "Madura".

spell was broken, and the people seated themselves in an orderly manner, listened to my exposition of the Lord's Prayer, and joined with me in supplicating the blessing of God upon their first act of worship in their renovated temple."[18] Missionaries were active in disassembling the temple as an idea and form. They became important agents in obtaining objects of worship, principally idols, to furnish museums in the early nineteenth century. By carrying off and desacralising such objects, they violated the piety of darshan (the act of seeing and being seen by a deity) and transformed "idols into blind artifacts" for an intrigued British public.[19]

The Hindu temple was made to seem a space of concentrated ritual and sensory excess, a place symptomatic of the depravity that afflicted India's present. John Fryer's brief description of the interior of "a pagod or Heathen Temple" in late-seventeenth-century Madras described it as "stinking most egregiously of the oyl [*sic*] they waste in their lamps, and besmear their Beastly Gods with."[20] Later, sensory excess and disorder gave way to more fanciful accounts of depravity, these being supplemented by visual material. The "Temple of Ganesa, Benares", an engraving made from Thomas Bacon's 1839 *Oriental Annual*, shows a scene of imminent, if implausible, sacrifice in a temple which bears no credible resemblance to anything discernible in the corpus of Hindu architecture or sculptural art. (Image i.2.) A priest, wearing only a loincloth, his long hair coiled on top of his head, wields a club high over the body of an infant lying on a rug at his feet. The infant, its right hand raised, turns an imploring face towards the reader. Two priests beat gongs strung between the carved trunks of elephant heads atop temple pillars, while another lies,

[18] From the Rev. G.U. Pope to the Secretary of the Madras Diocesan Committee of the Society for the Propagation of the Gospel, Sawyerpooram, 18 March 1844, *Missions to the Heathen*.

[19] White, *From Little London to Little Bengal*, 73.

[20] Fryer, *A New Account of East India and Persia*, 39.

seemingly in a stupor, on the right of the image. A flight of steps descending to the rear of the engraving and a shaft of light from a high window suggest subterranean gloom.[21]

The temple was sunken, both physically and morally, in fictional accounts that provided salacious, keyhole accounts of unbridled sensual excess. By the early nineteenth century the morality and moderation of the Protestant West, now an active agency in South Asia, measured itself against the wealth and excess of the temple. To a Protestant sensibility, the temple was a space of aesthetic and sensory alienation: the smells, textures, and noises of the temple in chants, libations, and crowds drew disapproval and even disgust.

The shape of the temple, in its structure and ornamentation, was regarded as a manifestation of Hinduism's innate corruption, a "debased and soulless architectural style . . . alike devoid of mental aspiration and spiritual beauty."[22] Kipling, who made frequent use of the temple as a site and symbol of the peril India posed to unprepared white people, described the sculpted exterior of the temple as "always on the point of bursting into unclean, wriggling life."[23]

The eroticism of its carvings was seen as a compelling danger made hypervisible by the temple. This association of the sacred and the sensual propagated in British accounts signified the cultural distance between the moral order presumed to accompany colonialisation, and its subjects. Buchanan's accounts spoke ostentatiously of the relationship between temple form and immorality:

> This morning I viewed the temple; a stupendous fabric and truly commensurate with the extensive sway of "the horrid king". As other temples are usually adorned with figures emblematic of their reli-

[21] Bacon, *The Oriental Annual,* opp. 99.

[22] "Madura", 31. For a discussion of a Protestant aesthetic, see Jenkins, "A Protestant Aesthetic?", 153–62.

[23] Kipling, *From Sea to Sea*, vol. 1, 55.

gion; so Juggernaut has representations (numerous and various) of that vice, which constitutes the essence of his worship. The walls and gates are covered with indecent emblems, in massive and durable sculpture.[24]

My book explores various expressions of this fascination with the sensual: in the literary imagination, in the aesthetic codes that guided the colonial state's guardianship and physical conservation of medieval temples, and in the fetishisation of eroticism in inter-War art history. Kipling revelled in his English protagonists' horror of the temple, describing the shivaling as a "loathsome Emblem of Creation".[25] The journalist Trevor Pinch began his salacious and monotonous indictment of India, *Stark India* (1930), with a street scene outside a temple, describing Shaivite temples as "shrines of Rage and Sex-Energy" that generated India's "sex-mad millions".[26]

The abstraction of the temple from textual traditions of Hindu thought was sharpened in visual iterations. The arrival of the photograph, in particular, allowed the temple to proliferate as a distinct visual subject. Maria Antonella Pelizzari's *Traces of India* (2003), a collection on Indian architecture as a photographic subject between 1850 and 1900, illustrates in every sense the capacity of the photograph to render, and reduce, thousands of years of architectural practice into discrete, accessible frames. Pelizzari describes the visual convictions of James Fergusson (1808–1886), the Scottish architectural historian whose commanding and connective surveys of world architecture relied upon the photograph as (almost) entirely equal to personal inspection.[27] Fergusson countered any deficit in the photographic by reminding the reader of his own first-hand expertise in India, and of the sheer scope of access offered by photographs. The second chapter of my book explores Fergusson's authoritative explications of the Hindu

[24] Buchanan, *Christian Researches in Asia*, 29.
[25] Kipling, *Letters of Marque*, 100–1.
[26] Pinch, *Stark India*, 24.
[27] Pelizzari, *Traces of India*.

temple, and the complex web of comparison and explication he created.

By the nineteenth century the temple had been established as an imaginary referent in which masochistic and sadistic fantasies were both indulged and exonerated. Powell and Pressburger's 1947 adaptation of Rumer Godden's novel *Black Narcissus* (1939) showed nuns maddened by sexual frustration running down claustrophobic corridors lined by pillars designed to resemble South Indian mandapa halls (Image i.3). It was not by chance that David Lean's 1984 adaptation of E.M. Forster's *A Passage to India* (1924) used a ruined temple as a visual shortcut, perhaps even catalyst, to Adela Quested's sensory disorientation before her visit to the Marabar Caves and false accusation of rape against Dr Aziz. Her initial openness, compared to the petty and racist Anglo-Indian community of her fiancé, leads her to explore a ruined medieval temple replete with fragments of erotic sculpture and aggressive langur monkeys. She flees in confusion and fear, pursued by the simian horde.

The association between Indian temple art and the erotic traversed both popular fictional and scholarly accounts of Indian art. Forster's friend, the art critic and historian Roger Fry, informed the audience of his 1934 lectures as Slade Professor of Art History at Cambridge that "the sensuality of Indian artists is exceedingly erotic" and that Indian art was "intensely and acutely distasteful to me."[28] Fry employed this vehement dislike as a comparative marker of aesthetic inadequacy. Describing carvings on the southern door of the Basilica of Saint-Sernin in Toulouse, he remarked, "How on earth, one wonders, came these Hindu figures here? Of course, they are not Hindu, but how otherwise describe their rounded, inflated forms, their pasty modelling, their intricately convoluted and flaccid rhythms?"[29] (Image i.4.) William Morris, who did so much to imitate and popularise,

[28] Fry, *Last Lectures*, 150.
[29] Fry, *Transformations*, 174.

with little acknowledgement, Indian design motifs, described "the ancient architecture of India" as "marred by extravagance and grotesquery of detail, which must be called ugliness."[30] In these texts and images, the Hindu temple emerged as a leitmotif of India's exoticism, impenetrability, and eroticism.

The Hindu temple was an errant subject of imperial governance. As places, structures, and institutions Hindu temples frequently frustrated attempts by the colonial state to extract revenue, create monuments, constitute knowledge, and, variously, to either involve or remove itself from the day-to-day administration of particular temples. Those challenges do not form a single and linear history, but they offer moments of insight into the terms of a complex and multifaceted engagement through which colonial authority was constituted and pursued, a process that owed as much to contingency as to the formulation and implementation of policy. Throughout the period of British influence, conquest, and governance in South Asia, the question of where the appropriate limits of that intervention should lie were a constant preoccupation in the colonial mind. In different chapters of this book the temple offers a means to map out debates within and between various scales of authority: from the responses of district-level officers, through Presidency-level departmental policy debates, to declamations by the Home authorities in London.

This book sits within a multi-disciplinary scholarship that has used archaeological, art-historical, anthropological, and historical methods to draw our attention to the importance of visual and material aspects, and implications, of imperial histories. Partha Mitter's landmark intervention, *Much Maligned Monsters* (1977), provided an exhilarating overview of European responses to Indian forms of art.[31] Richard Davis gave Indian images and objects a more animated history by exploring the paths through which

[30] Morris, *The History of Pattern-Designing*, 217.
[31] Mitter, *Much Maligned Monsters*.

their meanings were negotiated.[32] A range of significant scholarship has built on these foundations to use a variety of material cultures and fabrics with which to explore the complexities of the colonial encounter in South Asia.[33]

This rich historical and art-historical literature has used objects, images, and architectures to chart imperial histories, describing both the intentions of their makers and the successive custodies through which they passed.[34] Indeed, this scholarship demonstrates the capacity of Indian materials to breach the terms of colonial custody formulated over them in the nineteenth and twentieth centuries. My book owes a particular debt to the recent work on monuments and monumentality in South Asia which has explored the complex material legacies of archaeological regimes in colonial and postcolonial India, interrogating the principles of imperial governance that sought to forge "monuments" in India as emblems and spaces designed to contain India's past.

Indra Sengupta has explored "vexed" custodies – the colonial state's attempts to extend control over temples in order to reinvent them as monuments.[35] Mrinalini Rajagopalan offers a sustained and critical interrogation of five monuments in Delhi, unpicking the presumptions which underlay the material and legislative orchestration of these urban monuments by colonial and postcolonial regimes. In relation to the same city, Santhi Kavuri-Bauer traces the changing meaning of Mughal monuments across three centuries; her work engages directly with the contemporary Indian regime's hostile reframing of Indo-Islamic pasts.[36] Anand Vivek Taneja's study of the Feroz Shah Kotla complex challenges the

[32] Davis, *Lives of Indian Images*.

[33] For example, Raman, *Document Raj*; Mathur, *India by Design*.

[34] Cherry, "Afterlives of Monuments".

[35] Sengupta, "Monument Preservation and the Vexing Question of Religious Structures in Colonial India"; Sengupta, "Culture-keeping as State Action".

[36] Rajagopalan, *Building Histories*; Kavuri-Bauer, *Monumental Matters*.

bureaucratic definition of inanimate ruins by examining the social and devotional animation of structures. His work deftly demonstrates that many meanings live simultaneously to bring past and present together in ways that cannot be contained by state or scholarly definitions.[37]

The majority of this scholarship is concerned with Indo-Islamic monuments in northern India, and particularly in or near the capital, New Delhi. This focus reflects the preference of the Imperial Archaeological Department for Indo-Islamic materials and the conspicuous integration of those architectures in the new imperial capital of Delhi in the 1910s and 1920s. Two noticeable exceptions to the scholarly focus on Indo-Islamic materials are Indra Sengupta and Deborah Stein. Sengupta draws our attention to the legal and bureaucratic preoccupations of archaeologists attempting to make monuments out of temples in late-colonial eastern India.[38] Stein, like Taneja, extends this focus on the colonial records of the archaeological department, fusing anthropological and archival research to explore the diachronic lives of two temples in southern Rajasthan. She traces the interplay of authority and devotion within the fabric, using the temple as an axis and agent in the making of local and national pasts.[39]

Chapter Structure

The chapters of this book are case studies. These case studies, taken from various regions of British India, have been chosen as a means to explore a set of themes through which the temple, as a fabric and as an idea, was made coherent in the colonial imaginary. The chapters, therefore, are neither exhaustive nor definitive, but they are wide-ranging: the temple is explored as a space of revenue administration, as a desacralised public monument, as

[37] Taneja, *Jinnealogy.*
[38] Sengupta, "Culture-keeping as State Action".
[39] Stein, *The Hegemony of Heritage.*

a disputed incursion, as an architectural form, and as a space of thought.[40] In no chapter is the temple quite the same, though in each chapter the histories explored reflect the precarious, contingent, and violent nature of the imperial state.

In the first chapter, officials of the Madras Presidency government scramble to make sense of their rights and obligations to temples brought under Company authority at the end of the South Indian Carnatic wars – a series of conflicts fought in the middle of the eighteenth century between the English and French companies and a number of regional rulers. By 1799, the Company government based in Madras had dramatically increased its territories but had little operative knowledge or control of the land acquired by conquest or treaty. The temples explored in this first chapter were redoubtable and complex institutions which had been established through donations of wealth and resources over hundreds of years. The officers of the Madras government oscillated between trumpeting "the happy Distinction between British Generosity and Justice and Mahommedan rapacity and sacrilege,"[41] and – drawing on British histories of the resumption of monastic wealth in the sixteenth century – criticising the corruption of temple priests and their establishments. These pretensions of governance were soon confronted, and diminished, by the extraordinary complexity of temple administration, and by competing caste-based claims for certain rights and allowances.

The second chapter explores the formulation of historical and material accounts of the temple by scholarly, architectural taxonomies. Ponderously worded observations on the resemblance of temples with structures that had no connection with them drew on the established, civilisational co-ordinates of wonder.

[40] I would like to acknowledge Faisal Devji for this phrase after my presentation entitled "Stella Kramrisch's Hindu Temple" at the Oxford South Asian History Seminar Series, 30 October 2012.

[41] John Wallace, Collr, to BoR, 3 February 1802, Trichinopoly District Records, vol. 3661, 124–9, TNSA.

James Tod, who wrote extensively on the history and geography of Rajputana (mostly present-day Rajasthan), saw elements of original Gothic form in the medieval temples of Chandravati and speculated that these elements had subsequently made their way, via Africa, to Europe.[42] A review of *Architecture at Ahmedabad, the Capital of Goozerat* (1866) reversed Tod's direction of movement and observed that it was "curious to observe how the principles of Gothic architecture appear to have found their way into India."[43] Architectural scholarship, in particular that of the enduringly influential and didactic James Fergusson, replaced this speculation with authoritative taxonomies of architecture that used comparisons only to point out the relative deficiencies of Indian builders. Under Fergusson's guiding hand the temple was transformed into an index of cultural decline that began in the fifth century and culminated in the British imperial present. This chapter considers the place of Indian architectures, and the temple in particular, in terms of Fergusson's vast, though reductive, schemes of world architecture.

The third chapter continues the treatment of temples as architecture to explore their physical and legislated custody as monuments after the passage of the Ancient Monuments Protection Act in 1904. The conservation of India's physical past provided the colonial state with the means to prove and embellish its right to govern. The conservation of India's monuments was, according to Viceroy Lytton in 1878, the most "essentially imperial" task of government.[44] Architectural and archaeological accounts described Hindu antiquities as remnants, survivals from the widespread destruction of Muslim and Portuguese iconoclasm.[45] The physical form of the temple, and the immorality associated with temple

[42] Review of *Travels in Western India*, 484; Todd, *Travels in Western India*, 109, 224, 226, 238, 296.

[43] Anon., "Hindu Architecture", 250.

[44] Quoted in Cumming, *Revealing India's Past*, 3.

[45] Dalrymple, "Account of a Curious Pagoda Near Bombay", 323–36.

carvings for over a century, combined to create a state conservation practice that favoured the curation of material pasts defined as Islamic over Hindu. The archaeological authorities struggled to consolidate their claim to temples as monuments. The 1904 Ancient Monuments Protection Act provided a legislative definition and justification of custody over monuments for a non-devotional public. However, the physical conservation that took place under the strict aesthetic regime of the Archaeology Department often precipitated renewed devotional activity. Archaeological officers, to their consternation, were forced to share custody with those who regarded the temple as a living space of devotion.

The fourth chapter pursues the theme of temples as delinquent subjects of colonial governance. Spontaneous eruptions of subterranean divinity, in which gods came to be manifest from the earth as pindis and swayambhus, provided fulcrums through which political entrepreneurs could assert their own authority and test that of the colonial government. In Delhi during the 1920s and 1930s, new temples emerged and challenged the displacement of shrines during land clearances for the imperial city. These devotional sites were declared both innate and inviolable, a religious claim that was quickly augmented by political challenges to the colonial authorities. The designation of a shrine as prachīn (ancient) contested the right of the colonial state to define and control India's past, regardless of its (by this time faltering) claim to India's political present. Political fury at the violation of shrines transformed and amplified local disputes into national as well as nationalist contestations of the legitimacy of the colonial state.

The fifth chapter explores temples as creatures of the English literary imagination. Here I delineate the recurring motifs through which the Hindu temple was made familiar and meaningful in a variety of English-language texts: poetry, popular adventure stories, literary travelogues, and literature. The temple rendered into text offered a voyeuristic licence that at once permitted, and by dint of rule made it necessary for the European to look upon

Hindu eroticism. The temple became a place into which the erotic, supernatural, divine authority could be sequestered for the reading pleasure of the coloniser. Significantly, this fictionalised temple offered a space in which white agency could be exonerated from the pervasive violence of colonialism. These exotic fictional narratives served to allow violence – theft, murder, and torture – to be separated from the English character and therefore from an imperial British selfhood.

The sixth, and final, chapter examines the temple as the abstract, and therefore obedient, subject of art-historical analysis. The twentieth-century biography of the temple is read through the career and scholarship of the Czech art historian Stella Kramrisch who worked in India from the 1920s to the 1940s. Kramrisch's temple amalgamated devotional and divine energy. In rendering the temple as an art-historical – and dehistoricised – subject, Kramrisch collapsed the variety of regional, architectural, and dynastic traditions of temple building into a single archetype. Simultaneously, art-historical dealership and connoisseurship created the new global networks across which objects, desire, and money moved. The fetishisation of the temple – apparently a dramatic reorientation of the repulsion against it evinced in the nineteenth century – is interwoven with, and indeed emerged from, the global orders and possibilities created by empire.

Throughout British colonial rule in South Asia, successive attempts to realise authority over the temple floundered. Each attempt to "fix" the Hindu temple – whether in physical demarcation, aesthetic evaluation, or legislated definition – was compromised by the dynamic life of its supposedly static subject. The greater the precision of definition claimed, the further the temple receded from the grasp of the colonial state.

1

Company Rule and Temples in the Madras Presidency, 1800–1841

AT THE VERY beginning of the nineteenth century, after decades of war in the Carnatic, huge tracts of land passed into the hands of the Company government in Madras. The Carnatic and Mysore wars were a bloody and complex collision between deputed Mughal authority held by competing and allied dynastic claimants to the power centres of Arcot, Hyderabad, Gingee, and Mysore; the "Mahrattas" (Marathas) in the North; and the arriviste militarised mercantile French and English. As part and parcel of the spoils of conquest, hundreds of religious institutions were brought under the umbrella of the Madras Presidency government.

This chapter explores the Company's administration of three temples in the Trichinopoly (now Tiruchirappalli) District during the first four decades of the nineteenth century. These South Indian temples offer apposite examples of Hindu religious establishments being remade and reimagined through the exercise of Company authority. Temples that had been significant predominantly as fortifications and refuge during a long period of war were re-formed by the attentions of the revenue authorities, who became increasingly aware of their wealth. The government in Madras inherited the administration of temples in a landscape made more complex by decades of war and political instability. It found

itself to be the arbitrator of disputes, revenue administration, appointments, and the allocation of gifts and grants for repairs and refurbishments. As we shall see, through a series of assertions and contestations of their authority, Company officers took recourse to frames of reference familiar from their native contexts, drawing on English ecclesiastical history to decipher and navigate the temples' complex structure.

The administration of temples presents an illuminating case study of the Company's ambivalence and uncertainty in the delineation of private and sovereign property in India. The Company's position, characterised by imprecision and frustration, was informed throughout this forty-year period by two rather contradictory preoccupations: first, the material and moral interest of the Madras government in ensuring the "ancient splendour" of the presidency's temples, and second, a suspicion of the temples as sites of wealth and corruption. Temple assets were absorbed into the workings of the Revenue Department through local village and revenue officials, leading to the creation of a range of practices and contingent arrangements and understandings. Meanwhile, the Madras government made sporadic calls for definitive information about the workings of temple establishments in order to create a clear scheme that could be enforced across the presidency for the governance of such revenues. Company officers consistently found themselves at a loss to translate the accounts, offices, and processes of the temple in a way that made them fully comprehensible, let alone amenable, to governance. This caused in them an unease which found its starkest expression in a racially coded hostility towards the "litigiousness, rancour and prevarication" of the temple officers, chief among them the Brahmans, the priestly class that oversaw the divine and earthly concerns of the temples.[1]

[1] Secretary, Revenue Department, to Collr, 24 July 1826, Trichinopoly District Records, vol. 4377, TNSA; C.M. Lushington, Collr of Trichinopoly, to BoR, 26 November 1817, Trichinopoly District Records, vol. 3675, 294–395, TNSA.

Company involvement continued in the temples until, by the 1830s, British evangelicals had mounted a sustained and eventually successful campaign against "the baneful influence . . . of the gain of this unnatural association with Idolatry", which British authority in India was seen to both profit from and sponsor.[2] In 1841, the home authorities ordered the Madras government to "effect the immediate withdrawal from all interference with native temples."[3]

Two of the three temples that I focus on in the Trichinopoly District were (and are) located on the island of Srirangam: one, the huge complex of the Srirangaswamy Temple dedicated to Vishnu; and the second, a smaller Shiva temple, Jambukeswarar. The third, the Thayumanar Temple (also called the Malay Covil or Rock Pagoda) lay adjacent the district headquarters of Tiruchirappalli. These temples were among many brought into the presidency by conquest; they held significant amounts of land donated over centuries for the upkeep and enlargement of their establishments. The temples were multifaceted institutions, centres of sacred and earthly authority as well as holders of large and diverse sources of wealth. Thousands of people lived within the seven enclosures of the Srirangaswamy Temple in Srirangam, and the temple's establishment combined the residences of deities and mortals, priests and others, gardens, shops, and bakeries. Image 1.1 shows an intricate plan of the enclosures created around 1800. The temples were host to a suite of offices, rights, and claims. Their "secular management" consisted of the trustees (sthānattār), and accountants (carnums; karanams).[4] Officiating priests – Brahmans – were selected variously by the sthānattār, by inheritance, and by religious institutions (mutths) associated with the temple. Finally,

[2] Peggs, *India's Cries to British Humanity*, 103.

[3] H. Chamier, Chief Secretary, to President and Members of the Board of Rev., 12 June 1841, BoR Procs 24 June, 8134–8, TNSA.

[4] Stein, "The Economic Function of a Medieval South Indian Temple". See also Wilson, *A Glossary of Judicial and Revenue Terms*, 263.

there were those who held the rights to supply the temples with a range of services and goods whose selection depended on inheritance, or the bidding for contracts, or the payment of fees (jodigay).

Temples and the Topography of War

The town of Trichinopoly (now Tiruchirappalli), described as "the heart of the Carnatic", is dominated by a dramatic rock escarpment which rises to a height of 125 metres in the north-east of the town (Image 1.2). Trichinopoly lay at the principal crossing point of the Kaveri River and had long been, in peacetime, a significant centre for trade, growing into one of the largest towns of the Madras Presidency in the nineteenth century. The rock at Trichinopoly had been fortified since the sixteenth century and, alongside some large multi-walled temples three miles north at Srirangam, represented strategically prominent parts of the landscape for long periods before the nineteenth century.

The Srirangaswamy Temple of Srirangam consists of seven walled enclosures (the largest encompassing an area of almost 1 km × ¾ km) and was one of the richest in South India. By the 1830s, 7000 people lived within the temple settlement.[5] The oldest inscriptions in the temple date from the tenth century, though the largest phase of expansion was under the patronage of the Vaishnava Nayaks in the sixteenth century, and in particular by the Nayaks of Madurai who moved their capital to the adjacent Tiruchirappalli in 1616.[6] The smaller and comparatively less wealthy five-enclosure Shaivite Jambukeswarar Temple lies only a mile from the Vaishnavite Srirangaswamy Temple.

The three temples had been significant strongholds during the campaigns of the Carnatic wars of the mid eighteenth century. Atop the rock fort of Tiruchirappalli, "a man with a telescope" was

[5] The residences in the first three enclosures of the temple were brought under the municipality in 1871. Cole, *Temples at Trichinopoly,* 10.

[6] Rao, *The Srirangam Temple,* 6.

stationed at the Thayumanar Temple throughout the war.[7] The multi-walled temples at Srirangam presented ideal fortifications to defend key intersections of roads and waterways. In the early 1750s, the English launched a mortar attack from the Jambukes-warar Temple against the Srirangaswamy Temple – or rather against the French forces stationed within it. During the three years that the French had occupied this temple-fortress, they had "converted the three outer enclosures into a military camp barricading the gateways and mounting guns on the walls."[8] During the siege of Tiruchirappalli in 1751, the Srirangam temples were occupied successively by Muhammad Ali – son of the defeated Nawab of Arcot and ally of the English – and then by Chanda Sahib, the Mughal Dewan of the Carnatic and his French allies. The temples relied on their wealth to survive as devotional centres amidst all this warfare. The intention of Chanda Sahib and the French commander, Jacques Law, to destroy the Srirangaswamy Temple was prevented – according to the account of Ananda Ranga Pillai, du-bash (translator; spokesman) and courtier of the French – only by the payment of Rs 60,000 and the transfer of the temple's grain tore. The *Koil Olugu*, a historical chronicle of the temple, details the violence inflicted on property and person within the temple walls; but it also maintains that the occupying armies did not breach the temple beyond the first three of the seven enclosures, and that the "life of the temple was not seriously affected by the political and other disturbances of the age."[9] At no point, according to the *Koil Olugu*, was the deity unseated despite the vicissitudes of warfare. Indeed, the temple chronicle records that after Chanda Sahib's defeat and death in June 1752, 1000 Rajput warriors from his depleted army remained to protect the sovereign deity from the English, who now resumed control of the temple.[10] For the next two

[7] Dalton, *Memoirs of Captain Dalton*, 204; Rao, *History of the Śrīrangam Temple*, 206.

[8] Rao, *History of the Śrīrangam Temple*, 220.

[9] Ibid., 222.

[10] Ibid., 213.

years, the Srirangam Temple was occupied by the armies of Mysore under Nandiraja in his attempt to claim the town of Tiruchirappalli.

In 1754 the French and English hostilities ceased. The temples continued to be occupied sporadically by the armies of the English, French, and Mysore until the late 1790s, when the Carnatic fell definitively into the hands of the English Company. Temples that had been partially or entirely fortified by the military authorities were gradually returned to devotional purposes. In 1803, the temple of the goddess Nachiyar Koil (now better known as the Azhagiya Manavalan Perumal Temple) in Woraiyur, which had been used as a barracks, was restored to the authority of the Great Pagoda at Srirangam.[11]

Not all temple restorations ran smoothly. In Trichinopoly in 1821, the proposed return to Hindu claimants of the Naugananda Swamy shrine within the Rock Fort, which had been occupied by soldiers, was rejected on the grounds that a Protestant church had been established nearby. Now that the idea of Christian supremacy had been inserted into Company rule, the places of Hinduism and Christianity could be regarded as incompatible. The Collector, Charles Lushington, objected on sensory grounds: "the constant noise and mummery inseparable from Hindoo ceremonies" was unacceptable in the proximity of a Christian Protestant church, and, he added – despite the acquiescence of the military authorities to the temple's return – of the military hospital.[12] After protests by the Church authorities, the Archdeacon in Madras was assured that there was no intention to return the temple to Hindu devotion.[13]

[11] J. Wallace to BoR, 27 November 1803, Trichinopoly District Records, vol. 3662, 236–7, TNSA.

[12] C.M. Lushington to BoR, 6 January 1821, Trichinopoly District Records, vol. 4392, TNSA.

[13] R. Clarke, Sec., BoR, to Chief Secretary to Government, 22 December 1823, Trichinopoly District Records, vol. 4376, TNSA.

Hindu Temples as the Property of the Company Government

The absorption of shrines and endowments by the Madras government put, in Robert Frykenberg's words, "every local Hindu institution under a single, overarching structure. Tens of thousands of Hindu institutions were thereby inadvertently welded together within the imperial apparatus."[14] Frykenberg's use of the term "inadvertent" presages subsequent attacks on the Company government's involvement in temple administration, a subject to which this chapter will return. However, there is little in the correspondence from the Madras Presidency, or elsewhere, to suggest that Company officers felt surprised or in any way compromised by the inclusion of temples as part of the revenue landscape they now sought to survey and control in the name of the government at Fort St George. The Company state was corporate in nature and was articulated through a complex interdependence with local capital, authorities, institutions, credit networks, and languages.[15] Indeed, the scope of the Company's authority over temples, no matter how imperfectly implemented, was a simple extension of the sovereignty assumed over those territories that had come under its control at the close of the eighteenth century.

The first collector of Trichinopoly, responsible for the establishment of civil and judicial authority in the name of the Company, was John Wallace. His jurisdiction included the three richest temples in the presidency and he was a vocal advocate of the Company government's sovereignty over them. It was, he argued, the duty of the Madras government to introduce proper order, economy, and therefore glory, to the district's temples. He argued that the revenue authorities should take direct control over all the assets of the temple and, in their place, provide a single annual allowance to support all its functions. This allowance would replace

[14] Frykenberg, "Christian Missionaries and the Raj", 109.
[15] Raman, *Document Raj,* 8.

all taxable assets and place the administration of those assets, composed largely of agricultural lands, in the hands of the collector. In 1801, Wallace assumed direct control over the inām (lands donated to the temples) of the three principal temples and assigned a fixed allowance for the support of all temples in the district. In addition, any further donations would be placed in a fund administered by his office, the kacheri (cutcherry), for the repair of temples.[16]

Wallace argued that Company involvement in temple administration marked the benevolence of the new Company regime and would reverse the declining public functions of the temples: "the annual Festivals particularly that of Seringham [Srirangam] which formerly drew thousands of Devotees from all parts of Hindustan are now thinly attended." He saw it as the duty of government to provide financial support for a reform and renaissance of "the Pagodas and choultries [rest houses] which are now in a most decayed and filthy condition and for keeping the streets and avenues of the Seringham [Srirangam] Pagoda, which contains within its walls a very considerable town, in a state of cleanliness and repair which has been long unknown and which is much wanting." He lamented that "the internal management of the churches is without responsibility and consequently without proper arrangement."[17] His use of the word "church" was not accidental. British officers routinely described the temple's form and functions in words more familiar to them – the ecclesiastical landscape of church, chapel, and synod. The use of these terms was not an act of translation but of analogy. Wallace imagined temples, their assets now assumed by Company government, as the pre-eminent public institutions of the district and presidency.[18] His image of

[16] H. Dickinson, Collr, to BoR, 10 November 1826, Trichinopoly District Records, vol. 4397, TNSA.

[17] J. Wallace, Collr, to BoR, 3 February 1802, Trichinopoly District Records, vol. 3661, 124–9, TNSA.

[18] J. Wallace, Collr, to BoR, 29 March 1804, Trichinopoly District Records, vol. 3663, 75–6, TNSA.

the role of the Company government vis-à-vis the Hindu shrine included the benign and corrective supervision of both the temple's ceremonial practices and worldly prestige. It was the "duty" of the collector "to see that the usual ceremonies and feasts are properly celebrated, and that the servants of the establishment perform their duties regularly."[19]

The guiding principle of Company governance following conquest was to restore the practices established by the preceding regimes of the nawab of Arcot and, subsequently, the Mysore state. Wallace recommended that the Company maintain its grain donations to all the temples of the presidency, chief among them the Thayumanar Temple at Trichinopoly and the two temples at Srirangam. Government donations, he argued, "will take very little from its revenues while it will add considerably to the funds of the Pagodas and [will] strongly mark in the minds of the people of these countries the happy Distinction between British Generosity and Justice and Mahommedan rapacity and sacrilege."[20] This pared-down parable of Islamic conquest and confiscation followed by British restoration elided the extraordinary political and dynastic complexity of the Carnatic wars in which questions of religious affiliation were of little strategic interest or relevance. Now that the temples were under Company jurisdiction, the Madras government was particular that a sanad (a document under the government's seal) be created to make clear that "the present resolution may appear to be no more than a confirmation of prescriptive rights." In other words, the Company intended to do no more than restore the proper relationship between divine and earthly sovereignty that had existed before "Mahomaden usurpation".[21]

[19] H. Dickinson, Collr, to BoR, 17 May 1827, Trichinopoly District Records, vol. 4398, 190–2, TNSA.

[20] John Wallace, Collr, to BoR, 3 February 1802, Trichinopoly District Records, vol. 3661, 124–9, TNSA.

[21] Government to Board of Revenue, 21 June 1800, contained in W. Wayte, Secretary, Revenue Dept, to the Principal Collector in Tanjore and Trichinopoly, 21 March 1808, Trichinopoly District Records, vol. 3647, 325–48, TNSA.

This rhetoric simplified the complex and shifting web of alliances that had shaped the Carnatic wars. The distinction between volatile "Mohamaden" and pacifying British sovereignty was also at odds with the cultural, economic, and religious history of larger temples that had, for centuries, been lynchpins for a variety of forms of authority in the subcontinent, authority that had never been devotionally homogeneous.[22] One of the consorts of Sri Ranga at the Vaishnava Srirangam Temple was the deified daughter of a Muslim nawab. The shrine of Tulukka Nachiyar, a Muslim princess, lay within the temple's fifth enclosure, and local narratives emphasised the equanimity and inclusivity of the temple's traditions.[23] Wallace's arguments also contradicted English documentation of the Muslim patronage of temples. In the 1780s, William Fullarton had noted that

> [T]he wisdom of the Moorish conquerors of Indostan failed not to preserve this ancient fabric of Indian adoration . . . Hyder Ally never failed to make large endowments to the chief temples or pagodas. In 1781, when his army invested Tritchinopoly, he waited in person on the Bramins of Seringham Pagoda, with a propitiatory acknowledgement to Vishnou, the tutelary deity of that sanctuary.[24]

Fullarton recommended that the English Company follow Hyder Ali's example.

Instead, the Company government in Madras sought to reach back to a period before Muslim influence, to an imagined "Hindu" past. When asked to arbitrate over an appointment dispute at the Srirangaswamy Temple in 1810, the Board, hesitant to get mixed up in complex sectarian disputes, speculated that involvement in such matters may have originated under Tipu's government; it therefore asked the Collector to determine what had been the course of deciding on such disputes under "Hindoo government".

[22] Mayer, "Tombs and Dark Houses".
[23] Hemingway, *Madras Gazetteers*, 322.
[24] Fullarton, *A View of the English Interests in India,* 6–8.

The Board was seeking precedents in a remote past – looking to a time which long pre-dated the interventions of their own collectors as well as those that may have been made during the rule of the "Mahrattas" and Tipu Sultan. If state engagement was indeed found to have precedence, then, the Board ordered, the matter should be referred to the zillah courts which had jurisdiction in all matters relating to religion – a move that neatly sidestepped involving the revenue authorities.[25]

The Company government's conviction about distinct and exclusive Hindu and Muslim practices could also provide a convenient means to dismiss claimants to temple assets. In the 1820s, a claim was made by Goolam Hussain Kohaul to an inām (gift; award) given to a temple by Nawab Walajah, his grandfather, in 1755. The Board of Revenue evinced scepticism of his claim, basing it on their doubt that a Muslim would have made a donation "to the support of a religious persuasion differing from his own."[26]

The attentions of the presidency government naturally crystallised around the temple's accumulation and generation of wealth. Frank Presler, who wrote a long-range study of the relationship between the state and temples in South India from the 1800s to the 1970s, perhaps overstated the reach of local revenue authorities over temples: he describes the latter as "creatures of the state" in the first decades of the nineteenth century.[27] In the first three decades of the nineteenth century, the question of how money would flow between collectorate and temple accounts provided the moral and fiscal co-ordinates to this complex and evolving relationship. Information gathering, surveillance, and the collection of revenues became over this time the foremost preoccupation of district officials.

[25] BoR to Collr, 9 November 1810, Trichinopoly District Records, vol. 3650, 154–7, TNSA.

[26] BoR, to Collr of Trichinopoly, 18 October 1827, Trichinopoly District Records, vol. 4378, 453–5, 493–4, 533–4 (?), TNSA.

[27] Presler, *Religion Under Bureaucracy*, 19.

The "Accounts of the Church":
Company Officers and Temple Revenues

The largest temple revenues were derived from agricultural land given by private donors, including successive sovereigns, for the support and enlargement of the temple. The financial records of the temple were known as the devasthanam (abode of the gods) accounts. These accounts, as material records, constituent knowledges, and traditions were managed by a peishkar, appointed by the collector and placed under the authority of the deputy collector. The peishkar oversaw the disbursement of allowances to the temple, as well as the revenues that were claimed and collected by local revenue officers on behalf of the Madras government from the temples.[28] The devasthanam accounts were administered from within the kacheris, the district headquarters of collectors – the Company's cadre of district-level officers. The officers in the kacheris were supported by a number of native clerks, accountants, and writers, among them the peishkars. In the bureaucratic scheme of the Madras government, the kacheris were nodes across which Company authority was extended over the presidency, connecting Fort St George to its hinterland and, in turn, to the centre of Company governance in Calcutta and beyond to the combined home authorities of the East India Company, Crown, and parliament. The collector embodied Company sovereignty and was invested with responsibility and considerable powers of discretion over his district's resources – to survey, document, tax, and govern according to the wishes of the Madras government. The discretionary power, as we shall see, resulted in successive collectors modifying and overturning the decisions of their predecessors, to the consternation of the temples' own officers.

Jurisdiction over the temples shifted uneasily between the collectorate as the seat of revenue administration, and the adālat (the

[28] G.W. Sanders, Collr, to BoR, November 1825, Trichinopoly District Records, vol. 4396, 336–42, TNSA.

courtroom), creating frequent oversights and collisions between different interpretations of precedents and protocols. Orders received from the Madras government required and expected the Company's rights over and knowledge of the assets of the temple to be complete and authoritative, but simultaneously urged caution in the proliferation of engagements created by that claim. The prevailing tone of correspondence about the administration of the financial assets of the temple was soon dominated by uncertainty and mistrust. In 1826 the collector complained that "all the Devastanum accounts appear to have been kept in a sadly confused state, and those for whole years together have either been lost or wilfully destroyed."[29]

The Board of Revenue persistently wavered over whether direct grants, rather than the assignment of lands, were the most suitable means for the Company revenue authorities to order the devasthanam accounts. In 1808 the decision was taken to reverse Wallace's orders and revert to the allocation of lands as inām to the temples. This reversion would reduce the costs associated with the administration of inām revenue accounts and, it was claimed, reassure the local populace of the permanence of the government's support. The kacheri, however, was ordered to maintain a vigilant superintendence over the revenues allocated as the only method of preventing funds being "grossly misappropriated or dilapidated [*sic*]".[30]

Despite the government's professed intention of continuing to provide financial support to the temples, the claim that the temples received more than was necessary for their physical and ceremonial upkeep was a refrain of parsimony in correspondence

[29] H. Dickinson, Collr, to BoR, 10 November 1826, Trichinopoly District Records, vol. 4397, TNSA.

[30] Government to Board of Revenue, 21 June 1800, contained in W. Wayte, Secretary, Revenue Dept, to the Principal Collector in Tanjore and Trichinopoly, 21 March 1808, Trichinopoly District Records, vol. 3647, 325–48, TNSA. "Dilapidated" seems a mistake for "depleted".

from the Madras revenue authorities. By the end of the second decade of the nineteenth century, these authorities sought to extricate themselves from temple administration by ending all direct grants. When the collector of Trichinopoly, Charles Lushington, reported on the properties of the temples in 1818 he estimated that 2000 temples in his district received support from the government. Of these, 139 significant temples were given allowances in land and cash.[31] The vast majority of that amount came from government and the remainder from private endowments.[32] By the end of the 1820s, of the 4701 temples in the Trichinopoly District, government allowances were made to only twenty-three: the two temples in Srirangam, the Thayumanar Temple in Trichinopoly, and twenty temples described as "principal pagodas in the talooks [divisions]"; 102 other "principal pagodas" and 4576 "petty pagodas" received no government allowance. Their income was derived from ināms, lands dedicated to the temples, and donations – resources that were, in theory, known and enumerated by government.[33]

In 1817 the Madras government robustly reiterated its right to supervise donated assets. Legislation was passed clarifying that the management of endowments held by temples, mosques, rest houses, bridges, and other institutions rested wholly with government. All appointments to these institutions would be made by the Board of Revenue in Madras on the basis of selections and nominations by local agents, chiefly the collector.[34] The 1817 Regulation went

[31] The allowances to these 139 temples amounted to Star Pagodas 44,551–3–1. The "Pagoda" and the "Star Pagoda" were currency denominations – coins – within the local monetary system and should not be confused with pagoda as an antiquated synonym of the temple. To distinguish the two, I use the initial capital when referring to the coins.

[32] Star Pagodas 35,460–11–59.

[33] C.M. Lushington, Collr of Trichy, to BoR, 17 June 1818, Trichinopoly District Records, vol. 3676, TNSA; Secretary of the Board of Revenue to Collr of Trichinopoly, June 1829, Trichinopoly District Records, vol. 4382, TNSA.

[34] Sections XI and XII, Regulation VII, 1817, *Regulations Passed by the Governor in Council of Fort St George, 1802–1847*, Part 1, 365–8.

further than its antecedent in Bengal, passed in 1810, in making "all native servants, and all trustees, managers, or superintendents" of endowments subject to the same punishments for fraud and embezzlement as government employees.[35]

The realisation of this jurisdiction, however, presumed a cognisance of the affairs of endowments that the Madras government did not possess. Collectors in the presidency were therefore ordered to obtain information that would make the legislation operable. They were to quantify all the endowments in their districts, distinguishing between private and government donations. They were also to report on the means by which these resources were both collected and disbursed and, most notably, on the administrative measures which they believed the Company government should impose. Here the collectors were caught in a strange, and typically colonial, bind of bureaucratic aspiration and operative caution. They were to acquire definitive and accurate information about the temples' accounts but, on that basis, effect only a "general superintendence not detailed management of private endowments."[36]

Competition, Succession Disputes, and Company Adjudication

This Madras government directive to collectors to acquire definitive knowledge but refrain from detailed management of temple establishments did nothing to prevent the kacheri from being drawn into disputes. The priests of the Srirangaswamy Temple made repeated appeals for the kacheri to arbitrate in succession disputes, and official responses exposed the different understandings of what governance of the temples meant. In 1811 the collector of Trichinopoly asked the Board of Revenue to oversee the appointment of Shree Runga Narrain Iyer as jheer (senior priest) at the

[35] Gardner Cassels, *Social Legislation of the East India Company*, 252.
[36] BoR to Collr of Trichinopoly, 20 November 1817, Trichinopoly District Records, vol. 3657, 389–98, TNSA.

Srirangam Pagoda, to replace Treevengada Ramanoojah, the jheer who had died the previous year. The collector, George F. Travers, having consulted the carnum and peishkar of the temple, asked that the Board either appoint directly or instruct the pandits of the zillah to identify suitable candidates. He described the requisite qualifications for the post of jheer: "The person holding the situation should also be a Sunneyassee of the Shree Vistnoo Bramin cast of the doctrine of the Shree Ramanoojah of the tribe of Thenkalay, and ought to be well skilled in Sanscrit and Tamul in which languages he should understand the meaning of the Vedums and Sasters, and the rules of the sect established by former Ministers." The Board in Madras baulked at the suggestion and claimed to have no knowledge of why and how such an appointment could be made, despite the previous incumbent having been appointed by the Trichinopoly collector in 1804.[37] Despite their incredulity, the Board ordered Travers to investigate the terms of succession and instructed him to locate the table of succession that would make clear whether the appointment was hereditary, or whether the incumbent had the right to identify his successor. They specified that an upadesam – an instructional document understood to be a document of succession – was essential to the appointment. This order apparently affirmed the Company's authority to arbitrate succession but defined that authority as the right to recognise a marker of succession, the upadesam, that lay within the realm of the temple.[38]

The Board, in other words, wanted Travers to uncover an unambiguous formula for succession that would allow the preeminent authority of the Madras government to be maintained without the need for arbitration between different factions and claims. Travers explained that such a formula was not to be found at the temple and that there was disagreement over the selection

[37] G.F. Travers, Collr to BoR, 18 March 1811, Trichinopoly District Records, vol. 3669, 55–7, 130–3, TNSA.

[38] BoR to Collr of Trichinopoly, 15 April 1811, Trichinopoly District Records, vol. 3651, 32–43, TNSA.

procedure. The carnums of the temple claimed that earlier the appointment lay entirely with the authority of the raja, and now with the Company government. The "four principal Stalladars" (i.e. sthānattārs, or directors at Srirangaswamy), on the other hand, claimed that they had the authority to select the most suitable candidate, whose appointment they expected the government only to confirm. Travers reported that there was no such thing as a "table of succession", and he had found no evidence that such a table had ever existed. As for the possession of an upadesam, the collector pointed out that the term referred to an instructional or scriptural document which "all Bramins I believe receive . . . at a very early period in life", and therefore, although the successor would certainly possess such a document, such possession alone did nothing to thin the field of competition.[39]

Travers urged the Madras government to become more involved in the appointments. He reported that he believed that the three sthānattārs – namely, Parassur Bhutter, Vadeavassa Bhutter, and Rungacharry – who claimed the right to nominate the suitable candidate for the government's approval, did so in order to favour their own candidate, Allawar Jheer. The other stalladar and the carnums claimed Allawar Jheer was unqualified for the post. Only the government could ensure the appointment of someone of the necessary, "abilities, integrity and respectability".[40]

The question of the jheer's succession falls silent in the archive until 1819, when the Board of Revenue received a petition from Sree Munnarain Iier, who claimed he was the proper successor to Sreeranganadha, the late jheer of the Srirangaswamy pagoda. Munnarain's appointment had been prevented by "the People of the Pagoda" who had colluded with the tahsildar (a kacheri officer) to prevent his taking the post. His right to succeed had subsequently been confirmed by the assistant collector, W. Bell, though the peishkar had not enforced this order. The irascible Lushington, who had

[39] G.F. Travers, Collr to BoR, undated, 1811, Trichinopoly District Records, vol. 3669, 55–7, 130–3, TNSA.

[40] Ibid.

taken over as collector, dismissed the Board's request for a detailed response on the succession dispute, claiming that it was the Board who had themselves "virtually ordered" the appointment of the incumbent jheer in 1815, when they directed that the "Stulludars" of the temple – the "people" of whom Munnarain complained – select a suitable candidate whose appointment would be confirmed by the collector's authority. Lushington bemoaned the Board's orders for swift reports on petitions they forwarded to him and appears to have resented the Board's responses to complainants who undercut his own district authority by petitioning over his head. Within his district he claimed to spend two days each week hearing petitions, making it impossible for any petitioner to have to wait more than four days before knowing the outcome of his plea. In the case of petitioners who presented themselves in Madras, the Board's orders reached the kacheri weeks or even months ahead of the complainants, who would "generally remain at Madras or loiter on the road", making it unfeasible for them to be interviewed.[41]

At the Srirangaswamy Temple in Srirangam the post was vacant between 1830 – when the jheer appointed by the collector in 1816 died – and 1835. In the interim period, the affairs of the temple were managed by four sthānattārs. In 1835 a candidate, Vistnoochittaramanooja, was selected. Before his appointment, his knowledge of the sastras was tested by the pandit of the Southern Provincial Court.[42] The necessity of the Board approving the jheer of the Srirangaswamy Temple was regarded as a given, even though the Board professed little interest in the selection of the candidate "provided he is approved of by the majority of the persons worshipping at the Pagoda."[43]

[41] C.M. Lushington, Collector, to BoR, 12 January 1819, Trichinopoly District Records, vol. 3677, 10–12, TNSA.

[42] H.M. Blair, Collr, to BoR, 2 December 1835, Trichinopoly District Records, vol. 4404, 311–12, TNSA.

[43] BoR to Collr of Trichinopoly, 29 July 1830, Trichinopoly District Records, vol. 4394A, TNSA.

Assets, Accounts, and Corruptions in Temple Administration

The collectors' administrative disorientation was not limited to the problems of succession. Successive collectors struggled to make sense of the complexities of the temples' devasthanam accounts, let alone arbitrate and control them. When Company government was established in the district, the Thayumanar Temple at the rock fort in Trichinopoly was maintained from the revenues of inām lands donated for the upkeep of the temple. The nature and location of these lands remained unclear at the end of the 1820s, the collector admitting he could not ascertain from his own or the shrine's records whether the temple held any land in the neighbouring district of Tanjore. Despite this lack of information about the whereabouts of lands attached to the temple, the collector was confident enough about their value to estimate that they could be replaced by an allowance of Rs 6000. The Board of Revenue, endlessly suspicious of claims to land other than their own, doubted the veracity of the temple priest's claim to the inām villages because he could produce only "one document" as evidence.[44] In 1830, the Madras revenue authorities ordered the resumption of the revenues claimed by the temple and the introduction of an annual allowance that would support the performance of ceremonies at the temple. The government was wary, however, of granting an annual allowance that might be greater than the revenue-generating capacity of the inām lands and ordered the collector of Trichinopoly, along with the collectors of Madurai and Tanjore, to determine the extent and nature, and therefore the worth of the lands, information that he had already tried and failed to acquire.[45]

Uncertainty about the extent of the temple's assets continued and, in the 1830s, accusations were made that native officers, em-

[44] Secretary of the Board of Revenue to Collr of Trichinopoly, June 1829, Trichinopoly District Records, vol. 4382, TNSA.

[45] BoR to Trichinopoly Collr, December 1830, Trichinopoly District Records, vol. 4384B, TNSA.

ployed in the apparatus of the Company state, were complicit in
the opacity of temple accounts. In 1837, when the Thayumanar
Temple in Trichinopoly was sequestered, the names of court ad-
ministrators, the sheristadars, "were found entered in the accounts
of the Pagodas as having received bribes." The collector accused
the revenue officers of deliberately falsifying accounts from the
land revenue and expenditure accounts of the temple: "it has
ever been the object of the Curnums and Circar [government]
servants to secure to themselves as much as possible from the pro-
ceeds." In 1840 the collector accused the officers of the Thayumanar
Temple of continuing to collect land revenues from inām villages
in addition to claiming the allowance made by government to re-
place them.[46]

The kacheri's superintendence of the temple made it liable for
both its assets and its debts. In 1811, the carnum of the Jambu-
keswarar Temple used the temple's funds as a surety to buy sev-
enty pagodas worth of paddy. On his defaulting the debt, his
creditor, Seenavassa Iyengar, appealed to the collectorate to pay
for the paddy. Seenavassa Iyengar claimed there was more than
enough money to cover the debt from the annual allowance made
to the temple.[47] The matter was only settled two years later when
the Board ordered the collector to pay Seenavassa Iyengar, and
any other creditor in similar circumstances in the future, and re-
cover the debt by "gradual deductions" from the allowances made
to the temple. The recovery of this debt, however, was not to be
punitive: the revenue authorities in Madras ordered that repay-
ments should not have a deleterious effect on the activities of the
temple.[48]

[46] A.P. Onslow, Collr of Trichinopoly to BoR, 14 February 1840, BoR,
27 July 1840, 8899–9011, TNSA.
[47] Seenavassa Iyengar, Petition, 3 February 1811, Trichinopoly District
Records, vol. 3651, 35–7, TNSA.
[48] BoR to Collr of Trichinopoly, 16 September 1813, Trichinopoly District
Records, vol. 3653, 285–300, 381–3.

The amounts held under the devasthanam accounts were constantly questioned and disputed by the kacheri. As collector, Lushington complained that "[t]he difficulty of ascertaining the real amount of the revenue or even the number of villages originally assigned for the support of the Pagodas is considerably enhanced by the impossibility of believing the only persons capable of giving correct information on the subject."[49] Suspicions ran both ways. In 1817 the sthānattārs of the Srirangaswamy Temple complained to the Board of Revenue that the kacheri was not fulfilling its obligation to oversee and finance the physical upkeep of the temple from the allowances it held. The temple officers claimed that 10,000 Pagodas were held by the collectorate treasury, a figure disputed by the collector, who claimed that under a quarter of that amount was in his possession. The collector, for his part, protested that the sthānattārs vastly exaggerated the amounts held by his treasury and that considerable sums had already been spent on maintenance of the temple. He claimed that the sthānattārs had made inflated claims to grain from inām lands and, instead of declaring it in the devasthanam accounts and returning it to the kacheri, had kept for themselves the surplus left over after the priests and ceremonies were paid for.[50]

While a strong desire existed to affirm and assure the rights and precedents of the temples, government officers evinced a distrust of every native who was associated with them. Temple officers were routinely condemned as both corrupt and litigious, fraudulent and duplicitous. The truculent Charles Lushington was explicit in expressing his dislike of the "native character" of the Brahmans: "the experience I have ever had in the native character has led to the conclusion that written evidence is far preferable and more to be relied upon than oral testimony, and particularly

[49] C.M. Lushington, Collr of Trichinopoly, to BoR, 17 June 1818, Trichy District Records, vol. 3676, TNSA.

[50] C.M. Lushington, Collr of Trichinopoly, to BoR, 26 November 1817, Trichinopoly District Records, vol. 3675, 294–395, TNSA.

by that of Pagoda Bramins whose litigiousness, rancour and pre-
varication are proverbial."[51] Like his predecessor George Travers,
Charles Lushington clearly weighed the rights of native subjects
to redress at his office against the race, and therefore character, of
the complainant. In 1818 he suggested that complainants be
required to forfeit a specific sum should their complaint prove
to be "vexatious and groundless" – a measure he regarded as es-
sential to limit the complaints of temple officers and servants.[52]
Lushington created a list of property owned by the Srirangam
temples, the only means, he claimed, to prevent the collusion of
the temple sthānattār and kacheri-based peishkar in misap-
propriating that property. The Board of Revenue was less than
satisfied with the accounts Lushington provided, describing them
as "scanty", though the sums and property in question appear
to have opened their eyes to the potential for streamlining the
temple establishments. The Board, as was their wont, asked Lush-
ington to provide more detailed annual statements of the income
of and disbursements to the Srirangam temples, and to identify
which items on the list of temple properties were alienable in order
that the governor determine how to dispose of the surplus rev-
enues.[53]

In cases where the kacheri's attempts to arbitrate disputes
floundered, native kacheri officers bore the brunt of the English
officer's uncertainty. When the sale of garden land at the Sriran-
gaswamy Temple at Srirangam prompted an appeal to the kacheri
in the mid 1820s, both parties presented documentary proof of
their rights. The claimant of the garden held a document – a
cadjan – issued in 1755 and signed by "the Jeyur and the whole
of the Stallatars and other officers of the Pagoda", giving the

[51] Ibid.
[52] C.M. Lushington, Collr of Trichy, to BoR, 17 June 1818, Trichinopoly
District Records, vol. 3676, TNSA.
[53] BoR to Collr, Trichinopoly, 7 May 1818, Trichinopoly District Records,
vol. 3658, 107–9, TNSA.

original vendor, Vencatachellumpillay, the land and the right to alienate it as he saw fit.[54] The temple authorities, objecting to the alienation, possessed a cadjan signed by Vencatachellumpillay handing the land over to Shudagopah Iyengar for support to the temple.[55] The collector held the head sheristadar of the kacheri responsible for confusion about the garden litigation, claiming that he deliberately and fraudulently misled the previous collector about the case. He concluded his report with a single principle that provided a route through the controversy and affirmed the government's sovereign right to the temple's resources: the temple managers had "no right to alienate any of the property belonging to it without having previously obtained the sanction of the Government of the country for doing so." The proofs of the land's alienation, produced by both parties in the dispute, to and by Vencatachellumpillay, were deemed inadmissible.[56]

In April 1813 the collector of Trichinopoly, George Travers, and the peishkar of Srirangaswamy Temple, Romdass, were both accused of embezzling Rs 30,000 from the temple. Ramdoss worked under the former head assistant of the kacheri, Thackeray, who oversaw the affairs of both the temples at Srirangam. Romdass had accompanied Travers from his previous posting in the Ceded Districts and been appointed as peishkar of the temple by Travers himself soon after his arrival as collector. Travers was suspended and the actions of both officers were investigated. The white official made an emotional appeal against the allegations of his own involvement in the embezzlement, pleading that his admiration for the Company was such that he was constitutionally unable to commit any wrongdoing against it. He launched an enquiry into Romdass' affairs after what he described as "the con-

[54] "A European term used for palm or coconut leaves written upon", Wilson, *Dictionary of Revenue Terms,* 247.

[55] H. Dickinson, Collr, to BoR, 10 November 1826, Trichinopoly District Records, vol. 4397, TNSA.

[56] Ibid.

tinual torment which I endured from the Seringham Bramins",
and his own suspicion that there were irregularities in the "Ac-
counts of the Church".[57] Clearly intending Ramdoss to carry the
can for any wrongdoing, Travers placed the peishkar in an un-
enviable position. He appealed for complaints against Ramdoss
and "any other Church servants" and attempted to appoint five
respectable inhabitants to hear them. Then, failing to find anyone
willing to populate such a committee, Travers ordered his head
assistant, William Bell, to oversee the investigation and appealed
to the Board to send someone to investigate the matter. Travers'
prediction of the possible outcomes of the enquiry reveal his ra-
cial indexing of culpability. He suggested that if it were found
Ramdoss had embezzled, the man should be forced to pay back
the exact sum stolen. If, on the other hand, the enquiry found that
no wrongdoing had been committed, then Travers should be al-
lowed to sue for defamation those who had accused him of com-
plicity in the crime.[58] Ramdoss could be culpable, therefore, but
it was Travers' reputation that would be the subject of a counter-
suit.

William Bell submitted his report on the allegations a year
later, at the end of 1814. He compared three years of the deva-
sthanam accounts with the accounts held by a merchant, Naig-
linga Chetty, who supplied the temple with a variety of goods. A
significant difference – of 2940 chukrums, or 980 Star Pagodas –
existed between the two. Bell was dissatisfied with the explanation
that the purchase of some supplies for "ready money" either from
Naiglinga Chetty or another merchant explained the disparity.
Suspicion fell on Arnatchellam, a carnum at the temple who had
been dismissed for the theft of sixty-five Star Pagodas seven years
earlier, but who had been reappointed two years before Ramdoss'
arrival as peishkar. Ramdoss, who did not, at least initially, know
the language of the temple's administration, had depended upon

[57] Geo. F. Travers, Collr, to BoR, 24 September 1814, Trichinopoly District
Records, vol. 3672, 325–30, TNSA.
[58] Ibid.

Arnatchellam for translations and explanations of the workings of the accounts. Bell concluded that the four head Brahmans were culpable, for both taking no interest in the accounts of the temple and therefore making themselves vulnerable to the corruption of the carnum, and for failing to inform Ramdoss of Arnatchellam's former conduct. His findings and recommendations speak volumes of the opacity of the temple's financial administration and the kacheri's determination to implicate all temple officers in systemic failings rather than reach a judgment of individual wrongdoing. Arnatchellam became a scapegoat in the investigation even though Bell admitted he was at a loss to account for the discrepancy between the two sets of accounts.

Bell recommended a significant increase in kacheri invigilation of the pagoda accounts. Henceforth, the temple's financial records were to be inspected daily by the peishkar and one of the head Brahmans would have to affix a signature to them as proof of their invigilation. At the end of each month, the whole of the accounts were meant to be approved by both the peishkar and the sthānattār and submitted to the kacheri. The system Bell suggested was less a means to correct the accounts than to formulate robust proof of the culpability and corruption of "the evil minded Bramins of Seringham". He added: "[N]owhere does a more troublesome or litigious race of beings exist."[59] As for Ramdoss, he was acquitted of the charges made against him, though Bell took the opportunity to point out that he had "no very favourable opinion" of the peishkar. Ramdoss was dispatched to Vellicully the following year by the new collector, Lushington, who, like his predecessor, actively solicited complaints against him.[60] Suspicion of native

[59] William Bell, Head Assistant Collr, to BoR, 12 November 1814, Trichinopoly District Records, vol. 3672, 379–86, TNSA. Travers also attacked "the litigious dispositions of the Seringham Bramins". G.F. Travers, Collr to BoR, 18 March 1811, Trichinopoly District Records, vol. 3669, 55–7, 130–3, TNSA.

[60] Notice, by C.M. Lushington, 14 October 1815, Trichinopoly District Records, vol. 3673, 245–6, TNSA.

officers and the anticipation of corruption provided both pre-
tence and explanation for the flailing kacheri. Corruption ex-
plained and exonerated the kacheri's ignorance of the temple's
finances.

As noted earlier, the Madras government wanted to see proce-
dures established that were at once derived from and enforceable
by tradition. However, in practice, kacheri officers were respon-
sive rather than prescriptive in their treatment of disputes within
the temple establishments. The inconsistencies and fissures in
administration created by collectorate governance were highlight-
ed in 1810 in a dispute over the post of "cake makers" – those who
prepared food for divine and devotional consumption – at Sriran-
gam. Appanungar and Singamungar petitioned the Board of
Revenue in Madras as "the hereditary Mirasidars of preparing the
cakes of sacraments in the use of the temple."[61] They had been re-
placed by two rivals, Singamien and Seeringaroyen. The latter duo
had formerly held the position but been removed by a previous
collector after Singamien's brother was accused of eating meat
and consorting with "dancing girls". The complainants, Appa-
nungar and Singamungar, were appointed and held the position
until they were once again replaced by Singamien and Seeringa-
royen who, apparently having recovered from the disgrace of Singa-
mien's brother, paid a substantial peishkash (tribute) for the posi-
tion. The collector had, "after a most troublesome and tedious
investigation", determined that since the post was not hereditary,
and since he saw his principal responsibility to be to increase the
revenues of the pagoda, he believed the party that had offered
the larger peishkash should indeed be confirmed as cake-makers
to the pagoda.[62] The Board of Revenue concurred that the role
was rented rather than inherited and confirmed the appointment.

[61] Petition, 23 February 1810, Trichinopoly District Records, vol. 3650,
140–4, TNSA.

[62] G.J. Travers, Collr to BoR, 10 December 1810, Trichinopoly District
Records, vol. 3668, 326–31, TNSA.

The case led to yet another reiteration of native clerical culpability: Reddy Row, the former Javab-navis (an officer employed to write answers) was accused of suppressing and falsifying documents when presenting the cake-maker's right as hereditary.[63]

The administration of the temple establishments took on an increasingly moral tone, charging temple officers – increasingly personified by the generalised category of the Brahman – as being both corrupt and litigious. The Madras authorities also made it clear that the temple establishments were not to be trusted with anything more than a prudent allowance. At the end of the 1820s, amid protests by the Brahmans of the Jambukeswarar pagoda that the allowance had decreased between Wallace's original settlement in 1801 and the 1820s, the Madras government endorsed the reduction, warning that a "large surplus in hand might lead to an unnecessary and extravagant expenditure."[64]

Christian Missions and the Ejection of the Company from Temples

During the first half of the nineteenth century, parliament gradually extended its control over the activities of the Company governments in India. The size of the territory directly controlled by the Company had doubled between the end of the eighteenth century and 1813 and, as larger numbers of people came under its domain, pressure mounted on the Company to accommodate and support Christian missions in its territories.[65] In Britain, a culture was taking shape in which India became synonymous with moral corruption. This imputed degradation was largely, if not exclusively, fixed upon an imaginary realm of pagan (Hindu) religiosity. A tide of evangelical rhetoric laid out the "disgusting recital of

[63] Campbell, BoR, to Collr of Trichy, 31 December 1810, Trichinopoly District Records, vol. 3650, 140–4, 170–1, TNSA.
[64] Secretary of the Board of Revenue to Collr of Trichinopoly, June 1829, Trichinopoly District Records, vol. 4382, TNSA.
[65] Chancey, "The Star in the East", 507–22.

Indian atrocities" in front of parliament and people in Britain.[66] Evangelical authors raged that, at the Srirangaswamy Temple, "voluptuous Brahmuns were supported by a Christian Government" to the tune of £6240 a year.[67] These corrupt practices could, claimed reformers, be relatively easily eliminated, allowing "the otherwise glorious face of India" to be redeemed if only local government would withdraw support to Hindu temples and instead sponsor the improving presence of Christian missionaries.[68]

The involvement, albeit clumsy, of the kacheri with the internal affairs of the temple and the growing discomfort of the home authorities was brought to the fore by a Brahman sect dispute at the Srirangaswamy Temple. In the early 1830s, a quarrel erupted between the dominant Thenkalai Brahmans and the more numerous Vadakalai Brahmans. These two Vaishnava sects had emerged in the eighteenth century from a difference in the preference of texts between the Tamil Divya Prabandham and the Sanskrit Veda. Their contestation of rights over ritual functions at the Srirangaswamy Temple resulted in legal actions and arbitration in, successively, Trichinopoly, the Madras High Court, the Privy Council and, in the 1840s, the British parliament.

The dispute was rooted in kacheri approval of the distinct rights of sects within the temple establishment. When the Company assumed control of the Srirangaswamy Temple in 1801, Wallace, as collector of Trichinopoly, had supported the claims over rights of the smaller Thenkalai sect. These rights included the performance of rituals in the houses of Vadakalais, and receiving customary payments. In 1808 a decree was issued which forbade the Vadakalai Brahmans from entering the Srirangaswamy Temple. This decree was affirmed by the kacheri in 1814.[69] In 1826, the Vadakalai

[66] Roberts, *Hindu Infanticide*, 244.

[67] Peggs, *India's Cries to British Humanity*, 103.

[68] Roberts, *Hindu Infanticide*, 233.

[69] G.F. Travers, Collr, 27 February 1814, Endorsement to Wootamanumbees Petition delivered on 27 February 1814, Trichinopoly District Records, vol. 3672, 88, TNSA.

Brahmans unsuccessfully petitioned the Madras government, claiming a right to recite the Vedas in the Srirangaswamy Temple, and three years later the collector once again issued a proclamation prohibiting them from officiating in the temple.[70]

The Vadakalai community repeatedly attempted to insert – or, as they argued, to restore – their right to a share of the many shrines within the enclosures of the Srirangaswamy Temple complex. In the early 1830s, Ranga Aiangar was fined Rs 1000 for placing a sign which read "Vadakalai namam" over the entrance of the Nathamuni shrine. When the case was heard on appeal by the Madras High Court, the judgment made sense of the dispute by drawing on a more familiar sectarian divide. It declared that "the act in the place in which it was done precisely resembles the act of a zealous protestant who should be rash or wicked enough to scrawl 'no Popery' in a Roman Catholic Church, situate [sic] in the midst of the excitable and not highly instructed population of an Irish county."[71] The comparative subject positions employed in the judgment are revealing. The analogy between India and Ireland underlined the imperial Protestantism of Company governance and the supposedly quotidian volatility of subject populations. On receiving the judgment, the collector complained that he was powerless to intervene and punish the Vadakalai Brahmans for their repeated attempts to displace the Thenkalai Brahmans, who were by far the smaller and weaker sect.[72]

When, in 1841, the Madras government was ordered to "effect the immediate withdrawal from all interference with native temples and places of religious 'resort'", the dispute became a cornerstone in lengthy debates as to the best means of retreating from government interference, or trust, in the temples.[73] The dispute

[70] H.M. Blair, Collr, to George Garrow, Acting 1st Judge on Circuit, Southern Division, Trichinopoly District Records, vol. 4401, 253–5, TNSA.

[71] Rao, *History of the Śrīrangam Temple*, 232.

[72] H.M. Blair, Collr, to Registrar to the Provincial Court of Appeal, 11 December 1835, Trichinopoly District Records, vol. 4403, 324–7, TNSA.

[73] H. Chamier, Chief Secretary, to BoR., 12 June 1841, BoR, 24 June 1841,

crystallised the question of how, and to whom, authority over the temples would be transferred in order to end kacheri involvement. That the Thenkalai Brahmans were numerically weaker and yet endowed rights by custom meant that "anything like a general election would frequently be productive of great injustice."[74]

Once again, the Madras government called for information on the current state and potential transformation of its own authority. The collector in each district was ordered to "report in detail the arrangements he would propose for his district explaining the present extent of interference and control." In each case they were to include recommendations for the replacement of trustees whose terms had ended in either death or resignation. The Madras government stressed that no financial loss should follow from the retreat of kacheri superintendence over temple assets. Lands, the revenue of which was attached to support temples, were *not* to be returned. Instead, "as a measure of justice to the agriculturalists," government management of them would continue and the "net proceeds of the land" would be turned over to the newly identified temple trustees. Collectors were to report which of the monies held within the kacheri could be kept by government and what quantities handed over to the newly appointed – or rather recognised – trustees. They were warned against giving out any suggestion of the withdrawal disrupting "any authorised and customary payments and allowances" that currently existed.[75]

The considerable surpluses held from temple revenues were to be diverted to fund public utilities work begun in the districts in

8134–8, TNSA; Idolatry (India), Return to an Order of the Honourable the House of Commons, dated 21 June 1849 (in continuation of Parliamentary Paper, no. 664, of session 1845).

[74] A.P. Onslow to Board of Revenue, 4 September 1841; Idolatry in India. Return to an Order of the Honourable the House of Commons, dated 21 June 1849, in continuation of Parliamentary Paper, no. 664, of session 1845, House of Commons, 1849, nos 45, 46.

[75] H. Chamier, Chief Secretary, to BoR, 12 June 1841, BoR, 24 June 1841, 8134–8, TNSA.

1841. The Board of Revenue warned, however, that the diversion of funds away from localities would cause significant complaint amongst residents, an effect they assumed the home government was keen to avoid.[76] The Madras government was generally opposed to inām lands assigned to temples being handed over to agents appointed by the government, not least because this arrangement already existed in many cases. More problematic were the allowances set decades before the attachment of lands by the Company. In these cases, it would be impossible to determine the extent or position of lands that might be reassigned as inām.[77]

These discussions of how best to withdraw Company supervision whilst diverting some temple wealth permanently into government hands condensed the preoccupations of the district and presidency authorities. The Madras government insisted that the Regulation of 1817, by which control had been assumed over all charitable endowments, could not be removed without its replacement by "equal stringent and efficient enactment" to prevent the waste and misappropriation of the property of religious institutions. This condition for the divestment of Company invigilation vastly exaggerated both the de facto stringency and the efficacy of the regulations that existed under the Act.[78]

The presidency authorities complained that the London government's desire to see control of the temples handed back to native establishments in their entirety reflected their limited understanding of the populations they governed and, in particular, that population's propensity for corruption. Onslow, as collector of Trichinopoly, wrote voluminously and in detail about the corruption he had discovered at the Thayumanar Temple, and his belief that native boards of trustees would neither be able to check it nor avoid succumbing to it. In 1841 his proposals were

[76] Board of Revenue, 8 September 1947, Parliamentary Papers, no. 10, 7.

[77] J.D. Bourdillon, Secretary of the Board of Revenue, to the Acting Chief Secretary of Government, 10 October 1842, Parliamentary Papers, no. 13, 10.

[78] P.B. Smollet, Acting Agent to the Governor, to the Chief Secretary of Government, 14 June 1842, Parliamentary Papers, no. 21, 621.

criticised as insufficient to protect temple funds from "misappro-priation and spoliation" because they created no opportunity for the public scrutiny of temple accounts. He defended his plans not despite but because of the fractious nature of the trustees: "it does not seem to me that a body of natives composed as these are, I allude more particularly to the Trusts for the three principal Pago-das, are likely to come to such a good mutual understanding as to make a successful combination for fraudulent ends."[79] Nor, the collector added, was the withdrawal of Company supervision de-sired or desirable. The Madurai collector also argued that the with-drawal of Company authority was against the wishes of the tem-ple. He claimed that after he had assembled and informed the temple heads of his district, they petitioned him, objecting to the withdrawal and pointing out that in the absence of a single author-ity over the temples the result would be "the embezzlement, ani-mosity and ruin to the Establishment."[80] In Trichinopoly, Onslow painted a picture of a religious institution devastated by "the harpies by whom in the shape of agents, carkoons, curnums and other hang-ers on . . . who benefit by the endowments of the Pagoda."[81]

The debate hinged on how to control these temples from the outside. How could their resources be known and their functions moderated whilst keeping the officers of the state outside its precincts and ostensibly divorced from its administration? The Board of Revenue was deeply critical of the Trichinopoly collec-tor's initial plans for the withdrawal of direct control from the 116 temples in his district. The total revenue income of the temples amounted to Rs 137,914–6–6; 23 entire villages were attached to temples, and portions of another 91. Only 22 of the 116 temples

[79] A.P. Onslow, Collr of Trichinopoly, to BoR, 4 September 1841, Board of Revenue Procs, 30 September 1841, consultation nos 67–8, 12580–608, TNSA.

[80] J. Blackburn, Principal Collector, Madura, to BoR, 3 July 1841, Board of Revenue Procs, 22 July 1841, Procs 1–3, 8925–36, TNSA.

[81] A.P. Onslow, Collr of Trichinopoly, to BoR, 14 Feb. 1840, Board of Revenue, 27 July 1840, 8899–9011, TNSA.

received cash allowances from the collectorate treasury, amounting to Rs 56,298–13–7.[82] Where parcels of land within villages (rather than whole villages), orchards, and stands of trees were dedicated to a temple, this revenue was collected without the involvement of government servants. The collector doubted that any material change would come of the full transfer of these resources to the management of trustees who would, in any case, be the very headmen that had collected those resources.

Onslow proposed a closed economy of temple assets which relied on a combination of the self-interest of those involved and mutual surveillance. The Board of Revenue in Madras preferred to install a trust that was open to the public – and therefore state – inspection at any time and would rely on that threat to maintain its integrity. Onslow objected to the proposed scrutiny of temple trust accounts, claiming that no one would accept the position of dharmacurtah (temple manager) under those conditions and that such a requirement created an unnecessary and explicit suggestion of mistrust.[83] The functionaries of the temple, those whose living was derived from the financial welfare of the temple, would be vigilant against any misappropriation.[84]

In defending his proposal against the Board's recommendation of a larger electoral system of supervision, the collector pointed

[82] The sources of this total were derived from: land revenue paid directly: 51100–13–5; Profits derived from certain lands fully assessed to the revenue: 1764–3–3; Ready money collections with villages, orchards &c. 28389–11–2; Allowances paid from the treasury: Rs 56298–13–7; and Revenue from villages in other districts: 360–12–10; A.P. Onslow, Collr of Trichinopoly to BoR, 4 September 1841, Board of Revenue Procs, 30 September 1841, cons. nos 67–8, 12580–608,TNSA.

[83] Dharma-karttá: "In the south of India, the manager of a temple, and appropriator of the benefits derived from it", Wilson, *Glossary of Revenue Terms*, 137.

[84] A.P. Onslow to Board of Revenue, 4 September 1841; Idolatry in India. Return to an Order of the Honourable the House of Commons, dated 21 June 1849, In continuation of Parliamentary Paper, no. 664, of session 1845, House of Commons, 1849, no. 45, 44.

out that the existing schisms between rival sects at the Sriranga-swamy Temple would skew any electoral system: "I have only to advert to a dispute in this district which has frequently called for the interference of civil power to exemplify what I mean. I allude to the dispute between the 'Telangaliars' and 'Vadagliars' the superiority of right belonging to the weakest of the two sects in point of number."[85] Onslow also firmly recommended that government servants be included among temple trustees.[86]

Disagreement between the Board and Onslow over the ending of government interests in the three Trichinopoly temples created a fractious exchange about the meaning of the Company's withdrawal. The intention of the Board was not, in Onslow's words, "to divest themselves of all necessity of interference", a wording that suggested the aim of government was to be "rid of the trust now vested in them." Rather, the aim of government was surely, he argued, "to devolve the trust upon the people in such a way as shall appear best calculated to preserve the funds . . . from misappropriation or spoliation."[87] The use of the term "shall appear" makes clear that the processes of divestment of Company government from the temple establishment were more important than their end effect. The transfer of trust, therefore, sustained in both spirit and form the necessary protection of those assets from inevitable fraud.

In 1842 the Court of Sudder Udulat (Civil Justice) in Madras proposed a new act for the administration of religious institutions in the presidency through a set of measures which, in theory, would systematise the appointment of officers and make the financial affairs of the temple open to scrutiny beyond the jurisdiction of revenue officers. The law allowed the appointment of superin-

[85] A.P. Onslow, Collr of Trichinopoly to BoR, 4 September 1841, Board of Revenue Procs, 30 September 1841, cons. no. 67–8, 12580–608, TNSA.

[86] P.B. Smollett, Secretary of Board of Revenue, 26 August 1841, Indian Idolatory, 45, TNSA.

[87] P.B. Smollett, Secretary of Board of Revenue, 26 August 1841, Indian Idolatory, 45.

tendents of "the Hindoo or Mahomedan creed" by government according to the "ancient practice of succession", a provision that overlooked the failure, for forty years, of district officers to establish with any certainty what those ancient practices actually were. Once appointed, these superintendents would be subject to the authority of the courts. The law also allowed any three "principal residents" within a five-mile radius of the institution to demand inspection of the accounts held by superintendents. The composition of boards of trustees was to ensure a sufficient level of mutual suspicion to offset the natural propensity of the native for dishonesty.[88]

After the official withdrawal of kacheri supervision, payments of over Rs 52,000 were still made to the three major temples in the district, the bulk of which – around Rs 35,000 – went to the Srirangaswamy Temple.[89] Responsibility for the financial affairs of smaller temples was given to headmen, or to merchants living in or near the temples. Between one and three trustees were appointed to oversee the administration of small temples.[90] The withdrawal of state supervision from temples included a proviso that if worship had not taken place in them for twelve years, their lands would be confiscated and returned to the state.[91]

Conclusion

By the 1840s, the career of the Madras authorities as ruler and patron of the temples of the Madras Presidency was over. At the beginning of the nineteenth century, the presidency's Hindu temples, and in particular the vast and wealthy Srirangaswamy Temple, had offered a canvas on which the Company government

[88] BoR, 15 July 1841, cons. 3–4, 8672–98, TNSA.

[89] W. Elliot, Acting Collector, Trichinopoly, D. White, Actg Sec. to BoR, 3 May 1847, Board of Revenue, 27 May 1847, cons. 91, 7551–9, TNSA.

[90] A.P. Onslow, Collr of Trichinopoly, to BoR, 4 September 1841, Board of Revenue Procs, 30 September 1841, cons. no. 67–8, 12580–608, TNSA.

[91] Extract from minutes of Revenue Dept, 28 November 1854, Board of Revenue Procs, 7 December 1854, cons. 14, 16486–7, TNSA.

would colour in the wise and magnanimous rule of the British, in contradistinction to that of the recently defeated Muslim usurpers. In practice, presidency governance oscillated constantly between the will to innovate, arbitrate, and reorder on the one hand, and the desire to merely affirm tradition on the other. The Madras government's repeated calls for information and advice demonstrated an authority blunted by the shortcomings of its knowledge. In Trichinopoly District, successive collectors took custody of temples whose resources were rooted in complex local genealogies, of which they had only a fractional understanding. Their tenuous grasp was only exacerbated because of the selective use of kacheri involvement by the temple's guardians and functionaries. Faced with this complexity, the officers of the revenue authorities tied their understanding of the temples to formulations on the nature of religious institutions and a priesthood corrupted by wealth. A simplistic understanding of the English Reformation's stripping of monastic wealth melded with a colonial distrust of native corruption to provide a comprehension too reliant on suspicion – of both temple officials and the native servants on which the officials relied – to mediate the authority they presumed to possess.

In 1863 the desire to avoid state interference in religious matters or institutions was legislated again by the Religious Endowments Act. This Act articulated the lessons formulated in response to the great rebellion of 1857: that the Company state had overstepped itself and trammelled the religious sensibilities and sensitivities of the native population. The now imperial government would never again interfere in the religious affairs of its Indian subjects. As Chapters 3 and 4 of this book demonstrate, the 1863 Act simply provided another co-ordinate in the ongoing relationship between the district and presidency authorities on one side, and religious institutions on the other. Even after the Hindu temple ceased to be an asset of the colonial regime, it continued to be a place where local populations could compel the attention of government.

2

The Hindu Temple in Nineteenth-Century Architectural Scholarship

Introduction

IN 1884, ONE YEAR before his death, James Fergusson publish-
ed his seventh book on Indian architecture and archaeology:
*Archaeology in India, With Especial Reference to the Works of
Babu Rajendralala Mitra*. A self-taught "fervent amateur", Fergus-
son was the most prominent interpreter and classifier of Hindu
temple architecture in the nineteenth century.[1] He was also pro-
prietorial. His "Reference" to Rajendralal Mitra was part of an ag-
gressive rebuttal of work that most of his readers would not have
known. This chapter explores, first, Fergusson's hostility to Mitra,
in which a disagreement, ostensibly about architectural chronolo-
gy, offers an aperture into imperial racism. It then returns to trace
the emergence of architectural descriptions and classifications of
temples from the seventeenth century onward in order to under-
stand the broader significance of Fergusson's analysis, and the leg-
acies of the frames of comparison and description he created.

Fergusson's published work on Indian architecture spanned the
whole of his career, from 1845 until 1884. His interest in India had
begun with a stint in business. He had arrived in India in 1835

[1] Raub, "Repairing the Tower of Babel", 324.

and left nine years later having accumulated considerable wealth through the fluctuating fortunes of various financial interests, chiefly in indigo plantations. These investments allowed him, after his return to Britain, to live as a scholar.[2] In addition to wealth, Fergusson amassed a familiarity with a range of Indian architectural forms and, in Tartakov's words, "a remarkable store of racial prejudices".[3]

The scope of Fergusson's writings was vast and comparative, encompassing the architectures of Europe, Persia, Jerusalem, India, and China. His ambition was to create a "universal history" of architecture in which "each style shall occupy exactly that amount of space which the extent of its buildings or their merit would appear to justify."[4] His expansive analyses revolved around the identification and celebration of "true" or "pure" forms of architecture, of architecture that was, in his estimation, neither imitative nor derivative. The existence of "true art" was not an index to civilisation: even "the indolent and half-civilised inhabitants of India" had produced "great and beautiful buildings".[5] The notion of "true architecture" was sufficiently expansive to allow Fergusson's analyses to range across any and all architecture, and sufficiently ambiguous and idiosyncratic to allow him to cantankerously police it.

His analysis of Indian architecture was prolific. He began publishing on Indian architecture in the 1840s and established himself as a recognised arbiter of Indian materials: he supervised the Indian exhibits at the Indian Court in Crystal Palace in 1851 and the Exposition Internationale in Paris in 1861. He emphasised his intimate encounters with Indian architecture while travelling in India during the 1830s. This thorough grounding allowed him,

[2] Goldsmid, "Obituary of James Fergusson"; Elwall, "James Fergusson (1808–1886)".

[3] Tartakov, *The Durga Temple at Aihole*, 7.

[4] Quoted in Goldsmid, "Obituary", 115.

[5] Fergusson, *The Illustrated Handbook of Architecture*, 4.

he claimed, to "read in the chisel marks [. . .] the ideas that guided the artist in his designs, till I could put myself by his side and identify myself with him through his work."[6]

Despite the breadth and recognition of Fergusson's work, he fashioned *Archaeology in India* as a diatribe against one man who had not only challenged his ordering of Indian temple architecture but who had – claimed Fergusson with no hint of irony – dismissed his work as the "slanders of an ignorant and prejudiced foreigner."[7] Rajendralal Mitra was a Sanskritist who, Fergusson tightly noted, he had never met. In the late 1860s Mitra led a government expedition to explore the antiquities of Cuttack (now in Odisha). He had published his findings first in the proceedings of the Asiatic Society of Bengal and then, in 1875 and 1880, as *The Antiquities of Orissa*, a work described by Fergusson, again slightly richly, as "two ponderous tomes".[8] It is clear that Mitra's challenge to Fergusson was one of interpretation and, more pointedly, a challenge to his deeply felt sensibilities as a European arbiter and classifier of Indian architectures.

There is no evidence in Mitra's own publications that he regarded Fergusson as an "ignorant and prejudiced foreigner". Mitra cited Fergusson extensively as a guiding authority in terms of both his methodology and conclusions. He followed Fergusson's comparative method, using a range of classical and northern European and Chinese examples to describe both the forms and intended effects of temple architecture. The purpose of his work was to arrive at a "tentative" classification of the medieval temples of Orissa, a grouping to which Fergusson had paid little attention.[9] So, what was it about Mitra's work that made Fergusson so cross?

Mitra's innovations touched a deep nerve in Fergusson's analysis.

[6] James Fergusson, *An Historical Inquiry into the True Principles of Beauty*, xviv, quoted in Kohane, "From Scotland to India", 37.

[7] Fergusson, *Archaeology in India*, 7.

[8] Ibid., 6.

[9] Mitra, *The Antiquities of Orissa*, vol. 1, 24.

The latter's eminence in the field of Indian architecture and his volu-
minous publications rested on a set of explicit and repeated tenets,
and it was these that Mitra had challenged. Fergusson's vituperative
response to Mitra is useful as a starting point to examine colonial
understandings of the temple in the nineteenth century. Fergusson
regarded Mitra's attempt to deviate from his cardinal arguments
as far more than a scholarly disagreement. Mitra's challenge to
Fergusson's pre-eminence and the scheme he had established for
Indian architecture was a racial slight which, within their impe-
rial context, was tantamount to rebellion.

The dispute hinged on two matters, one to do with interpreta-
tion and the other to do with methodology. First, they differed on
whether stone had been employed in the period before Ashoka,
who ruled in the third century BCE; and, second, on whether
textual sources had any role to play in the elucidation of Indian
architectural history. On the first matter, Fergusson was emphatic
that no significant stone architecture existed before the emer-
gence of Ashokan Buddhism in the subcontinent and that its
appearance had been catalysed by contact with Greek civilisation.
On the second matter, Fergusson was adamant that no body
of texts or living tradition could have any bearing on his analysis.
Everything Fergusson – or indeed anyone else – needed to know
about temple architecture could be read from the physical remains
of temples.

On both counts Mitra disagreed. He pointed out that Fergus-
son himself had acknowledged the use of stone in the foundations
of buildings, in walls and embankments, before the third century
BCE. Mitra asked why "men who, according to Megasthenes, had
built walls 30 feet high" at the Magadhan capital of Pataliputra
"could not, or did not, extend it . . . until taught to . . . by Greek
adventurers or their half-caste descendants."[10] Mitra set his own
analysis in conversation with Sanskrit texts. While making explic-
it that his classifications found no literal equivalent in the Sans-

[10] Quoted in Fergusson, *Archaeology in India*, 14.

krit treatises he used – they were not concerned with schematising form on a subcontinental scale – he drew on them and deployed them comparatively in order to refine interpretations of both the temples themselves and their historical context.

Mitra's interests were more curtailed, less wide-ranging than Fergusson's vast field of architectural research. He drew comparative examples but ultimately placed his subject – the temples of Orissa dating from the tenth to the fourteenth centuries – at the centre of his analysis. Fergusson's analysis, in contrast, was dependent upon a vast and territorially uninterrupted gaze which he claimed encompassed any and every structure built by humans. He regarded the profuse ornamentation that characterised many later medieval temples as evidence of corruption. Mitra on the other hand regarded them as characteristic not just of the medieval temples of Orissa but of a broader cultural spirit of temple design that transcended the differences between Aryan and Dravidian schools of architecture – schools that Fergusson had laboured to secure as defining and distinct categories.[11]

Guha-Thakurta regards Fergusson's vitriolic attack as the last gasp of an imperial white presumption crumbling under the weight of an Indian scholarship that reframed the Indian past according to national, rather than imperial, ways of seeing things.[12] Fergusson's elaborate outburst can certainly be used to think about the particular ways in which imperial archaeological research meshed the colonial present and the Indian past. His organisation of Indian architectures transformed them into a crumb trail providing evidence of a degenerative process through which India sank civilisationally into the necessarily imperial present.

Fergusson presented what he saw as Mitra's scholarly pretensions as a parable against the ill-advised softness of colonial governance blind to the many weaknesses of the native character. It

[11] Mitra, *The Antiquities of Orissa*; Guha-Thakurta, *Monuments, Objects, Histories*, 104–8.

[12] Guha-Thakurta, *Monuments, Objects, Histories*, 109.

was this sort of indulgence, he believed, that had precipitated the rebellion of 1857, when "we petted and pampered the Sepoys till they thought they were our equals." He saw Mitra as an intellectual parvenu whose vaulting ambition in critiquing his betters he linked to the Ilbert Bill – a legislative measure that had been mooted in 1882 to broaden the responsibilities of native magistrates outside of Calcutta, allowing them to preside over cases in which Europeans stood accused of a crime.[13] The very idea of natives being allowed to pass judgment on Europeans had outraged the white Anglo-Indian community in India and precipitated a series of protests in which the deficiencies of the native character were given centre stage. Fergusson offered Mitra's scholarship as an example of why the Ilbert Bill, had it been passed, would have been "disastrous to the good government of the country." He wrote: "If, after reading the following pages, any European feels that he would like to be subjected to his jurisdiction, in criminal cases, he must have a courage possessed by few; or if he thinks he could depend on his knowledge, or impartiality, to do him justice, as he could on one of his own countrymen, he must be strangely constituted in mind, body, and estate."[14]

Having touched on the imperial prestige that had been tied to architectural interpretation by the end of the nineteenth century, I want to return to the emergence of Anglophone knowledge that attempted to make the Hindu temple legible as architecture. The rest of this chapter traces a trajectory of learning from the earliest glimpses of temple form, through textual scholarship in the 1830s Madras Presidency to the twentieth-century legacies of Fergusson's resolutely imperial constitution of the Hindu temple.

[13] Upinder Singh says, when arguing the contextual importance of the Ilbert Bill controversy which erupted in 1883, the year before Fergusson's book was published: "That a scholar of Fergusson's stature should have written such an undignified tract . . . fits with the political climate of 1883 . . . in which racist sentiments exploded into the open . . ." Singh, *Discovery*, xiii.

[14] Fergusson, *Archaeology in India*, vii.

Early European Accounts

Temple form had appeared somewhat impressionistically and speculatively in European texts written before the nineteenth century. Temples were indistinct subjects within the landscape of native religion and the term "temple" was also used to refer to mosques and Hindu and Jain temples.[15] The term "massy" was used again and again to describe Indian architecture as an ill-defined but substantial element within landscapes that were written up as both strange and, in a more familiar register, picturesque.[16] Just as the early Company administration of temples attempted to understand these establishments in relation to more familiar historical and Christian analogies, early European descriptions of temple architecture relied upon frames of reference already established in the European imagination. In the seventeenth century the French traveller Thevenot described decorations on the chapel, choir, altar, and architrave of the temples he saw using European architectural terms – for example, fronton (enclosed court) and cornice (decorative embellishment).[17] The chronological and cultural coordinates given to temples in these accounts spoke more of the erudite pretensions of the author than historical evidence or credibility. The Dutch traveller Linschoten speculated that the Elephanta aves were of Chinese origin. Other accounts held the caves to be the work of Egyptian architects or Alexander the Great.[18] The French naturalist Pierre Sonnerat regarded the temples of South India, at Chidambaram, Srirangam, and Mahabalipuram to be undatable but reported that, based on the calculations of resident

[15] See no. 14, "View of a Mosque Near Rajemahel", in Hodges, *Select Views in India*; Thevenot, *The Travels of Monsieur de Thevenot*; Caunter, *The Oriental Annual*, 179–80.

[16] Hunter, "An Account of Some Artificial Caves in the Neighbourhood of Bombay", 287; Caunter, *The Oriental Annual*.

[17] Thevenot, *The Travels of Monsieur de Thevenot*.

[18] The English version of Linschoten's account was published in 1598; Dalrymple, "Account of a Curious Pagoda".

priests, the Jagannath temple at Puri was 4883 years old.[19] He be-
lieved the intricacy and extent of the cave temples at Ellora and
Salsette "indicate at least a thousand years of continual labour, and
the depredations of time design, at least, three thousand years ex-
istence."[20]

Eighteenth-century accounts of Indian landscapes offered tem-
ples as worthy of considered opinion. In the late eighteenth cen-
tury the artist William Hodges noted the perfection of Grecian
form but asked why the deviation from those exemplars should
"blind [us] to the majesty, boldness, and magnificence of the Egyp-
tian, Hindoo, Moorish, and Gothic, as admirable wonders of ar-
chitecture." Why, he asked, should European opinion "unmerciful-
ly blame and despise them, because they are more various in their
forms, and not reducible to the precise rules of the Greek hut,
prototype and column? Or because . . . their proportions are dif-
ferent from those to which we are become familiar by habit."[21]
Even this benign appraisal of the Hindu temple was tied to re-
gisters of aesthetic worth by then well established in Europe.
Hodges' catholicism of taste, which Mitter argues was informed
by his sensibilities as an artist, was formative of the secular, civili-
sational history of architecture that created scope for a vast, com-
parative, diachronic schemes in which environment, manners (soon
to be race), and artefacts could be calibrated across every part of
the world.[22]

Hodges used the temples at Deogarh in Odisha and Tanjore in
Tamil Nadu to illustrate, respectively, "the earliest state of Hindoo
architecture" and later "improved form and decorations".[23] The

[19] Sonnerat, *A Voyage to the East-Indies and China*, 108. Mitter discusses
the speculative chronologies created for Hindu temples in relation to the
European sensibilities of mass and sublimity. Mitter, *Much Maligned Mon-
sters*, 119–20.

[20] Sonnerat, *A Voyage to the East-Indies and China*, 109.

[21] Hodges, *Travels in India*, 63.

[22] Mitter, *Much Maligned Monsters*, 123–6.

[23] Hodges, *Select Views in India*, plate nos. 22 and 23.

work of artists Thomas Daniell (1749–1840) and William Daniell (1769–1837), uncle and nephew, respectively, made the form of the temple more familiar to English audiences. Their meticulous, if artful, temples were part of the tableaux of native life and included figures moving across open courtyards or resting near foliage. (Image 2.1.) Temples are a recurring element in Maria Graham's gentle and appreciative account of her extensive travels in India published in 1812.[24] In Graham's text – which deftly embeds considerable detail within a seemingly and deceptively impressionistic narrative – temples appear as ruined devotional centres, places of architectural wonder and curiosity.

These accounts fed a British appetite for replicas and models of temples. Thomas Daniell provided a design based on the "chastest models of Hindu Architecture" for a Hindu temple which was constructed by the sculptor John Charles Felix Rossi for Major John Osborne – a friend of Warren Hastings – at his estate, Melchet Park in Hampshire, in 1800. William Daniell drew the completed temple, a square shrine standing twenty feet tall. The decorations of the temple combined a cornucopia of elements drawn and deviating from common temple forms. The temple was adorned with figures, including the deities Vishnu and Ganesh, who sat above the doorway. The veranda of the temple was covered by a canopy on each side of which, in a departure from South Asian temple form, sat a Nandi, the bull vehicle of Shiva. Inside the temple, opposite the door, instead of a god was a bust of Warren Hastings (1732–1818), Governor General of India from 1773 until 1785, to whom the temple was dedicated.[25] As the first governor general, Hastings had presided over a formative period of East India Company governance in eastern India and had, for liberal opponents of the East India Company become a hated figurehead of its rapacity.

[24] Graham, *Journal of a Residence in India*. The *Theatrical Inquisitor* described Graham as "a perfect phenomenon in the history of woman": *Theatrical Inquisitor*, 159.
[25] "Some Account of a Hindu Temple", 448.

Osborne's reformulation of the temple as a devotional tribute to Hastings was a challenge to the parliamentarians who subjected Hastings to a lengthy impeachment trial between 1787 and 1795.

The Hindu temple became a desirable, and portable, visualisation of the picturesque exotic. Replicas of stupas already played a significant role in Buddhist pilgrimage and devotional ritual, and diminutive models were objects of veneration.[26] Portable models in clay, stone, wood, brass, and silver replicated the temple's properties as both receptacle and divine physical form. These skilfully made high-status objects became collectable colonial miniatures during the nineteenth century, being acquired, gifted, and donated into museum collections. In 1842 a "splendid Indian Pagoda" was presented to the Carlisle Museum by Simon Heward, who had settled in Carlisle with his two half-Indian daughters, which caused "general admiration and wonder".[27] A model of a South Indian Hindu temple in silver was presented by the city of Madras in 1893 as a wedding gift to the Duke of York and future King Edward.[28] To pilgrims and devotees, these objects were portable and surrogate embodiments of the divine, albeit far more elaborate (and more costly) than the sacred diagrams (yantras and mandalas) and the figures of gods that could be bought near temple sites. As collected objects, the temples were regarded as architectural models, illustrations, or versions in miniature of monumental temple architecture. The Hindu temple was, therefore, familiar to metropolitan audiences in a variety of forms by the beginning of the nineteenth century.

[26] Guy, "The Mahābodhi Temple".

[27] "Horticultural Society Show", *Carlisle Journal*, 24 September 1842, quoted in Saville-Smith, "Cumbria's Encounter with the East Indies", 183.

[28] The temple was part of the brief "Swami ware" fashion for silverware and other household objects which included religious motifs in late-nineteenth-century Madras. The silver temple is now held as part of the Royal Collections at Windsor.

The next section of this chapter explores the earliest ambitions to create a pan-subcontinental taxonomy of Hindu temple architecture.

Text, Architecture, and Buildings: Ram Raz and the Recovery of the Hindu Temple

Fergusson's comprehensive study, which reflected Victorian imperial ambitions of command, displaced an earlier orientalist scholarship embedded within locality and Sanskrit text. Fergusson's antipathy to the use of texts had been a departure from earlier orientalist scholarship. At the beginning of the eighteenth century, British writers propounded a belief that the secrets of the temples were held within as-yet-untranslated Sanskrit works. Whereas early modern travellers had seen little meaningful distinction between mosques and temples, the use of texts created a fundamental separation in the classification of architectures. Hindu and Muslim architectures were gradually striated into different styles and separate pasts (which met only in historical narratives of antagonism), and linked to distinct corpuses of text. While the key to Hindu architecture was believed to be located within a single authoritative (and apocryphal) Shilpa Shastra, the inscribed guides to Muslim architecture were believed to be located outside South Asia. In 1830 it was reported to the Royal Asiatic Society that "an account of the systems of Saracenic or Moorish Architecture, which prevailed in the Moorish Kingdoms of Granada, Seville, and Cordova, in those of Africa, and Asia Minor, and in those of Tartary and India" was "understood to be in one of the libraries in Spain."[29] In both Hindu and Muslim cases, architecture would be understood, or rather unlocked, by the discovery and decipherment of one key text.

[29] "Appendix No. IV", *Transactions of the Royal Asiatic Society* (*TRAS*), lxix.

The identification and translation of architectural treatises became a preoccupation of learned societies in Britain and India. The Royal Asiatic Society of Great Britain used the prestige of its patronage, and its ability to lobby the Company government, to mobilise networks and individuals and collect information. In 1834 the Society published an *Essay on the Architecture of the Hindus* by a Company magistrate and scholar, Ram Raz. The essay had originally been conceived as a work of collation and translation commissioned by a British official at Fort St George in Madras, Richard Clarke. What it became, and aspired to do, however, was far more. The author, Ram Raz, had risen through the ranks of the Company government by dint of his exceptional linguistic acumen and ability – from Clerk, to English Master at Fort St George in Madras, to Magistrate in Mysore. The Asiatic Society published the essay posthumously, after Ram Raz died suddenly at the age of forty-three, while the essay was being prepared for publication.

In its execution, Ram Raz's essay, far more than a translation, was a complex and accomplished articulation of temple form. It attempted a restorative history, realigning living traditions of temple design with the Sanskrit texts from which he presumed their antecedents had been formed. His essay was an attempt to reconstitute the lost science of architecture.[30] This reconciliation was by no means simple. Ram Raz lamented that the artisans (shilpas) he spoke to were "generally men of very limited acquirements and totally unacquainted with the science" of architecture and that, conversely, the "venerable sages" who wrote Sanskrit texts on architecture were guided by "a mistaken ambition to render themselves reputable by the difficulty and abstruseness of their style."[31] The Shilpa Shastra had been assumed to be a single text from which the "system" of Hindu architecture could be distilled.[32] In fact,

[30] Desai, "Interpreting an Architectural Past".

[31] Extract from letter, Ram Raz to Richard Clarke, 18 October 1827, in Ram Raz, *Essay on the Architecture of the Hindus*, x–xi.

[32] "Appendix No. IV", *TRAS*, lxix.

the Sanskrit texts, known broadly as shilpa shastras, represented a diverse corpus of textual traditions and contained a huge number of subjects related to temple construction: rituals to accompany construction, suitable locations and soils, and the necessary moral character of builders, in addition to questions of proper physical form. Ram Raz's project was one of huge complexity, bringing text, living practice, and architecture into conversation with each other to create a working system of knowledge that had, he believed, informed the apex of temple design and construction.

Ram Raz filtered the texts that he identified, and isolated from within them descriptions of form, scale, and style. He then carefully married this text to both information from artisans and "existing models of the art, the technical terms [from the texts] being no longer in use."[33] His "existing models" were a range of South Indian temples, living shrines which dated from the early medieval to the modern period. Ram Raz extrapolated illustrative designs in order to offer a set of exquisitely drawn diagrams of temple form. (Plate 2.2.)

His work was enthusiastically supported by a variety of men involved in the cataloguing and understanding of Indian architecture. More broadly, and evident in the case of Ram Raz's work, European officers claimed a position as arbiters of vast corpuses of Indian texts and material while Indian scholars were kept within the subordinate role of interpreter and informant.[34] The foreword to the essay, written by William Harkness after Ram Raz's death, diminished the latter's role to that of mediator or, at best, interlocutor. The preface offers the essay, written by a "Hindú", as marking "not only an epoch in the history of science but also in that of the Hindús themselves." Ram Raz was positioned as both subject and author of his work – trapping him and his subject, the temple, within a broader frame of imperial knowledge production.

Despite Harkness' condescension and circumscription of both

[33] Raz, *Essay on the Architecture of the Hindus*, 23–4.
[34] Guha-Thakurta, *Monuments, Objects, Histories*, 94–5. See also Mantena, *The Origins of Modern Historiography in India*.

author and essay, it is apparent that Ram Raz had performed a subtle but significant manoeuvre with regard to the scholarly regimes of European writing. He made frequent references to European design motifs to describe the principles and components of Hindu architecture. These terms explained things to the unfamiliar European reader; they were not used to provide a definitive orientation for the architecture he described. In his introduction to the essay, Ram Raz broached two of the recurring preoccupations in European readings of the Hindu temple: the presumed diffusion of form between Europe and Asia, and the temple's relative inferiority within the comparative schemes. On the first question, Ram Raz makes clear that he sees no conclusive evidence for the relationship between European and Indian architectural form and, therefore, no means of creating a hierarchy of influence between the two. On the second question he concludes, with great subtlety, that although his intention had been to compare Indian architecture to that of Europe, his expertise on the latter was limited and so he would do no more than say that Indian architecture met the European definition of sublimity:

> An eminent author makes the architectural sublime to consist "in magnitude, height of the buildings, and solidity of the materials;" another author, "in splendour, magnificence, and an imposing appearance." These characteristics of the sublime, most of the Indian temples possess in an eminent degree . . . in beholding these majestic and stupendous works, we are struck with admiration and respect, and animated with emotions of piety, virtue and religion.[35]

In both form and purpose, Ram Raz concludes, the Hindu temple was equal to the most lauded Western traditions of building construction.

The Western reception of Ram Raz's posthumously published work was limited and sceptical. A review published in the *Architectural Magazine* doubted the essay's utility. Temple architecture

[35] Ram Raz, *Essay on the Architecture of the Hindus*, 62.

was "calculated for an age of general ignorance" and "could only be erected under a despotic hierarchy or monarchy." Dissociated from their source the images of temple ornamentation, the review believed, might be of use. There was no "design . . . that we should consider deserving of being copied exactly" but certain motifs could be "purified" and made use of by "the scene decorator" or "cabinet maker".[36] Almost eight decades later, Owen Jones' compendium on design, published in 1910, briefly mentions Ram Raz's essay but concludes that too little was as yet known to judge "whether the Hindoos are only heapers of stone, one over the other, adorned with grotesque and barbaric sculpture."[37]

Ram Raz's essay argued that temple architecture was the result of a relationship between text and practice that had been dislocated by the time he wrote. This observation was subsequently submerged beneath two other scholarly preoccupations: that Indian architecture was most usefully understood as the manifestation of a set of involuntary cultural, racial, and psychological characteristics; and, second, that textual prescription itself had a regressive and stunting effect on the development of the temple after the fifth century. The subsequent work of architectural scholars, led by Fergusson, placed the temple within a field of comparative, form-based interpretation and sidestepped any substantive engagement with text. Until Rajendralal Mitra's intervention, Ram Raz's work was acknowledged largely for the purpose of dismissing it.

The "Stone Book": James Fergusson and Ethnographies of Architecture

Fergusson dismissed the corpus of texts on architecture and iconography as useless, and, indeed, saw them as connected to the degeneration of design that followed the earliest period. This line of thought was pursued by the majority of British art historians

[36] Anon., review of *Essay on the Architecture of the Hindus*, 273.
[37] Owen, *The Grammar of Ornament*, 82.

who followed. In keeping with this high Victorian view – which held texts illegible to the Anglophone scholar to be of no analytical purpose – Kenneth de Burgh Codrington, Keeper of the Indian Collection at the Victoria and Albert Museum and later Professor of Indian Archaeology, commented in the 1940s that later medieval temples, "made according to priestly rule, are not beautiful, possibly because the artist was no longer free, but bound by verbiage."[38]

Fergusson presented the temple as a "stone book" through which Indian history could be read, free from any recourse to, or dependence upon, the frailties and flaws of Indian texts or living Indian informants. He argued that Indian architecture was the mechanistic expression of certain tendencies and propensities (rather than conscious preferences) of various ethnic groups. The ethnology and history of India could be mapped through architecture precisely because Indian builders were incapable of any reflexive understanding of their creativity or creations. The "stone book", moreover, was a record of unparalleled veracity that could not be displaced or altered undetected. His thesis consummately embodied its imperial context. Architectural form exhibited proof of Indian civilisational decline without the material of the temple having been corrupted by that same interminable process of decay that had corrupted other facets of Indian society, religion, and governance. The allusion to the "book" was significant. Stone buildings were valuable to the imperial scholar precisely because they were *not* text. Architecture, Fergusson argued, offered a means to bypass the inaccuracies and fantasies that he regarded as the characteristics of Indian texts – a presumption that persistently undermined the perceived significance of Ram Raz's work. Texts were corruptible, and therefore, in India, inevitably corrupted through translation and alterations for reasons that lay beyond the cognisance and expertise of Euro-

[38] Codrington, *Ancient India from the Earliest Times*, 15.

pean officers. This analysis rendered unnecessary the acquisition of languages, which were irritatingly profuse, and a reliance on texts made unreliable by the native's innate propensity for falsehood. Enough knowledge had been accumulated by the 1870s, argued Fergusson, to "check the vagaries of Indian speculation".[39]

This set the tone for subsequent imperial scholarship. Henry Cousens, the government archaeologist who documented a large corpus of temples in western and southern India, deprecated attempts in 1919 to insist that all archaeological officers should possess knowledge of Sanskrit. Such officers, he claimed, should necessarily be architects and engineers, those being the only qualifications that would allow them to check the work of draughtsmen and surveyors who could not be "depended upon".

Epigraphical work could be more conveniently sent out to philologists in India and Europe. Textual scholarship, regarded by Cousens as "mere" translation, was a subsidiary service discipline to the brisk and practical business of "monumental archaeology".[40]

Fergusson regarded photography as an indispensable boon for his work and in the mid 1870s held a collection of 3000 photographs of Indian architecture.[41] Photography offered him a further unmediated abstraction of the temple from the complexities and intricacies of its living environments. The disembodied, two-dimensional, and portable image made the temple Fergusson's creature. In 1866 he remarked: "I have learnt as much, if not more, of Indian Architecture during the last two or three years, than I did during my residence in India, and I now see that the whole subject may be made intelligible, and I see how it may be done." When back home, Fergusson evoked his time in India to assert and protect the authority and authenticity of his interpretations. Anyone without his own first-hand experience of architecture

[39] Fergusson, *History of Indian Architecture*, vol. I, 328.
[40] "Tribute to Mr Cousens", 11.
[41] Fergusson, *History of Indian and Eastern Architecture*, vol. 1, xi.

in situ could not hope to "know where to begin" even when presented with the most reliable images.[42] Perhaps because he wrote the majority of his analysis many thousands of miles away from his subject, he missed no opportunity to demean the work of others and draw attention to his own years of first-hand familiarity (though how long he spent away from the business houses of Calcutta is not clear). Even in his analysis of temples in Kashmir, a region he never visited, he found an opportunity to diminish those drawn to "the perfection" of Kashmir's climate in preference to the "hot and dusty plains of India".[43]

The link between ethnicity and architecture was the subject of substantial exploration in the second half of the nineteenth century, an intellectual agenda that owed both its scope and interest in reductive racial types to imperialism. John Ruskin regarded the intrinsic nature of peoples to be manifestly evident in architecture and made direct connections, as did Fergusson, between deficiencies of form and racial character.[44] While Ruskin disliked and distrusted Fergusson's reliance upon the photograph as well as the pretentiousness of his global analysis, both men happily used their evaluations of architecture to draw lessons about the inescapable hierarchy of human societies. Ruskin's naked imperialism, most evident in his 1870 Slade Lectures at Oxford, have been noted by Edward Said in *Culture and Imperialism* as stark evidence that "British world domination" was central to "his aesthetic and moral philosophy".[45]

Reading architecture as the involuntary expression of racial traits reached its nadir in the work of the Austrian scholar Gustavus Zeffri. Published in 1876, Zeffri's sweeping and simplistic scheme divided humans into three races, diagnostic of three principal forms of art and architecture. (Images 2.3, 2.4, 2.5.) The

[42] Fergusson, "The Study of Indian Architecture", 6–7.
[43] Fergusson, *History of Indian and Eastern Architecture,* vol. 1, 251.
[44] Ogden, "The Architecture of Empire".
[45] Said, *Culture and Imperialism,* 104.

"Negro", having a face "drawn downwards in melancholy lines", produced structures that were "triangular or mound-like architectural constructions". The "Turanian" or "Mongol" had a face drawn in upward line, and "Faithful to his nomadic traditions, and the lines of his head and face, his architectural constructions take an according form. Like his facial lines, the roofs of his houses are twisted upwards." Finally, the "the *white* man" alone had a face that combined vertical and horizontal elements and could, therefore, command both horizontal and vertical lines in his art: "[I]n accordance with his powerfully arched brow, [he] over-arches not only rivers and chasms, but builds his magnificent cupolas and pointed arches, the acme of architectural forms."[46] Zeffri's crude and racially obsequious analysis was so reductive that it refused any possibility of elaboration. However, the form and purchase of his ideas sat within broader and more conventional canons that connected race to architecture.

Fergusson's all-encompassing theses of architecture were part of this rapidly broadening, indeed global and imperial, landscape of objects, histories, and cultures created in the nineteenth century which relied upon hierarchies of comparison. Comparative evaluations provided the intellectual motor of Fergusson's scheme of thought. Archly noted similarities and distinctions were woven into his taxonomies of Indian architecture. The comparisons range from evocative to absolute. In his *History of Indian and Eastern Architecture* published in the 1870s, he applied a quantitative scheme devised in an essay, "True Principles of Beauty in Art", in order to compare the Parthenon with the Taj Mahal. The Parthenon, perhaps unsurprisingly, triumphs, achieving twenty-four to the Taj Mahal's twenty points.[47] These comparisons served to signal Fergusson's mastery of his subject on a global scale; they also created and consolidated a canon of architectural merit against which Indian architecture was measured. The Chalukyan temple

[46] Zeffri, *A Manual of the Historical Development of Art*, 22–6.
[47] Fergusson, *History of Indian and Eastern Architecture*, vol. 2, fn text, 284.

at Halebidu, restored through conjectural reconstruction to its originary whole, provided one pole and the Parthenon the other. Between "these two extremes lies the whole range of the art." The Parthenon was the best example of "refined intellectual power" whereas the temple was "a joyous exuberance of fancy scorning every mechanical restraint." Indeed, the Parthenon showed more "human feeling" than the temple showed intellect. [48] While Greeks thought first and felt second, Hindus simply felt, and even that to a lesser degree.

Fergusson's taxonomies depended on the disaggregation of the buildings he identified as exemplars of their kind into labelled, ranked elements that could then be used to order a vast diversity of structural forms. These disaggregated fragments allowed him and others to reconstitute the remains of temples without any reference to the textual materials used by Ram Raz and Mitra. From the early nineteenth century, conjectural drawings had been used to demonstrate a complete knowledge of an incomplete subject. James Prinsep's conjectural drawing of the plan of the Vishveshwar Temple in Benares (1831–2) re-created an original floor plan of the temple, now lost. Fergusson's reconstructions restored temple form in order to trace out his subcontinental classifications and schematics of emergence, maturity, and decline.

His comparisons and analysis of architecture also encompass vast telescopic time frames and abundant speculation. He could suggest, as in the case of the Srirangam temples, that the transference of architectural form from one civilisation to another might have gestated across millennia, from, for example, some ancient contact between ancient Egypt and South India. His comparisons were also provocative and open-ended, almost fanciful rather than conclusive. He would note similarities and conclude only with a ponderable conundrum. Where, for example, could the Dravidian preference for straight-line plans and curvilinear shikhars (towers above the temple's sanctum) have come from? Fergusson specu-

[48] Ibid., 448–9.

lates that perhaps the transfer in remote antiquity was from Persia. Elsewhere, for example in his comparisons of Dravidian and ancient Egyptian pillared halls, he dismisses the possibility of direct influence but speculates that some seed might have been planted "which fructified long afterwards".[49]

These speculative, illustrative connections of fragmental form and generative principle bound Fergusson to his European audience in a shared familiarity with and sensitivity to the exemplars through which he explained Indian architecture. Indian pendants, below domes, for example, "are used to an extent that would have surprised even the Tudor architects of our country . . . [and] . . . have a lightness and elegance never even imagined in Gothic art; it hangs from the centre of [the] dome, more like a lustre of crystal drops than a solid mass of marble or stone."[50] These similarities domesticated the temple by connecting its most salient aspect to examples that were familiar to the European reader. Fergusson's tendency to deploy such wide-ranging examples in grandiose speculation accounts for his vituperative response to Mitra. The latter's crime was to dare to cast doubt on his unquestioned command of global scale. As an Indian limited in his knowledge, what right had he either to emulate Fergusson's analysis, or to detach it from its global mooring by focusing on a regional school of architecture?

Fergusson offered a purpose for his analysis of Indian architecture that centred the discerning eye of the European reader. Once appraised, categorised, and understood, elements of that architecture, he suggested, might provide useful stimuli to the slowing pace of European architecture. On the question of utility to ongoing and future British design, he was adamant that "copying the Indian styles [was] a crime." However, if the principles were "deeply studied", some trace elements might prove useful. Having himself deeply studied the temple, he offers one such possible element:

[49] Fergusson, *History of Indian and Eastern Architecture*, vol. 1, 408. Cole drew on the same text in *Temples at Trichinopoly*.

[50] Fergusson, *History of Indian Architecture*, vol. 1, 317.

the "Hindu-Corinthian" – the conversion of a circular pillar into a square, weight-bearing pillar through a foliage design at the summit – is singled out for qualified praise. (Image 2.6.) Qualified because "The Hindus, of course, never had sufficient ability or constructive skill to enable them to produce so perfect a form as the Corinthian or Ionic capitals of the Greeks or Romans." Nevertheless, the decorative flourish at the top of the (imperfect) pillar might be "almost the only suggestion that Indian architecture seems to offer for European use."[51]

Fergusson's Taxonomies of Temple Architecture

Fergusson created the enduring meta-categories of Hindu temple form and charted its chronological development from inception to decline; from its embryonic, simplest, and purest form through gradual, incremental elaboration. This order was created by the comparative analysis of disassembled parts of the temple and by drawing on vocabularies and examples from across classical civilisation, medieval Europe, and the Ancient Near East. Temples were lifted from their physical, economic, political, and cultural environments and histories in these peculiarly imperial, striated analyses.

He argued that Buddhist architectures had emerged from the wooden architectures that preceded them. He pointed to the presence of wooden form rendered in stone within early Buddhist cave temples at Pune, Nasik, and Karle in western India as a literal petrification of wood-based architecture. Their stone form, he argued, possessed, "an essential woodenness".[52] From these initially hybrid constructions of the second century BCE, "progress towards lithic construction" began.[53] Plate 2.7 shows the curved lines of the exterior of "cave 19" at Ajanta drawn by T.C. Dibdin

[51] Ibid., 300.
[52] Fergusson, *History of Indian and Eastern Architecture*, 148.

for Fergusson's *Illustrations of Rock-Cut Temples of India*. Fergusson saw brief architectural achievement in form in the earliest stone-built temples, in which remnant elements of earlier wooden form remained – the temples at Mamallapuram, south of Chennai in Tamil Nadu, as the immediate Hindu successors showing "the petrification of the last forms of Buddhist architecture."[54] Plate 2.8 shows the rock-cut temple, Dharmaraja Ratha at Mamallapuram, included in Fergusson's work to illustrate the architectural bridge between Buddhist and Hindu architecture. He argued that decline followed the arrival of stone architecture. The further Hindu temples deviated from their Buddhist antecedents, he said, the worse they became, while stressing "how pure [Buddhist architecture] was at first, and how it gradually became idolatrous and corrupt, and how at last it perished under its own overgrown hierarchy."[55]

He expressed little interest in iconography or the devotional functions of the temple, though he did appraise sculptural form. The rock-cut Dharmaraja Ratha at Mamallapuram contained "the soberest and most reasonable version of the Pantheon yet discovered, and, consequently one of the most interesting, as well as probably, the earliest." The praise was relative: the earlier sculpture was a purer form, showing none of the "combinations or extravagances" found at the rock temple complexes of Ellora or Elephanta in western India. These icons were of incidental interest for Fergusson and he regarded them as more properly fit for the study of Hindu mythology; they had only passing significance for architecture, only serving to confirm to him that purity of form indicated an earlier date.[56]

European architectural scholarship assessed and appraised temple architecture as if it were the work of a lamentably weak apprentice. If only the Dravidians had "had it in them to think"

[53] Ibid., *Architecture*, 138.
[54] Ibid., 336.
[55] Fergusson, "The Study of Indian Architecture", 10.
[56] Fergusson, *History of Indian Architecture*, vol. 1, 331–2.

of the variated plans of the Chalukyan temples, "light and shade would have been obtained."[57] Fergusson regarded the monolithic walls and descending size of the gateways at the Srirangam Temple as similarly disappointing: "Had the four great outer gópuras formed the four sides of a central hall, and the others gone on diminishing, in three of four directions, to the exterior, the effect of the whole would have been increased in a surpassing degree."[58] The government archaeologist Henry Cole echoed this criticism almost verbatim a decade later: "the bathos of their decreasing in size and elaboration as they approach the sanctuary being a mistake which nothing can redeem."[59] This irredeemable error in the temple's construction had replaced the proper order of a visual grandeur – it was self-evidently true that a sense of grandeur must increase as the spectator approached the centre of the temple.

Fergusson pointed out, contra to the earlier convictions of the Royal Asiatic Society, that there was "not only one Hindu and one Mohamedan style in India" but instead that several existed, divided by region and the ethnicity of the people who lived there.[60] These differences could be deciphered to provide maps revealing cultural boundaries and transformations across history. Differences in form – of pillars, towers, and doors – were isolated, compared, and ordered into "sequences" to illustrate and demonstrate patterns of ethnic movement over time. Fergusson delineated and mapped three principal schools of temple architecture: a northern Indo-Aryan school; a southern Dravidian style; and an intermediate style exemplified in Chalukyan temples of the Deccan and Karnatak regions. (Plate 2.9.) All the temples he encountered – in person and, later, in photographs – were calibrated according to their conformity or divergence with this tripartite order.

The Dravidians in the South were "one of the greatest building races in the world." He regarded the Dravidian style as "united in itself"

[57] Fergusson, *History of Indian and Eastern Architecture*, 346–50.
[58] Ibid., 368.
[59] Cole, *Temples at Trichinopoly*, 10.
[60] Fergusson, "The Study of Indian Architecture", 6.

and entirely discrete, spatially and ethnically.[61] The term "Dravidian" applied to peoples speaking Tamil, Telugu, "or some cognate dialect".[62] Dravidian architecture, despite its achievements, could not avoid an inevitable if "gradual process of degeneration" until it disappeared in the eighteenth century. This decline from the earliest "perfect" temples was so consistent, claimed Fergusson, that it provided in itself a reliable means of dating temples without recourse to epigraphy. It is worth pointing out that his conviction about what he classified as superior as also necessarily earlier led to some dramatically erroneous dating, later medieval temples being assigned to much earlier periods.

Unlike the geographically delineated style of Dravidians, the Indo-Aryan school of architecture was defined by its correspondence to ethnic groups who spoke languages derived from Sanskrit, from the Himalayas to the Vindhya mountains, and from what is now Maharashtra in the west to Odisha in the east. Colonial histories regarded the arrival of the Aryans in around 2000 BCE and their establishment as the dominant cultural power across India as an ethnic watershed.[63] Having inherited the term "Aryan" from his orientalist predecessors, Fergusson smartly dismisses any question that the Aryans who lived in India had any connection to those found "across Europe". Indians were not, "whatever the philologists might say to the contrary . . . Aryans in any reasonable sense of the term." They were not, in other words, white. Merged with the prefix "Indo-", however, the term became "much less objectionable".[64] These Indo-Aryans, "the Sanskrit-speaking races to whom we owe all the important literary productions of India," having intermingled with the aboriginal populations, soon lost "their purity of race", the loss having been compounded through "the innate decay of enervation by the climate." This narrative served

[61] Ibid., 9.

[62] Fergusson, *History of Indian and Eastern Architecture*, vol. 2, 84.

[63] Fergusson, "The Study of Indian Architecture", 7. On the imperial historiography of the Aryan myth, see Trautmann, *Aryans and British India*.

[64] Fergusson, *History of Indian and Eastern Architecture*, vol. 2, 85.

also as a racial parable about the dangers of miscegenation and was aimed squarely at Fergusson's own white peers.

He used the concept of an Indo-Aryan style to delimit a diffuse northern group of architectures spanning a period from the seventh century CE to the present. This conjectural map of the Indo-Aryan style contained one pronounced gap: he admitted puzzlement at the absence of ancient temples in the Gangetic region, the area he presumed was the heart of what the later historian Vincent Smith, drawing on Hindu nationalist nomenclatures, termed "Aryavarta".[65] The iconoclastic destruction of temples by Muslim rulers from the eleventh century onwards was regarded as a given. Such demolition during waves of Islamic violence configured the idea of the temple as a key referent and site of broader patterns of transformation.[66] The wrecking of Hindu architecture offered a neat physical and chronological delineation of medieval India, allowing one set of materials, and one scholarly remit, to end and another to begin.

That destruction, however extravagantly imagined, could not explain why there were so few signs of ancient temples in the Gangetic region but so many in Dharwar in the west and Orissa in the east. In the absence of evidence, Fergusson could only suggest that the "accidental discovery of old temples" at some time in the future would confirm his thesis of the significance of the Indo-Aryan school.[67] In the case of Dravidian temple style, therefore, architecture was made a concrete and diagnostic index of ethnicity. With the Indo-Aryan case Fergusson reversed his analysis to make a corrupted ethnicity the index of a diversity of both existing and absent forms.

[65] Vincent Smith elevated Fergusson's categories to rename the Indo-Aryan the "Aryavarta style", presenting ranked exemplars, beginning with the temples of Orissa, to the temples in Khajuraho and Mount Abu. Smith, *A History of Fine Art,* 114.

[66] For an account of the colonial state's narrativisation of Islamic Iconoclasm, see Rajagopalan, *Building Histories,* 155–90.

[67] Fergusson, *History of Indian and Eastern Architecture,* vol. 2, 86.

Between – both literally and figuratively – these two schools lay a third. The Chalukyan school of architecture provided the geographical and historical point of convergence between Indo-European and Dravidian temples. The landscapes in which the temples were found spanned a number of boundaries: the southern parts of the Bombay Presidency, the Madras Presidency and the north of the princely state of Mysore, and south-eastern parts of the territories of the Nizam of Hyderabad. The school was named after the Chalukyan dynasty which ruled between roughly the sixth and twelfth centuries, save for a two-century interregnum after their territories were captured in the eighth century. In this region the Indo-Aryan style of the North and Dravidian style of the South were deemed to have met and merged. Chalukyan temples were thought to combine the worthiest forms of both the northern and southern school. Fergusson was much taken with the ruins of the Kedaresvara Temple at Halebidu in Karnataka, and the larger Hoysaleswara Temple of which he undertook a speculative visual reconstruction. (Image 2.10.) He offered qualified and comparative praise to the temple at Halebidu when commenting on its extent and the workmanship of its decoration: "It is not, of course, pretended that it compares to Greek or to the higher utterances of the European intellect, but in many respects it excels anything that Gothic art produced during the middle ages. The quantities of design exhibited at Haḷēbīd are certainly not the highest of which the art is capable, but in their grade they may challenge comparison with those of any known building in any other style."[68]

Certain Chalukyan temples were held up as exemplars that allowed both their own qualities and the field of temple architecture to be described and measured. The government archaeologist Henry Cousens followed Fergusson's taxonomies and was especially enamoured of the Chalukyan style. He too believed the

[68] Fergusson, *Architecture in Dharwar and Mysore*, 51, quoted in Cousens, *Chālukyan Architecture*, 20.

Chalukyan temples combined the finest forms of the northern and southern schools. "It therefore seems certain," he wrote, "that the Chālukya builders saw some grace and beauty of line in these northern spires which they endeavoured to express in their modified Dravidian outline." Covering a smaller geographical area than the northern or southern schools of architecture, these exemplars provided concentrated distillations of far wider swathes of architectural history.

Later authors elevated the temples of Aihole as a meeting point for all that was significant and necessary in temple design. Writing in the 1920s, Cousens was convinced that the development of the Chalukyan style could be "easily traced" in the architecture of the temple at Aihole in Bijapur.[69] At Aihole "we have an unbroken sequence in the styles from the fifth to the fourteenth century – from the earliest cave to the latest mediaeval temple."[70] In the 1940s Percy Brown described Aihole as a "cradle" of temple architecture. It was here, that the shikhar (tower) was added to the formerly plain central shrine "to give . . . dignity".[71] The temples at Aihole and at Badami, some fifteen miles away, combined Indo-Aryan and Dravidian styles. Brown continues Fergusson's analytical idiom, tracing out the lifespans of the two broad schools of architecture. At the Mahakutesvara Temple, dating from before the sixth century, Brown sees "an early phase in the evolution of the Dravidian sikhara."[72] At the Virupaksha Temple, he notes an "embryo *gopuram*".[73]

Assessments of Chalukyan temples were more tolerant of the sculptural richness of the medieval temple – a characteristic of Hindu architecture that had often been criticised. Chalukyan temples were distinguished by a "superabundance of lace-like carving"

[69] Cousens, *Chālukyan Architecture*, 18–19.

[70] Cousens, *Progress Report of the Archaeological Survey of Western India, 1908–1909*, 35.

[71] Brown, *Indian Architecture*, 67.

[72] Ibid.

[73] Ibid., 70.

that gave them "a very pleasing appearance, a bright sparkling of light and shade."[74] One image, Fig. 2.11, shows a perforated stone panel and doorway from temples in Dharwar. Writing in the 1890s, Cousens lavished praise on the finely sculpted decorations that covered the temples. He wrote of the temple at Ittagi: "The whole surface of the building glistens and sparkles with the thousand lights and shades caused by this minute and delicate work. Some of the fine bands around the pillars might almost furnish designs for lace or embroidery, so elaborately are they wrought."[75] The praise heaped on the stonework was not without qualification. Cousens observed that the temples were "least attractive when viewed from a distance."[76]

He believed that the style emerged from the southern, Dravidian school of architecture but subsequently evolved until, at the finest temples, "nearly all trace of its descent from the Dravidian is eliminated." At Chalukyan sites, the Hindu sculpture was redeemed of its worst frailties. At the Kasivisvesvara Temple at Lakkundi in the Dharwar District, Cousens found "two prancing horses" sculpted in a cornice,

> the larger of which is one of the best representations of that animal in Hindu sculpture the writer ever remembers to have seen. It is much mutilated, but the action is spirited, the outline good, and the leg of the rider hangs in the stirrup in the most easy attitude. As a rule, the horse has puzzled and defied the skill of the native artist; the result has always been a failure – cumbersome and out of joint – so that it is a pleasure to find this little group so well cut . . . The elephant usually met a better fate at their hands, and revelling in their mastery over its form, they have introduced it into all their ornament in all sorts of places and in all sorts of attitudes.[77]

In his subsequent book on style, Cousens fell into line with the general European admonishment of decorative carving and

[74] Cousens, "Chalukyan Temples", 1–2.
[75] Cousens, "Ancient Chalukyan Stone Carvings", 23.
[76] Cousens, *The Chālukyan Architecture of the Kanarese Districts*, 20.
[77] Cousens, "Ancient Chalukyan Stone Carvings", 23.

modified his view, only admitting that "the mass of ornamental encrustation which covers their surface . . . [is] not altogether unpleasing."[78]

Cousens' temple forms were manifestations of devotion, not politics. The profuse decoration was "wrought for the whole-hearted love of their work, and its dedication to their country's gods: their dynasties may die out, but their gods never." Devotion had dictated the artistic style of these temples; political ambition and socio-economic history was of little, if any, significance when interpreting the aesthetic underlying their design. Similarly, Cousens showed no interest in the engineering techniques used in their construction – these too were of no significance. He found both the lighting and the ventilation of the temples "left to chance".[79]

Self-reproduction and the Hindu Temple

The fine and profuse decoration on the exterior of Chalukyan temples led to the development of another, enduring, reading of architectural generation: that of dynamic multiplication and development.[80] This multiplication could take place at a single temple complex or serve to throw the temple form across space. Percy Brown noted that the Alampur temples, a hundred miles from the "triad of ancient capitals" of Dharwar (Aihole, Badami, Pattadakal), were a "small replica" of the principal Chalukyan temples "but with no accountable association". He drew on Cousens' work and suggested that the repetition showed "some kind of thought transmission in the field of architectural expression", but his analysis emphasised architectonic principal centripetal repetition – presenting the temple itself as an "organism of repeating cells".[81] The Kasivisvesvara Temple, twenty-five kilometres from Dambal,

[78] Cousens, *The Chālukyan Architecture of the Kanarese Districts*, 19–20.

[79] Cousens, *Chālukyan Architecture*, 21.

[80] For a clear and elegant introduction to this reading of the temple, see Hardy, "Form, Transformation and Meaning", 107–35.

[81] Brown, *Indian Architecture*, 63.

showed a "marked development of the Chālukya tower, where the ascending lines of niches is more fully expressed; and the northern tower, from which the idea was borrowed, is reproduced in miniature, as an ornament, within each."[82] The dynamic character of the temples – in terms of their spread across both space and time – was understood to be a mechanistic impulse which could be read from the body of the temple itself.

Edwin Lutyens was the chief architect commissioned to design the new imperial capital at Delhi in the second decade of the twentieth century. He disliked Hindu architectural styles and wrote to his wife that it was this very property of self-multiplication that unnerved him: "The Hindu temple would frighten me with its innumerable figures all building up out of little selves and the same big self."[83] The British art historian Roger Fry also pointed out this characteristic to define his dislike of Indian art. It was a tradition, he claimed, that emphasised the "less important qualities, with mere diversity, multiplicity and intricacy."[84] Although visually compelling and enduring, the thesis of self-multiplication increases the remoteness of the temple from its cultural and political contexts. The argument is based in the formalist thought for which Fry was well known. He thus locates the principal energy for the temple's transformation over time within its own materials. The theme of "self-generation" will be returned to in Chapter 6, which explores the emergence of a field of art history that centres its analysis on the spiritual energies as formative properties of the temple.

Conclusion

Architectural study, for all its elaborations, shrank the temple to a palatable form. Fergusson offered architecture as the means to

[82] Cousens, *Chālukyan Architecture*, 19.

[83] Edwin Lutyens to Emily Lutyens, 1 August 1918, LuE/16/11/1-10, Lutyens' Letters, RIBA.

[84] Fry, *Transformations,* 68.

best know the peoples "whom we have undertaken to guide and govern" and to correct the "very untrustworthy" nature of the purported histories that were available.[85] He created the enduring categories into which the Hindu temple could be organised. Simultaneously, he fixed the place of Indian architecture as a lower order of structural and decorative form. Brief mentions of Indian architectures in pan-global and historical compendiums distilled his ideas to create defining glimpses of temple architecture. Wilhelm Lübke's *History of Sculpture, from the Earliest Ages to the Present Time*, published in the 1870s, describes India, "that fairyland of the East", as a place in which the architecture was created by and reflective of a "tendency of mind" which suppressed the noble and pure in favour of the "wild, fantastic, and monstrous".[86]

Fergusson's attacks on Mitra were more than a racist reflex, though they were that too; more centrally, they were a defence of the analytical fabric of his own work. Fergusson's classifications were based on his global constellation of disassembled structural elements drawn from across the world and orchestrated by his commanding European hand. He regarded European and Indian architecture as parts of fundamentally different ethnic trajectories. European architecture had developed in cycles of achievement and degeneration but had in the end arrived at a point of awareness and mastery. Indian architecture on the other hand existed as the expression of mechanistic rote and repetition. While diffusion and mutual influence were always remote possibilities, the two trajectories met decisively only with colonisation.

This chapter has explored the isolation of the temple as a category of architecture and the subsequent amassing of its meaning in singular and simple principles. Later, in Chapter 6, I will revert to European understandings of the temple's form and explore Stella Kramrisch's reading of the temple. Her analysis of the

[85] Fergusson, "The Study of Indian Architecture", 12.
[86] Lübke, *History of Sculpture,* 14.

temple as a spiritual edifice rests upon and feeds off the scholar-
ship discussed in the present chapter.

The next chapter considers the archaeological management of
Hindu temples as monumental remains and explores the tensions
between antiquarian and devotional custodies of the temple.

3

―――――――――――

Colonial Archaeology and the
Idea of the Temple as a
Monument

ARCHITECTURAL SCHOLARSHIP divided and organised the
Hindu temple into categories and archetypes that lent
themselves to Fergusson's remote, commanding apprais-
al. This chapter turns to the custodies that were created to reframe
temples as places of public resort and physical emblems of an In-
dian past. From the beginning of the nineteenth century, certain
temples, such as those at Mahabalipuram in the Madras Presidency,
Elephanta in Bombay, and Puri in the Bengal Presidency, gained
notoriety as antiquities, celebrated in travel accounts and literature.
From the 1860s, as the colonial state began to invest itself with
custody of India's physical past, these and other medieval Hindu
temples were brought into the ambit of the colonial archaeological
authorities. I examine custodies that were formulated by the 1904
Ancient Monuments Protection Act, a piece of legislation that ex-
pressed the imperial state's ambition to assert control over India's
vast and diverse material remains.

The 1904 Act built on the Religious Endowments Act passed
in 1863, which was itself grounded in the Bengal and Madras
Regulations (discussed in Chapter 1). It followed decades of
archaeological survey and scholarship, both state and private ini-
tiatives, through which India's past had been documented and

segmented.[1] It was heralded to enact a policy of benign imperial acquisition. In 1903 Viceroy George Nathanial Curzon lauded the Act as the means by which the Government of India would be able to "lay hold of the large majority of monuments in British India at a price greatly below that which they ought to fetch."[2] This would allow imperial custody of India's antiquities as materials of "public interest" and protect those monuments most worthy of being sequestered from India's chaotic present. The Act was not repealed after independence in 1947 but augmented and modified by the Ancient Monuments and Archaeological Sites and Remains Act of 1958.[3]

This chapter uses the temple to consider the assumptions and sensibilities which underwrote the imperial desire to create a realm of archaeological antiquities protected by the state. In particular, it considers the tension that existed between the cultivation of materials as monuments, objects, and spaces of devotional observance.

Curzon's interest in acquiring buildings to create protected monuments assumed their vacancy and availability. In fact, these "monuments" were frequently inhabited and fulfilled a number of functions. The question of whether, or how, archaeological custody might be extended to structures or objects at which "periodic religious observance" existed was especially vexed. To exclude devotional sites would remove the possibility of custody over "most Indian monuments". To include them and maintain the possibility

[1] There is a voluminous literature which narrates the history and legacies of imperial archaeology in South Asia, focusing on institutional and intellectual pasts and legacies. See, for example, Chakrabarti, *A History of Indian Archaeology*; Lahiri, *Finding Forgotten Cities*; and Lahiri, *Marshalling the Past*. More critical, recent work includes Chadha's *Bureaucratic Archaeology* and, in terms of more general imperial history of archaeology, Effros and Lai, *Unmasking Ideology in Imperial and Colonial Archaeology*.

[2] Curzon, 16 February 1903, Legislative Department, Papers Relating to the Ancient Monuments Protection Act, 1904 (VII of 1904), NAI.

[3] *The Ancient Monuments and Archaeological Sites and Remains Act, 1958.*

of compulsory acquisition risked "interference with . . . religious en-
dowments", something that the colonial state had, for some
decades, been keen to avoid. The Act sought to establish proce-
dures for either state acquisition of buildings that would be con-
served as monuments or the formulation of agreements between
owners and local civic authorities that would provide both rights
of devotional access and conservation. In consultative discussions
before the Act was passed, officials were reluctant to reach agree-
ments that made government responsible for repairs at sites where
religious usage continued and sceptical as to whether such agree-
ments would ever be successful.[4] Asked to comment on the pro-
posals, R. Ramachandra, acting collector of Kurnool, said he was
powerless to intervene in the "very dilapidated condition" of the
Mallikarjuna Jyotirlinga Temple (now in Andhra Pradesh). He
doubted that the trustee of the temple would reach an agreement
under any section of the proposed Act and that, as collector, his on-
ly recourse to raise funds for renovation was to resume the inam
lands of the temple which had, compared to the wealth created by
pilgrimage, little value.[5] In a similar vein, the government epigraph-
ist for southern India saw an urgent need for government con-
servation of temples, railing against "the wanton destruction of
ancient inscriptions" caused by temple restoration by the Nattu-
kotai Chettys and asking for the wording of legislation to specifi-
cally outlaw their "vandalic acts". Nevertheless, he warned that the
complexity of trusteeship that existed at many South Indian tem-
ples would make any agreements reached vulnerable to subse-
quent contestation.[6]

[4] Denzil Ibbetson's note, 22 July 1902, Legislative Department, Papers Relat-
ing to the Ancient Monuments Protection Act, 1904 (VII of 1904), NAI.

[5] R. Ramachandra, Acting Collector of Kurnool, to the Chief Secretary of
Govt, 19 November 1903, Papers Relating to the Ancient Monuments Protec-
tion Act, 1904 (VII of 1904), NAI.

[6] Appendix I, Precis of Opinions, Papers Relating to the Ancient Monu-
ments Protection Act, 1904 (VII of 1904), NAI. For a fuller discussion of the

When the Act was passed, Curzon, less interested in detail, praised it as both paying "most scrupulous deference to religious feelings or family associations" and ensuring the state possessed "statutory sanction" to protect India's antiquities – "the most beautiful and precious collection of ancient monuments in the Eastern world" – on behalf of the nation. Rejecting the "frigid language of the preamble", he endorsed the spirit of the legislation in terms that entirely ignored the warnings of civic officers about the complexities of custodies and usage. Instead, he vaingloriously placed his own sensibilities and authority centre stage: "As a pilgrim at the shrine of beauty I have visited them, but as a priest in the temple of duty have I charged myself with their reverent custody and their studious repair."[7]

The Ancient Monuments Protection Act therefore acquired for the colonial government new rights and obligations over India's material past.[8] It created a threefold categorisation of standing antiquities and set out the rules by which the British Indian state could acquire custody – by negotiation or compulsion. This custody, in theory, gave officers of the Archaeological Department complete control over the physical fabric of listed monuments. In 1902 fewer than 150 buildings in British India were under the protection of the state, many of them British monuments built in the nineteenth century. By 1915 that number had risen to over 700.[9] The Act appeared to offer the colonial state licence to impose conservation to a degree unknown in Europe, and especially in

temple renovations carried out by the Chettis, see Branfoot, "Remaking the Past".

[7] Curzon, in Extract from the Proceedings of the Council of the General Governor of India, 4 March 1904, Legislative Department, Papers Relating to the Ancient Monuments Protection Act, 1904 (VII of 1904), NAI.

[8] For a critical overview of the act, see Rai, *Hindu Rulers, Muslim Subjects* 184–92.

[9] John Marshall, "Note on Archaeology", Proceedings of the Govt of Bombay, General Department, Archaeology, 1915, 71–86, OIOC.

Great Britain, where the passage of similar legislation was subject to a variety of caveats. Not until 1913 was an Act passed in Great Britain which gave the state similar abilities to intrude in private rights, though even this Act still excluded all ecclesiastical buildings in religious use.[10] The Indian Act expressed a very specific European consensus that had been developed over centuries of cultural and religious debate about the meanings, significance, and material manifestations of antiquity.[11] In Britain, in the mid nineteenth century, the Anglo-Catholic taste for "eclectic" restoration – which permitted selective destruction and rebuilding – took place amid a "massive" project of church construction and restoration.[12] Those tastes, however, gave way later in the nineteenth century to the "anti-scrape" movement which aggressively decried the destructive and imitative practices of restoration. John Ruskin and William Morris, through the Society for the Protection of Ancient Buildings (founded in 1877), successfully promoted the sanctity of original, or at least the idea of "original fabric" as it had come to rest in the present, and rejected any attempt to replicate the medieval genius of sculpture.[13] The convictions of preservation were underwritten by a complex of explicit and coded sensibilities towards the fabric and aura of antiquities: Protestant aloofness from the material mediation of worship; the irreversibility of time; and an aesthetic order affronted and wounded by industrialised modernity. The British India Act was a blunt and legislative distillation of these sensibilities removed from their cultural context and given muscle by imperial governance.

In Britain, legislation and culture were – within the parameters

[10] Boulting, "The Law's Delays", 19.

[11] Nikolaus Pevsner dated the first debates over the revival and survival of medieval Gothic style to the aftermath of the English Civil War (1642–51) and traces its intensification at the end of the eighteenth century. Pevsner, "Scrape and Anti-scrape".

[12] Ibid., 43; Miele, "The First Conservationist Militants".

[13] Criticisms of restoration had been voiced by others from the late eighteenth century but with little success. Pevsner, "Scrape and Anti-scrape", 42–3; *Notes on the Repair of Ancient Buildings*; Miele, "'A Small Knot of Cultivated People'", 73–9; Miele, "The First Conservationist Militants".

of class, taste, and confessional conviction – calibrated and recon-ciled. In British India, legislation articulated an imperial entitle-ment to acquire and control, in Curzon's words, this "most beau-tiful and precious collection"; to rescue and redeem monuments from the claims of unruly native publics.

Here I explore the Hindu temple as a very particular type of monument. The rights that the 1904 Act ostensibly gave imperial archaeologists to make monuments from temples was, as we shall see, almost invariably and inevitably tested by devotion. Hindu temples presented complex and indistinct targets for archaeologi-cal custody. Far from being able to "fix" the medieval temple as a material of the past conserved in the present, the imperial Archae-ological Department found itself in a near-constant process of ne-gotiation and compromise. We will also return later to the imperi-al distinction and preference for Islamic and Buddhist materials. With few exceptions, and none in northern India, archaeologists working for the imperial Archaeological Department regarded the Hindu temple as a delinquent subject, less amenable and less worthy of conservation and cultivation as a public monument.

By looking in particular at the Hindu temples of Bhubaneswar in eastern India, this chapter explores the gradual shift that took place in governmental disposition during the forty years after the Act was passed – a shift provoked by a variety of local disagreements and dissonances between the doctrines enshrined in the Act and the practices of popular Hinduism. The codes created by the Act created a spartan aesthetic which hinged on a very particular histor-icist sensibility and which reflected culturally specific ideas about the material mediation of devotion. In contrast, Hindu devotional practice was premised on the daily life of the deity within the tem-ple, the reception and exchange of gifts, ornamentation, and liba-tions.

Once temples were registered under the Act, activities which could be defined as vandalism ranged from the pouring of libations, the drying of pulses, the smearing of cow-dung, the holding of school classes, the offering of fruits, and the renovation of sculpture.

Aside from the variety of non-devotional purposes to which a medieval temple could be put, the greatest tension was between the codes of archaeological conservation and those of popular Hindu ritual. There was a clear conflict between the aesthetics of conservation distilled from European affective registers, and those of popular Hindu ritual practice: matt was preferred over luminosity; plainness over ornament; sight over touch; patina over renewal. We will consider the competing agencies of colonial archaeologists, entrepreneurial priests, and attendant devotees at sites that had been selected and designated as antiquities.

Temples as Monuments

Before the Act was passed at the start of the twentieth century, James Fergusson, and then Henry H. Cole in his short-lived appointment as Curator of Ancient Monuments (1881–3), had railed against the public "misuse" of monuments. Writing about the temples at Srirangam, Cole quoted Fergusson on the corruption of form by devotion:

> One of the great charms of this temple when I visited it was its purity; neither whitewash nor red nor yellow paint had then sullied it, and the time stain on the warm coloured granite was all that relieved its monotony; but it sufficed, and it was a relief to contemplate it thus after some of the vulgarities I had seen. Now all this is altered. Like the pagodas at Rameshvaram, and more so those at Madura, barbarous vulgarity has done its worse, and the traveller is only too fully justified in the contempt with which he speaks of these works of a great temple which have fallen into the hands of such unworthy successors.[14]

The vulgarities of devotional attention – in paint, oil, and whitewash – stood in disagreeable contrast to the effects of time on natural stone, the latter being effects that only European sensibilities were deemed capable of either appreciating or protecting. Precise aesthetic codes of conservation were not established under the

[14] Cole, *Preservation of National Monuments. The Madras Presidency*, 13.

1904 Act, though some elaboration was provided in Director General of Archaeology John Marshall's *Conservation Manual* (1923).[15] Guha-Thakurta's assertion that the conservation of monuments under the terms of the Act "amounted to their effective museumization" overemphasises the intention of the Act and neglects its effects.[16] The 1904 Act may have sought to separate monuments from religious usage and assumed devotional and archaeological custody would be distinct; in practice, however, the sovereignty of temple deities met and mastered both the aesthetic codes and the bureaucratic formulas of the Ancient Monuments Protection Act.

Elaborate bureaucratic practices were set in place – if not, as we shall see, in motion – to facilitate the monument's upkeep and invigilation. The Act established an unprecedented claim to physical custody over the temple. Under the first state-funded archaeological surveys led by Alexander Cunningham in the 1860s, the fate of archaeological materials was of far less importance than their assessment and documentation. Indeed, Cunningham was afforded licence to take a share of the objects discovered.[17] However, the proprietorial claim of government to standing monuments had grown at the end of the nineteenth century, not least under pressure from advocates of conservation in Britain. During the second phase of the survey, from 1871, the importance of preserving exemplars from within emerging taxonomies of architectural history was raised.[18] The reports of Cole encapsulated the growing concern with appropriate custody and maintenance of antiquities as part of a landscape. Cole considered Ahmedabad, for example, to be "one of the most picturesque and artistic in the whole of the Bombay Presidency" and brought to government's attention the

[15] Marshall, *Conservation Manual*. This manual was designed to replace the existing guide, *The Military Works Handbook*.

[16] Guha-Thakurta, *Monuments, Objects, Histories*, 61.

[17] Trevithick, "British Archaeologists, Hindu Abbots", 647.

[18] Ibid., 648. The move from exploration to collection is described in Guha-Thakurta, *Monuments, Objects, Histories*, 55.

"readiness, on the part of both Natives and Europeans, to utilise ancient architectural memorials for domestic purposes."[19] He employed a striking sketch of a temple in the city to illustrate his point. (Image 3.1.) The documentation and collection required by earlier phases of the Archaeological Department's work were now supplemented by the need to actively intervene in the fabric of buildings identified as antiquities and desired as monuments.

Marshall, appointed in 1902 as the first director general, reorganised and reinvigorated the Archaeological Survey and regarded the custody of India's material past as representative of the shift from colonial power to imperial authority.[20] The process of making monuments suggested new purposes and new publics for these buildings. However, the idea of a "national past" was reworked in an imperial context. The expected gratitude from colonial subjects for the provision of protection was anticipated and understood in terms of (divided) national, racial, and religious interests. Curzon's reiteration of the strict impartiality which would be observed in dealing with India's antiquities served only to underline that he extended his divisive principles of political rule to the classification and interpretation of South Asia's material past:

> To us the relics of Hindu and Mahommedan, of Buddhist, Brahmin, and Jain are, from the antiquarian, the historical and the artistic point of view, equally interesting and equally sacred. One does not excite a more vivid and the other a weaker emotion. Each fills a chapter in Indian history. Each is part of the heritage which Providence has committed to the custody of the ruling power.[21]

Marshall endorsed "the vast educative influence which resides in the monuments of a great past" and stressed the importance

[19] Cole, *Preservation of National Monuments, Bombay Presidency.*

[20] The remit and organisation of the Archaeological Department are laid out in Resolution of the Government of India, Home Department (Archaeology and Epigraphy), nos 134–46, 28 April 1906, OIOC.

[21] Curzon, 1899, in a speech to the Asiatic Society, quoted in Vogel, "The Preservation of Ancient Monuments in India", 88.

of "convert[ing] the monuments into places of popular resort."[22] However, the custody of monuments as places of "public resort" was underwritten by assumption and preference: firstly, the presumed capacity of the Archaeological Department to control access to these monuments and regulate modes of behaviour around them; and secondly, a tacit preference for the curation of monuments classified as non-Hindu.

Between 1905 and 1915 the majority of the outlay of the governments of the Central Provinces, Bombay, and Madras was taken by the conservation of Hindu monuments, specifically temples. However, the single paragraph on "Hindu monuments" in Marshall's 1915 report was dry by comparison with the effusive treatment of Islamic buildings. Bhubaneswar was described as possessing a "crowd of temples". The temples of South India, with no adjectival endorsement, were described as being subject to an "active and systematic campaign of protection and repair."[23] The comparatively tight-lipped treatment of temple conservation reflects an aesthetic preference for certain Islamic monuments in northern India. The palaces, throne rooms, and gardens of the Sultanate and Mughal past provided a fitting ceremonial inheritance for the colonial state and received ebullient treatment in Marshall's reports to the Indian and home governments. In their case, imitation and restoration were acceptable. Marshall reported that by 1905 the monuments of Delhi had "been restored to their former beauty or put into a thorough state of repair and defence against their natural enemies . . . Around the tomb of Humayun a barren wilderness is being converted into a stately garden, that shall be worthy of the glorious resting place of so great an Emperor."[24] The Sultanate and

[22] Note by Director General of Archaeology regarding "archaeological programme for Delhi Province", Proceedings of the Department of Education, Archaeology and Epigraphy, March 1914, 53–61, OIOC.

[23] Marshall, "Note on Archaeology", Proceedings of the Govt of Bombay, General Department, Archaeology, 1915, 71–86, OIOC.

[24] "Note by the Director General of Archaeology on the work of the Archaeo-

Mughal remains that were incorporated into the new imperial capital in Delhi appealed as remnants of an elite culture less remote to the British than the material culture of "ancient" Hindu dynasties. The geometric form and adornments of the Sultanate and Mughal monuments created by fellow emperors were more sympathetic to the eye of dominant Protestant European sensibilities. The comparatively weak attention paid to the temples and shrines in and around Delhi when the new capital south of the city was laid out in the second and third decades of the century will be discussed at greater length in the next chapter.

The Temples of Bhubaneswar

The many medieval temples in Bhubaneswar had been subject to a series of conservation measures before the 1904 Act came into force. Fergusson regarded the temples as the most "perfectly pure" example of Indo-Aryan architecture in India.[25] Built between the eighth and twelfth centuries, the temples were believed to have escaped the "ravages which devastated the principal Hindu cities in the earlier and more intolerant age of [Muhammadan] power."[26] The Lingaraj Temple, built in the eleventh century, was described by Fergusson as the "finest example of a purely Hindu temple in India."[27] Conservation had been carried out between 1898 and 1902 by the Archaeological Department, and in 1900 when John Woodburn as lieutenant governor of Bengal granted an annual allowance of Rs 400 for its maintenance. The grant to the Lingaraj Temple was withdrawn three years later when the temple authorities refused to allow European officers to enter its compound to inspect it.[28]

logical Survey Department in India", Government of Bombay, General Department Proceedings for June 1905, OIOC.

[25] Fergusson, *History of Indian and Eastern Architecture*, vol. II, 95.

[26] Ibid., 92.

[27] Ibid., 99.

[28] Draft letter to Chief Secretary of Government and to Director General

The question of access simmered throughout the decades following the passage of the Ancient Monuments Protection Act and during the occasional grants made for the repair and upkeep of the temples. In 1911 the question of the temples' repair and custody was reopened after the Lingaraj Temple Committee and the Public Works Department (PWD) made simultaneous and almost identical complaints to government.[29] The Temple Committee protested the destruction of a subsidiary shrine next to the Ananta Basudev Temple by the PWD. Babu Priyanath Chatterji, member-in-charge of the Temple Committee, argued that the smaller shrine had been "mythologically connected" to the Ananta Basudev Temple and complained that its removal "cripple[d] the idea of beauty and congruity" within the temple complex.[30] In turn, the superintending archaeologist complained that the committee had dismantled a Padmeswari temple within the Lingaraj enclosure. The neglect of "obvious formalities" had, claimed archaeologist Albert Henry Longhurst, led the Temple Committee to "feel justified not only in obstructing measures recommended by competent official authority, but also to demolish minor structures on their own account and remove the materials into another compound for use in the restoration of a totally distinct building in no way connected with the one destroyed."[31] Although Longhurst conceded that the committee had cause for protesting the demolition of the shrine near the

of Archaeology, 1918, Kolkata I.I., Temples of Bhubaneswar, Orissa, no. 26, ERC.

[29] The relative prosperity of the Lingaraj Temple had been sufficient to have merited the creation of a Temple Committee under the terms of the Religious Endowments Act in 1863.

[30] Babu Priyanath Chatterji, Member, Bhubaneswar Temple Committee, to Superintendent, Archaeological Survey, Eastern Section, Bengal, 29 January 1911, Government of Bengal and Orissa, Education Department, Archaeology Branch, File VIIIE/5 of 1913, SAO.

[31] A.H. Longhurst, "Conservation Notes on the Puri District", Temples of Bhubaneswar, Orissa, 1911, File no. 26, ERC.

Ananta Basudev Temple, the conservation note which required the destruction of that shrine asked for the dismantling of five further shrines in different enclosures in Bhubaneswar.[32] The destruction was, claimed the superintendent of archaeology in the Eastern Circle, D. Brainerd Spooner, preferable to reconstruction which, incurring the introduction of new materials, would, "destroy in large measure the authenticity of the building."[33] Better, it seemed, to entirely dismantle the building than restore it and destroy its integrity as an antiquity. In what Spooner regarded as a flagrant disregard of this principle, stones from the dismantled Padmeswari Temple were now being used to repair the Lingaraj Temple. The Temple Committee also, he claimed, had felt itself empowered to grant permission for the restoration of the Gauri Temple, close by the Lingaraj Temple, without any reference to government. "[I]t ought to be made legally impossible," he asserted, "for anyone to tamper with the Bhuvaneswar temples without the full knowledge and express permission of Government."[34] This control could only be sought under the terms of the Act and a list of temples was now prepared for the purpose of placing them definitively under the care of the state.

In theory, the temple committees – established by the Religious Endowments Act of 1863 – provided a reliable partner for conservation under the terms of the Act. The extent of the committee's jurisdiction over the various temples in Bhubaneswar, however, was unclear and explicitly questioned by Spooner as superintending archaeologist. A report was commissioned from an Indian revenue officer, the tahsildar of Kurda, B.S. Mardraj, to establish the forms

[32] Ibid.

[33] D.B. Spooner to Secretary of State of Bengal, General Department, 30 January 1911, Government of Bengal and Orissa, Education Department, Archaeology Branch, no. 3, 1913, SAO.

[34] D.B. Spooner to Secretary to Government, Bengal, General Department, 30 January 1911, Temples of Bhubaneswar, Orissa, 1911, File no. 26, ERC.

of custody and usage of fourteen of the Bhubaneswar temples.[35] Mardraj's report found that an "idol" existed in every temple except the Raja Rani and Chitrakarani temples, and that the first six temples on the list – Bhaskareswar, Mugheswar, Brahmeswar, Parasurameswar, Maitreswar, and Sari Deul – were not "used for religious purposes". However, in all but the Sari Deul some attendance was visible for the offering of bhog (food offered to gods) or water libations by temple sevaks.[36] In the case of the Bhaskareswar, Mugheswar, and Brahmeswar, sevaks held a land grant for provision of water libations. Even in the absence of public worship mediated by a pujari (priest), therefore, the presence of a deity was evident from the attention of devotees. The other temples were all "used for religious purposes", and though Mardraj himself provided brief sketches of the claims and practices he found, he recommended that the government address the Temple Committee of the Lingaraj Temple for fuller information.[37]

The subsequent debate over the presumption of custody of the temples under the Act of 1904 illustrates the complexity entailed in the search for a contract for conservation. Under the terms of the Act, archaeological officers acquired control over all repairs but such control did not necessitate the financial responsibility of government. The principal argument made against notification, therefore,

[35] The fourteen temples were: i. Bhaskareswar; ii. Mugheswar; iii. Brahmeswar; iv. Parasurameswar; v. Maitreswar, vi. Sari Deul; vii. Chitrakarani; viii. Rajarani; ix. Sahasaraling Tank; x. Anant Vasudev; xi. Jambeswar; xii. Raitul; xiii. Mukteswar; xiv. Sidheswar.

[36] Sevaks or sebaks were devotees who claimed to be invested with some appointed task or position within established routines of puja. The term is derived from Bengal case law and was used extensively to describe sevaks who claimed a right to care for and obtain a living from the custody of temple and/ or images of gods. See Wilson, *A Glossary of Judicial and Revenue Terms*, 475–6.

[37] Report by B.S. Mardraj, Tahsildar, 8 September 1911, Government of Bengal and Orissa, Education Department, Archaeology Branch, no. 3, 1913, SAO.

was not one of control but of cost. Priyanath Chatterji objected to any agreement which designated the committee as the owner of the temple and therefore liable for the costs of any repairs deemed necessary by the archaeological authorities. He insisted that responsibility for structural repair, as opposed to the management of the temples' affairs, lay fully with government. The endowments held in trust by the Temple Committee, Chatterji insisted, were not meant for repair but only to meet the cost of puja – the care and worship of the deities presiding in the temples. The specifics of ownership were moot, not least in the archives of the state. The only endowment which passed to the committee under the 1863 Religious Endowments Act was that of the Lingaraj Temple. However, the committee had been entered as the owner of twelve temples under the previous revenue settlement. The committee's management of the other, smaller temples in Bhubaneswar had simply been assumed by the committee and government alike. In the context of negotiations over custody for the purpose of registering the temples as monuments, the Temple Committee disclaimed ownership.[38] The Government of Bengal now recommended that the collector assume guardianship over all of the temples. A division of custody would be introduced between the collector and the Temple Committee: the structure of the temples would be controlled and repaired by the PWD under instructions from archaeological officers, and the committee would continue to oversee worship.[39]

This separation, however, presumed far too much, not least the suggestion that custody of the deity and custody of the building over which the deity presided could be neatly divided. The Temple Committee would not cede its control over the temple's physical care even if it refused to meet the costs. What is more, Chatterji wanted reference to the Ancient Monuments Protection Act to be

[38] B.A. Collins, Under Secretary to the Government of Bihar and Orissa, Education Department, to the Commissioner of Orissa Division, 24 August 1912, Government of Bengal and Orissa, Education Department, Archaeology Branch, File VIIIE/5 of 1913, SAO.

[39] Ibid.

avoided in any agreement reached. The costs of repair of the temples, he claimed, should be met by government under the terms of both Act 19 of 1810 (Bengal Charitable Endowments, Public Buildings and Escheats Regulation) and the Religious Endowments Act of 1863, neither of which, he pointed out, had been repealed or superseded by the Act of 1904.

Chatterji's appeal calls to our attention the variant lives of legislation in different phases of the colonial intervention in India. The 1863 Religious Endowments Act was designed specifically to distance the colonial state from religious institutions with which it found itself deeply embroiled. Curzon himself, however, had claimed in the Legislative Council that the 1904 Act was the fulfilment of section 23 of the Act of 1863, a claim which invented an illusion of legislative continuity and consistency.[40]

In 1913, as negotiations over the Lingaraj Temple stalled, Government Pleader G.C. Paharaj offered a solution. He suggested that since no endowment existed to meet the repairs of the temple, the committee's acceptance of the government custody over the temple's fabric was unnecessary.[41] He went even further, questioning the custody of the Temple Committee over even the deity. He argued that government, and not the Temple Committee, were in fact the trustees of the god, Lingaraj. He used the legal concept of *cestui que* trust to define a jurisdiction whereby the god owned the temple but government was legally responsible for it.[42]

[40] A reference to Curzon's speech in the Legislative Council, Rama Ballabh Misra, District Officer, Puri, to Commissioner of the Orissa Division, Cuttack, 16 –17 September 1913, Education Department, Archaeology, Government of Bihar and Orissa, File VIIIE/5 of 1913, SAO.

[41] "The Regulation does not bind down the Government to preserve the temples but defines the policy of the Paramount Power to see to the repair of public edifices erected by the former or present Government or individuals", G.C. Paharaj, Government Pleader, Puri, to Collector of Puri, 13 September 1913, Education Department, Archaeology, Government of Bihar and Orissa, File VIIIE/5 of 1913, SAO.

[42] See Black, *Black's Law Dictionary*, 189. This interpretation elaborated the existing interception of Hindu practices of gifting and the management

Paharaj's interpretation placed the Ancient Monuments Protection Act within a longer tradition of the bond of interdependence and co-patronage between kingly and divine sovereignty in South Asia. The government's claim over custody of the fabric of the temple was legitimated not despite, but by virtue of, divine sovereignty. Indeed, their claim was greater than that of the Temple Committee, the legitimacy of which rested solely in colonial legislation. Paharaj's argument was accepted, and in November 1913 the commissioner of Orissa was declared "guardian" of the fourteen temples nominated under the 1904 Act.[43] However, and despite Paharaj's argument – and despite the fact that devotion took place in the majority of temples taken into custody – the Lingaraj Temple was not included in the list of temples to be notified under the Act but left under the authority of the Temple Committee. In a further measure of compromise, a commitment was made under the terms of the notification that only Hindus would carry out repair or restoration work in temples under worship. This pragmatic commitment was made by E.H. Johnston, a Sanskrit scholar who was an under secretary in the Bengal Government.[44] This listing of the temples as protected monuments was short-lived and in 1918 registration of all but the Raja Rani Temple (in which no tradition of worship existed) had been withdrawn due to differences with the Temple Committee over "appropriate manner of their preservation". The government agreed to finish repair works before handing control over all thirteen temples back to the Temple Committee.[45]

of the gods by the colonial judiciary. See Duff, "The Personality of an Idol", 42–8; Sontheimer, "Religious Endowments in India"; Birla, *Stages of Capital*, Chapter 2.

[43] See footnote 34.

[44] E.H. Johnston, for Under Secretary to Government of Bengal and Orissa, to Commissioner of Orissa Division, 26 August 1915, Kolkata ASI, Temples of Bhubaneswar, Orissa, no. 26, ERC.

[45] Blakiston, *Annual Report*, 30.

In the same year that this protection was withdrawn, two very different reactions, made in two distinct realms of British-Indian administration, were expressed towards the nature of state custody over the temples. As member for education on the Viceroy's Council, Sir Chettur Sankaran Nair recommended an accommodation between the terms of the 1904 Act and the temple authorities, in particular on the matter of restricting entry to Hindus, in order to, he said, "restore confidence" and "to demonstrate the real feelings underlying [government's] policy towards distinguished monuments of the country."[46] Simultaneously John Marshall, as director general of archaeology, expressed his incredulity on learning that worship had been allowed to continue in temples notified under the Act. If temples were government property, he asked, "how is it possible for worship to be resuscitated in them? If they are Government property, they should be fenced round, put under lock and key and a notice put up without delay stating that they belong to Government and are not in use for religious purposes."[47] He regarded the preservation of Bhubaneswar's temples as the first duty of the superintendent of archaeology in eastern India. However, he was convinced that the variety of architectural specimens in the town would allow the exclusion of any temples where worship was carried out from the register of protected monuments.[48] Beyond his presumed division between the divine and the antique, Marshall was preoccupied by the reversal of the work that had been carried out on the Bhubaneswar temples between 1898 and 1902. He had been stung by the architectural historian James Burgess' virulent criticisms of temple repair in Bhubaneswar. In his 1910 revisions

[46] Draft Letter to Chief Secretary of Government and to Director General of Archaeology, 1918, Kolkata ASI, Temples of Bhubaneswar, Orissa, no. 26, ERC.

[47] John Marshall, Director General of Archaeology, to D.B. Spooner, 25 June 1918, Kolkata ASI, Temples of Bhubaneswar, Orissa, no. 26, ERC.

[48] J.H. Marshall, "Archaeological Remains in Bengal, Bihar and Orissa", 28 February 1905, para. 89, D.G.A. Conservation Notes (Bengal and Orissa), File LOT-31, ASI, Kolkata, ERC.

and additions to Fergusson's *History of Indian and Eastern Architecture* (1876), Burgess had contrasted the lack of damage wrought to the temples by "the Muhammadans" to the "sordid proceedings" of the PWD. During Superintending Archaeologist Theodor Bloch's restoration work, carried out in 1902, broken and missing carvings had been replaced by stonemasons, an innovation which incensed Burgess: "It is pitiable to think of the barbarity of 20th century imitations, or supposed – but very inferior – imitations being inserted in these venerable structures."[49] Marshall believed that Burgess' criticism was, at least in part, the result of personal malice. Bloch had "vexed" Burgess in the past and Marshall had refused Burgess access to the Archaeological Department's drawings after he had claimed the work of a superintendent archaeologist as his own at an exhibition.[50] However, Marshall did feel obliged to revisit the repairs and evaluate Burgess' public criticism of the department. If allowed to remain, stated Marshall, the ill-executed repair work would be a "standing monument to the discredit of Government".[51] By 1918, the temples of Bhubaneswar had become not only medieval archetypes but exemplars of the mistakes which could be made in the course of their protection.[52]

Marshall's desire to see the correction of Bloch's 1902 repair work temporarily overcame the need to divide archaeology from worship. At the Lingaraj Temple, the list of repairs was extensive: "Modern wall-paintings and hideous figures of men and beasts, white-washing, new plastering, visitor's names scribbled in charcoal and all such modern accretions inside and outside the temple should be removed. Some sculptural friezes have been wrongly restored;

[49] James Burgess in a footnote to Fergusson's *History of Indian and Eastern Architecture*, vol. li, 104; Bloch, *Archaeological Survey Annual Report*, 45–6.

[50] J.H. Marshall, Director General of Archaeology, to D.B. Spooner, 22 June 1918, Kolkata ASI, Temples of Bhubaneswar, Orissa, no. 26, ERC.

[51] Ibid.

[52] "The mistakes made at Bhubaneswar in copying sculptures and other motifs calling for artistic sincerity certainly must not be repeated": Note by D.B. Spooner, 20 October 1911, File C.154, ASI, Central Provinces and Berar, ERC.

the hands of the image of Ganesa in the southern niche have been misplaced when last restored. This should be set right."[53]

Discussions of the necessary repairs stalled on the question of the Temple Committee's obligations once the works financed by government had been completed. Ultimately, the Government of India refused to sanction money unless the Lingaraj Temple was notified under the 1904 Act.[54] In 1919 the officially perceived recalcitrance of the committee culminated in a plan to use the "scandalous mismanagement" of the Lingaraj Endowments as a means to replace the committee with "something more efficient and more reasonable" for the purpose of pursuing repairs to the temple.[55]

The negotiations and intrigue over the temple's repairs were interrupted in 1920 by the Reforms Scheme, introduced with the aim of slashing imperial expenditure. These wide-ranging reforms significantly increased the powers and responsibilities devolved to provincial governments. They were designed both to save money and garner provincial allies at a time when the imperial government was facing significant and widespread pressure from nationalist resistance. Under its terms, the financial commitments to monuments under the care of the Archaeological Department were frozen and the protection of all unnotified monuments, including the Lingaraj Temple in Bhubaneswar, became a provincial responsibility. This division ended the centralised control of conservation that was fundamental to the 1904 Act.[56]

[53] Conservation Note on the Lingaraja Temple at Bhuvanesvar by K.N. Dikshit, Offg Superintendent, Archaeological Survey, Eastern Circle, 14 July 1919, GoBO, Education Dept, Archaeology Branch, B Proc., Dec. 1921, nos 7–49, SOA.

[54] H. Sharp, Offg Sec. to GoI, Dept. of Education, to Chief Sec., Govt of Bihar and Orissa, 7 February 1919, Proceedings of the Department of Education, Archaeology, and Epigraphy, February 1919, OIOC.

[55] Note on file, 1 April 1919, signed M.M. and Sharp, with newspaper cutting sent by Political Department, Repairs to the Lingaraj Temple at Bhubaneswar and Its Further Maintenance, Government of Bengal and Orissa, Education Department, Archaeology Branch, Dec. 1921, nos 7–49, file XIE/39, SAO.

[56] In 1922 the imperial government sanctioned Rs 2410 for the repairs

Hindu Temples and Conservation

The debate triggered by the repair and conservation of the Bhubaneswar temples drew into sharp focus the tension between Marshall's dictums of archaeological preservation and Hindu rituals of devotion. Early in the second decade of the twentieth century, conservation work was separated from research and made the primary responsibility of the assistant superintendent of archaeology in each circle.[57] The purview of the superintending archaeologists spread over thousands of miles and every order for structural repair and conservation work had, in theory, to be checked and passed by the director general of archaeology from his offices in Delhi and Simla. Executive control of work, therefore, was spread so thinly that the centralised enforcement of the tenets of conservation became impractical. The need for the director general to approve cost estimates and their subsequent passage through provincial government left little time for them to be spent, if they were approved, within the financial year.[58] This bureaucratic impediment was compounded by the reductions on spending imposed on the department and the 20 per cent fee charged on all estimates by the PWD and by the poor opinion many archaeological officers had of conservation work.[59] Although consistently recommended as the "principal work" of the Archaeology Department, scholarly archaeologists regarded it as a distraction from exploration and research.[60] Jean Philippe Vogel, who replaced John Marshall as director general for eighteen months in 1910, made clear

to be carried out, a fraction of the original estimate of Rs 71,000: Spooner, *Annual Report*, 41.

[57] From 1904, the Archaeological Department divided its jurisdiction into "Circles" that covered the whole of British India. These divisions are reflected in the annual reports of the superintending archaeologists, published by the Government of India.

[58] Spooner, *Annual Report*, 2.

[59] Ibid., 2–3.

[60] Henry Cousens, Superintendent of the Western Circle, complained that "crowded out all original exploration". Henry Cousens, Supt Western Circle,

that he regarded conservation work as a distraction, if not a waste of time.[61] The extent to which conservation work was directly overseen by a superintending archaeologist varied enormously and, in practice, the work was divided between the PWD and parties who claimed devotional custody of the temple.

The conservation of temples invariably required some degree of physical intervention, from the clearing of vegetation to the complete dismantling and rebuilding of the structure. The greater the degree of material repair, the greater the potential for what the upper echelons of the Archaeological Department regarded as misjudged conservation. Reading through inspection notes, it becomes clear that contraventions of the proper order of conservation were incessant. The archaeological authorities no more trusted those ordered to carry out sanctioned conservation or restoration work – generally officers of the PWD – than temple managers and devotees who claimed the temples for religious usage.[62] Once structures had been listed as monuments and work carried out, archaeological surveyors were placed in a state of perpetual frustration and dismay. Almost every inspection by the superintendent lambasted what was regarded as incompetent and inadequate restoration. Affronts ranged from the "smearing" of concrete painting across the sculpted surface of the temple, whitewashing (which was condemned by conservation but deemed necessary for temple restoration), and the replacement and re-carving of decorative and iconic sculpture.[63] This last category of repair work provided the

to Sec. to Govt, General Department, 4 April 1907, Proceedings of Government of Bombay, General Department, Archaeology, January 1908, OIOC.

[61] Resolution, Government of India, Department of Education, Archaeology, 22 October 1915, Proceedings of the Govt of Bombay, General Department, Archaeology, 1915, 71–86; Vogel, "Notes by Dr Vogel", 131.

[62] Charges Against the Officers of the Public Works Department in the Central Provinces in Connection with the Conservation of Ancient Monuments , October 1912, Proceedings of the Department of Education, Arch. and Epi., nos 1–2, 1912, 357–60, OIOC.

[63] One Superintendent of Archaeology, Henry Cousens, pointed out that

greatest area of contention. In keeping with the preference for the repair and restoration of categories of monument defined as "Muhammadan" in northern India, Marshall admitted that "the reproduction of geometric designs is sometimes admissible, particularly in living monuments of the Muhammadan epoch."[64] However, in the case of Hindu temples, "[th]e repair of divine or human figures is never to be attempted and that of free floral designs only in very exceptional cases. Empty niches should remain empty, if their images are lost; and the spaces occupied by images in friezes and string courses should, in repaired portions, be left blank."[65]

Reconstruction – to a lesser or greater extent – was inevitable, even if that reconstruction meant only the reinforcement of masonry by the addition of cement. New plaster or masonry was to be stained to achieve an "authentic" appearance. Walls should not, as one conservation note commented, "appear as though they had been coated with sugar."[66] Marshall was very particular in relation to stains to be applied to any new work, supplying his own recipes for use and requiring all applications to be tested by local engineers on stones which could be sent to the archaeologist's office for approval. Ironically, though in keeping with the gulf between Marshall's determination and his ability to control repair work, no evidence exists that this was done.

when the Act specified the requirement of "cleansing" for the purposes of preservation, it would be universally understood in India to require whitewashing. H. Cousens, Supt, Archaeological Survey, Bombay and Berar, to Sec. to Govt, General Department, 8 December 1903, Government of Bombay, General Department Proceedings for the Year 1904 (Archaeology), OIOC; various files, ASI Central Provinces and Berar, ASI Kolkata, ERC.

[64] Marshall, *Conservation Manual,* 25.

[65] Ibid.

[66] J.F. Blakiston, Assistant Superintendent, Eastern Circle, Conservation Note on the Ancient Monuments in and Near Vishnupur, Bankura District, Bengal, 11 July 1915, General Misc. Department, File 9A-20, October 1915, nos 30–105, "Archaeological Remains in the Burdwan Division", SAB.

Dyes recommended to provide repairs with a patina of antiquity included burnt coconut, red oxide, coal-tar dissolved in petrol or turpentine, dhobi nut dissolved in spirit, and liquid glue mixed with powdered charcoal. One of Marshall's recipes, however, when used at Bhubaneswar, was reported to have produced a "bright pinky colour which is as conspicuous as it is unsuitable." Engineers charged with carrying out the work pointed out that "harmonious staining of the repairs is a well nigh impossible task", firstly since the stain tended to wash off in the rains, and secondly because the original builders of the particular temple under conservation, Parasurameswar, used different shades of stone:

> [T]his variated surface must originally have received a uniform coat of colour or paint, otherwise it would have been intolerable from the beginning . . . with the lapse of centuries, this original stain has so largely worn off, that the basic medley of colours is now disclosed, complicated in parts by the varying effects of the colour first applied. There is thus really no prevailing colour for the [Public Works Department] to match and I must acknowledge that short of giving a uniform colour-stain to the entire surface and one thick enough to overcome the variation now existing, I really do not see how aesthetically satisfying results can ever be attained.[67]

Staining, which suited the European conservationist taste for surfaces which *appeared* unadorned, was neither authentic nor practicable. In stark contrast to the "stain" was the prevalent habit of whitewashing surfaces in the service of cleaning and restoration. Marshall loathed whitewashing and orders for the removal of whitewash repeatedly appear in annual inspection notes (sometimes traceable over two decades of inspection notes for the same monuments).[68] Whitewashing, although reviled by Marshall who

[67] D.B. Spooner to Director General of Archaeology, dateless draft, 1911, Temples of Bhubaneswar, Orissa, 1911, File no. 26, ASI, Kolkata, 1904–78, ERC; T. Bloch to Superintending Engineer, Orissa, 5 August 1909, "Archaeological Department, Central Circle, Bhubaneswar", File no. 9, 1900–10, ERC.

[68] "Attempts are Made to Enforce the Removal of Whitewash at the Shiva

described it as "revolting", did enter the lexicon of conserva-
tion techniques. In 1919, a dispute broke out between two archae-
ologists in the Madras Circle as to whether the inclusion of "a few
handfuls of surki and cowdung" acceptably transformed "white-
wash" into "colourwash".[69]

Proper conservation required a reordering of the temple in its
physical environment. If a temple was unused, conservation meas-
ures were carried out in a concentrated expenditure of labour and
money. These measures were specifically designed to make the
temple more conspicuous: by cleaning vegetation and debris from
the area immediately surrounding the temple; by establishing a
clearly demarcated and preferably walled courtyard; by prevent-
ing the incursion of any "everyday" activity around the temple; by
erecting notices warning the public both not to interfere with the
"monument" and, more rarely, by placing bilingual "cultural notice-
boards" which purported to explain the architectural significance
of the temple. Iron gates were erected to protect the garbhagriha
(inner sanctum), and, if possible, the mandapa (an entrance hall ad-
jacent to the garbhagriha).

These concerted attempts to reconfigure the temple as a monu-
ment required the rearrangement of moveable sculpture. No
attempt was to be made, according to Marshall's 1923 *Manual*,
to re-erect fallen or displaced sculptures. Sculptures which were
not fixed within the temple or which were lying in the compound
were to be collected and rearranged according to form and chronol-
ogy on purpose-built platforms, ideally covered and surrounded
by barbed wire and notices. There was an implicit preference for
a single temple to be enclosed within a compound, a taste at odds
with the tendency of additional shrines to accumulate within or

Temple in Deobaloda in Durg District", File C61, ASI, Central Provinces and
Berar, ERC.

[69] Proceedings of the Department of Education, Archaeology and Epi-
graphy, October 1919, 257–8, OIOC.

adjacent to existing temples.[70] Referring to a small Hindu shrine near an eleventh-century Jain temple in Durg in Berar, now in Maharashtra, the conservation notes written by Albert Henry Longhurst urged that "all this rubbish [should be] removed from the compound, together with the object of worship . . . they are of no interest to us and only make the place look untidy."[71] Once conservation work had been completed, funds could be provided for a chowkidar (guard) to watch over the monument and, in theory, regular inspections of the monuments by archaeological officers.

Where sculpted surfaces were damaged, before or after repair, the established policy, advocated in Marshall's *Manual*, was to leave "blanks" as visible interruptions of sculpted surfaces. (Image 3.2 shows a contemporary example of this practice at the Baskareshwara Temple in Bhubaneswar.) These flat stones declared that a temple was the recipient of official conservation rather than popular, devotional repair. The blank stone – monolithic and contrasting very obviously with the sculpted surfaces – embodies the paradoxes of a conservationist practice which combined ostensible aesthetic restraint with both structural interventions and active repression of the mores of those who inhabited the temple as a devotional space. The blank stone is the clearest manifestation of a Protestant conservationist desire to coyly suspend the monument in the present, and defer to the creative genius of the past.

The interplay of fabric (presumed to be original) and additions made during repairs came to the fore in the case of a Mahadeva temple in Gandai (now in the state of Chhattisgarh). The temple was rebuilt entirely by Superintending Archaeologist J.F. Blakiston between 1914 and 1917, but by the 1930s had been returned to devotional use. As part of the rebuilding, extensive sculptural

[70] This is noted by Leslie Orr, "What is a Temple and Who Does it Belong To? Answers for Colonial Madras", unpublished paper, Annual Conference on South Asia, Madison, October 2008.

[71] Conservation Notes by A.H. Longhurst, "Shiva Temple at Deobaloda in Durg District", File C. 61, ASI, Central Provinces and Berar, ERC.

work was carried out by a team of masons from Agra who, "in their enthusiasm" and despite instructions to the contrary, re-carved and replaced missing sculptures. Most of this work was removed and replaced with "blank" stones at the immediate orders of Blakiston. However, one figure on the eastern side of the temple was not spotted until 1937, when the "incongruous" work was ordered to be removed.[72] Despite the determination to detect and remove new sculptural work, the assistant engineer had placed newspapers and coins in the temple's new block foundations when it was rebuilt.[73] This inclusion of concealed but deliberate markers of time provides a fascinating meeting point between the coy historicism of archaeological conservation and the Hindu inclination for self-aware renewal and rejuvenation.

All aspects of temple conservation, although this was rarely explicitly stated, were designed to encourage and enhance a new public gaze. A conserved temple and its associated sculptures were objects to be looked at; a preference at odds with darshan, which requires an interaction between the deity installed in the temple and the devotee. In contrast to the single large-scale interventions which were followed by regular policing and light maintenance, devotion combined, where possible, daily cycles of renewal with the possibility of substantial sponsored rebuilding, augmentation, and restoration.[74] The temple as imperial monument was, therefore, surrounded by people seemingly intent on destroying, altering, and misplacing, or at the very least entirely misunderstanding, the temple.

The directions provided in Marshall's *Manual* assumed that

[72] Letter from engineer who served in reconstruction to G.C. Chandra, Superintendent, Archaeological Survey, Central Circle, 11 June 1937, ASI, Central Provinces and Berar, File C78, ERC.

[73] Ibid.

[74] The episodic renewal of a working temple, generally financed by donation made specifically for that purpose, is known as *jeernodharanam* in Sanskrit and *tirupani* in Tamil.

once a temple was registered, the archaeological authorities operated with unlimited authority to prevent these incursions and to remove any material culture associated with the practices of Hindu devotion. The *Manual* ordered the removal of "modern and undesirable accessories", such as "red lead (*sandur*) or *ghi* . . . lamps, pictures, coloured rags and the like." However, Marshall directed that this was to be done in a manner which did not "offend the religious sensibilities of people who have an acknowledged interest in the building."[75] Such "acknowledged interests" were legitimate *only* if they had been defined and affirmed during the registration of the temple as a monument under the terms of the 1904 Act. Section 5 (2) of the Act did allow for the continuation of worship in notified temples, with the caveat that government would be fully responsible for both the cost and execution of any repairs. In determining the course of conservation on sites where religious activity continued, legislation drew attention to the "now" of the conservationist moment (which archaeological practice tried so hard to negate): if religious practice was ongoing in a structure at the time when it was registered, it could not be halted. However, once a disused temple was registered as a monument, it could not, according to the Act, be restored to religious use. At the moment of conservation, local civil administrators, usually the collector's office, would be charged with compiling a clear description of the extant rights to a temple. In cases where the temple was not in use, these rights were usually invested in local landholders.

There were two principal concerns associated with the ongoing use, or resumption, of buildings for religious purposes after state-funded conservation. The first was that occupation would disfigure the work carried out by the state, corrupting or re-corrupting the form carefully restored by conservation. The second, which chimed with the financial conservatism of the post-reform imperial government, was the possibility that the resumption of religious

[75] Marshall, *Conservation Manual*, 11.

usage would result in the closure of a public monument conserved and opened at government expense. To address the latter concern, a clause was added to agreements in 1922 which required any funds expended by government to be returned on the closure of a monument. This clause was applicable to those cases where the monument could not "be acquired compulsorily by the Government".[76] I have found no archival evidence of the clause ever being enacted. By the 1920s, despite Marshall's insistence to the contrary, antiquity and divinity coexisted and archaeologists shared custody with a range of claims made by temple managers, by sevaks and pujaris (officiating priests).

Far from facilitating the centralised control of monuments – the ostensible purpose of the legislation – the 1904 Act resulted in the terms of nomination and selection for conservation becoming diffuse and localised. The state lost the initiative and was placed in a position which was largely reactive, inspecting temples nominated for repair; investigating proprietorial claims and often rejecting the desired or existing repairs.[77] Temples were nominated for protection by those who saw no contradiction between the financial benefits of state custody and the continuation or resuscitation of religious usage. Beyond the supposed supervision of the director general of archaeology, agreements for protection were formulated which reached pragmatic compromises with local caste-based devotional custodies. As early as 1908, an agreement for conservation of a temple at Buguda, in Ganjam District in the Madras

[76] Director General of Archaeology, to all Superintendents of Archaeology, 11/01/1922, Education Department, Misc., File 9A-28, July 1922, nos B51–3, "Insertion of a New Clause in Agreements for the Preservation of Religious Buildings", SAB.

[77] One extreme example was that of two Shiva temples nominated for protection by Babu Baney Madhub Banerjee of Calcutta. On inspection, the two temples were found to be "utterly worthless structures": D.B. Spooner, Superintendent, Archaeological Survey, Eastern Circle, to Sec. to Government of Bengal, General Department, 22 March 1911, General Misc. Department, File 9A-3, April 1911, nos 148–3, SAB.

Presidency, allowed that public access be limited to "such classes as are by the Shastric injunctions or by custom entitled to admittance."[78]

Official anxieties about the reintroduction of religious use at conserved sites were expressed in terms of corruption and creeping contamination. At the beginning of the twentieth century, before the passage of the Act, Bodh Gaya in Bihar was held as an example of an instance where conservation had been followed by the assertion of "spurious Hindu worship".[79] The temples of Bhubaneswar and Konarak were considered to be at particular risk in eastern India.[80] At Konarak, the navagraha (the lintel from the side of the Sun Temple) was regarded as a vulnerable target for rededication and worship. The sculpted lintel, weighing over twenty-four tonnes, had been moved some distance away from the Sun Temple in the late nineteenth century in an aborted effort to appropriate it for the India Museum in Calcutta. The stone was subsequently covered with a shed to protect it from the weather and to act as a museum for the sculpture.[81] Restoring the lintel to its proper place as part of the temple structure was in keeping with the principles of proper restoration. However, the stone was, by the first decade of the twentieth century, subject to worship within the shed and

[78] Board of Revenue (Land Revenue) to C.J. Weir, Commissioner of Land Revenue, 3 January 1908, ASI Kolkata, File 1B-102, Ganjam District, ERC.

[79] On the dispute over the conservation of Bodh Gaya, see Lahiri, "Bodh Gaya", 33–43.

[80] Governor of Bengal, General Department, to Archaeological Surveyor, Bengal Circle, 25 August 1903, General Department Proceedings, August 1903, nos. 273–6, Conservation and Preservation of Archaeological Remains, Re-occupation and Misuse of Mosques, SAB.

[81] The lintel was decorated with the nine planetary deities. The plan to move the stone in 1867 rested on borrowing one of the cars used at the Jagannath Festival in Puri. Lt G. Nolan, Executive Engineer, Poree Division, to A.G. Crommelin, Superintending Engineer, Cuttack Circle, 4 May 1866, Government of Bengal, General Department, General Proceedings, nos 18–20, August 1867, 10–11, SAB.

moving it back to the unused temple risked the restitution of worship, through contamination, at the main temple site.[82] After the Sun Temple was notified under the Act in 1915, a complaint was received from the sevaks who attended the navagraha stone. They claimed a continuity of tradition with the use of the principal temple and complained that their access to the stone was being impeded by the Archaeological Department. The chowkidar employed by the Archaeological Department had previously opened the shed to the pujari and facilitated the entry of visitors whose interest in the museum's exhibits crossed from secular tourism to pilgrimage.

The colonial authorities objected to this custom and could produce (their own) documentation which stated that in 1896 the temple of Konarak had been listed as "entirely deserted, i.e. not in the custody of anybody." The collector of Puri, R.E. Russell, advised extreme caution in the treatment of the Brahmans officiating over the worship of the navagraha stone lest the Archaeological Department find it transformed, effectively, into a temple.[83] A formalisation of the arrangement, to prevent the priest from being occasionally locked out, would, it was feared, transform the museum into a temple and risk the exclusion of non-Hindus. However, no suggestion was made that the priests should be excluded from the museum. The collector of Puri described the worship as "an anomaly according to the Hindu ideas", given that it sidestepped the need for mahasnana (a purification ceremony) of the shed where the stone lintel was stored. Worship was therefore "irregular and improvised".[84] The magistrate of Puri, Mr Deb, also categorically rejected the claims of the sevaks, using a restricted

[82] Secretary to Government of Bengal, General Department, to Archaeological Surveyor, Bengal Circle, 25 August 1903, General Department, Misc., August 1903, nos 273–6, SAB.

[83] R.E. Russell, Officiating Collector of Puri, to Commissioner of Orissa Division, 8 February 1921, Government of Bihar and Orissa, Education Department, Archaeology Branch, December 1921, nos 50–71, SAO.

[84] Ibid.

definition of what could, or should, be subject to Hindu worship. "The Navagraha images," he wrote, "are no more worshipped than the outrageously obscene images on the walls of the temple . . . These are not 'Thakurs' [Lords] but evil spirits and are never worshipped by Hindus."[85]

Regardless of these attempts by Hindu officers of government to undercut the sevaks' claims by reference to orthodoxy, the colonial state could not marshal the precepts of Hinduism in the same way that they could (even impotently) deploy the claims of scientific archaeology. The converse, however, was not the case. The petition of the navagraha sevaks claimed that "the images will be more carefully preserved by our worship, by application of butter which keeps the stone images in better condition than if they were left untouched."[86] Both the formalisation and refusal of the right of the pujaris to enter the museum were potentially treacherous. At length, and in keeping with the habits of colonial administration, no decision was taken. The position of the archaeological authorities on the question of re-use was one of nervous fragility. In cases where re-use seemed probable or imminent, the only course of action available to the Archaeological Department was physical closure of the temple, using iron grilles, and the surveillance of the temple by a chowkidar (though as with the case of the navagraha stone, this was no guarantee that access would be restricted).[87] If, despite these measures, the temple was reinhabited by a deity and

[85] Magistrate, Puri, to Commissioner, Orissa Division, 4 March 1915, Government of Bengal, Education Department, Archaeology, September 1915, nos 1–61, SAO. A note by J.C.B. Drake comments that Deb's opinion "probably represents the facts but his views on matters of this kind have, perhaps, to be treated with caution."

[86] Sebaks of Navagraha Thakurs, Kanarak [*sic:* spelling in the original], to Chief Secretary to Government, Bengal and Orissa, 3 February 1915, GoBO, Education Department, Archaeology, September 1915, nos. 1–61, SAO.

[87] For example, that of the Sita Devi Temple, Deorbija, in Durg District, Conservation Note, Deorbija Temple, 13 November 1951, File C63, Central Circle, Patna, 1937, ERC.

puja instituted, there was nothing the authorities could or would do to prevent the sacralisation of the temple.

The case of a temple (listed then, as now, as "Stone Temple") in Garui in District Burdwan, Bengal, illustrates the inability of the Imperial Department to measure its authority against Hindu devotion. When the Garui Temple was declared protected in 1924, no worship was "in evidence".[88] Four years later, in 1927, "owners" of the temple were registered under the terms of the Act and declared their intention to reinstall an image in the temple after the Archaeological Department had completed repairs.[89] In 1932, villagers in Garui gifted a piece of land containing a well to the Archaeological Department. The gift was made on condition that the well was included within the temple compound and a gate constructed to give the villagers free access to the site, "enabling the petitioners to use the water for the purpose of worshipping the 'Deity' to be reinstalled in the temple."[90] The removal and reinstallation of the idol was placed within a longer historical narrative. After the construction of the temple, the deity had been stolen and the temple damaged in the mid eighteenth century Maratha bargi (mounted soldiers) raids.[91] When the family who originally endowed the temple regained their fortune, a new Vishnu was acquired but was worshipped in the homes of the temple sevaks. The sevaks now made clear that they regarded the repair works undertaken by the PWD, on behalf of the Archaeological Department, to be readying the temple for the reinstallation of the idol.[92]

[88] Spooner, *Annual Report*, 111.

[89] K.N. Dikshit, Conservation Note on the Temple at Garui, District Burdwan, 6 June 1928, File no. 99, 1931–48, ASI, Kolkata, ERC.

[90] Dibakar Mukherjea, for villagers of Garui, to Collector of Burdwan, 8 March 1932, File no. 99, 1931–48, ASI, Kolkata.

[91] The bargi were mercenaries employed by Raghuji Bhosale in his attacks on eastern India in the mid eighteenth century. The raiders are a recurrent feature in memories concerned with place and migration in eastern India: for example, see Chakrabarty, "Remembered Villages".

[92] Collector of Burdwan, to Superintendent, ASI, Eastern Circle, 8 July 1932, File no. 99, 1931–48, ASI, Kolkata, ERC.

In 1935 the sevaks complained directly to the Archaeological Department that those repairs to the temple were still wanting: the "interior needs complete cleaning, plastering and white-washing where the crest . . . requires a pointed 'iron Trident'." The same petition requested a copy of the agreement made in 1927 and stated it had given them the right "to re-instal our 'Deity Vishnu' in the said Temple just after its completion." Within a year, permission was given by the superintendent of the Archaeological Survey for the reinstallation of the idol within the temple.[93]

In a little over ten years, then, the stated policy of the Archaeology Department, that a dead temple could and must stay beyond the reach of devotion, had not only been reversed, but the work of the department had been appropriated, indeed commandeered, to the purpose of speeding the reinstallation of the deity and the resumption of worship.

In 1932 the Sewara community of Kharod, having raised Rs 500 for its repair and maintenance, petitioned for the return of the Savari Temple in Bilaspur (now in the state of Chhattisgarh). The temple had been declared protected in 1917 and ownership was assumed by the commissioner on behalf of government. The petition claimed that in the fifteen years government had had responsibility for the temple, the repairs had been inadequate. The commissioner of Bilaspur capitulated and entered into an agreement with the Sewara community for the temple's maintenance without any reference to the Archaeological Department. A year later, in 1933, the archaeological surveyor, on seeing the repairs carried out on behalf of the Sewara community, described them as "sickening" and "hideous" and asked for the "stolen" warning notice board to be replaced.[94]

The conservation carried out under the hybrid ordinances of

[93] Superintendent, Archaeological Survey, Eastern Circle, to District Magistrate, Burdwan, 13 January 1936, File no. 99, 1931–48, ASI, Kolkata, ERC.

[94] Archaeological Surveyor, Central Circle, to Secretary of Government, Central Provinces, Public Works Department, 13 July 1933, File 20/1915, ASI, Central Provinces and Berar, ERC.

central legislation and district authority provided a constant source of outrage to archaeological officers on their occasional tours during the second and third decades of the twentieth century. Marshall's purist and Edwardian determination to invigilate all works carried out was based on his well-evidenced conviction that much conservation activity transgressed both the letter and spirit of the conservation manual. However, by the 1930s a broad symmetry evolved between monumental and devotional protection. The dissonance between conservation and worship decreased as appointments into the Archaeological Department allowed devotion to be incorporated into the work of archaeological engineering. Provincial practices necessarily included negotiations with sevaks, temple managers, and donors.

A significant reversal was made in the arrangement of the sculptural assemblage of the temple. Whereas previously such fragments were to be stored nearby but emphatically outside the temple, by the early 1940s loose sculptures were to be gathered and stored within temples.[95] In 1941 N.K. Karandikar from the Poona Archaeological Department spent two months overseeing a scheme for the repair of temples in Bastar. After a long and largely technical report on the conservation of the Mama Bhanja Temple in Barsur he reported, under the heading "Final touches to the work done", that "On the 21st of May, the Shrine room was thoroughly washed clean and the image of Ganesh was placed on a seat of concrete slab with due sacred sence [*sic*] and ceremony." Karandikar does not specify whether he observed the formal ritual of ashtabandhanam (installation), but he clearly regarded the re-dedication of the temple as the proper work of the department. He then tidied the compound and left the site on 23 May after "offering my prayers to God Ganesh for his having blessed me in safely executing my assigned duty."[96] There is nothing to suggest that Ganesh would have any connection

[95] K.P. Sarathy, for Home and Judicial Member, to Sub-Divisional Officer, Danteswara, 17 September 1943, File C63, Central Circle, Patna, 1937, ERC.

[96] "Descriptive Report of the Conservation Work to Mama Bhanja Temple at

with this temple before a Marathi Brahman archaeologist over-
saw the temple's repair and renewal.

Karandikar's work at the nearby Narainpal Temple included the
provision of an "ornamental seat for the image of Sree Vishnu". He
observed in his report his suspicion that the lack of a plinth for the
God suggested that the "proper ceremony" of Pran Pratistha (con-
secration) had not been carried out, noting also the absence of Garud,
Vishnu's bearer. The creation of such a "massive architectural con-
struction" without "a simple but prominent seat for the image to be
worshipped," Karandikar concluded, "is an unusual and incom-
prehensible thing to the Hindu mind."[97] He also suggested dispens-
ing with the notice board at repaired temples, quite reasonably doubt-
ing that "people take least notice of it".[98]

Karandikar's alterations, and effective re-dedication, were hardly
out of place in the history of temples in South Asia. The Archaeo-
logical Department had merged into the history of successive in-
terventions and modifications of the medieval Hindu temple.
At the start of the twentieth century, the tenets of conservation were
held to be implacably opposed to the aesthetics of Hindu worship.
Forty years later, those rules could be transformed into a vehicle
for Hindu devotional practice.

A new Ancient Monuments Act was passed in 1958. The new
Act reordered but did not repeal its predecessor. One fundamental

Barsur . . . by N.K. Karandikar, Poona Archaeological Department, April and
May, 1941", for repairing Mama Bhanja Temple at Barsur along with its corres-
pondence, papers, etc. and conservation and protection to temples of Bastar,
no. 14, 1941, Archaeological Survey of India, Central Province and Berar,
ERC.

[97] N.K. Karandikar, Report of the Special Repairs carried out at the Narain-
pal Temple at Narainpal during 14 January to 12 March 1942, File no. 14/1941,
Archaeological Survey of India, Central Province and Berar, ERC.

[98] N.K. Karandikar, to State Engineer, Bastar State, Kagdalpur, 27 January
1942, no. 14/1941, Archaeological Survey of India, Central Province and Berar,
ERC.

difference was the removal of the distinction – and order of prece-
dence – assumed by the earlier Act to exist between antiquity and
religion. The 1958 Act made the state, through the local collector,
responsible for the prevention of "pollution or desecration" in a
place of religious worship covered by the Act.[99] The new Act re-
ordered the two competing orders of veneration; returning full
sovereignty over the temple to the deity.

Conclusion

The Ancient Monuments Protection Act and John Marshall's
Conservation Manual attempted to graft the aesthetic codes of
metropolitan conservation onto India. Protestant aloofness from
the material mediation of devotion made it conceivable and de-
sirable to set apart material antiquity from the present. In India,
the spartan conservationist aesthetic had little, if any, cultural
purchase and state-enforced rules of conservation held little ap-
peal for the majority of Hindu donors. The project of conserv-
ing Hindu temples from religious practice was so futile that it was
immediately compromised. Conservation might be considered a
"predatory . . . recollection", to borrow Arjun Appadurai's term.[100]
However, not only did conservation fail to exert any authority
over the material practices of Hinduism in temples where archa-
eological custody was claimed, the interventions of archaeologists
could precipitate the renewal of living devotion and divine sover-
eignty. Archaeological conservation expressed the imperial state's
ambition to set aside the material remains of India's past from,
if on behalf of, its present. However, rigid codes of conservation
collided and were submerged beneath the more flexible but abso-
lute sovereignty of the Hindu deity.

[99] *The Ancient Monuments and Archaeological Sites and Remains Act, 1958.*
[100] This term is Arjun Appadurai's and describes recollections which are
"premised on the idea that for them to subsist something else must go." Ap-
padurai, "The Globalisation of Archaeology and Heritage", 44.

The next chapter continues to explore the agility of Hindu devotional materials and spaces. It examines the social, religious, and political claims that accumulated at Hindu shrines during the turbulent municipal and nationalist politics of inter-War Delhi. Hindu shrines that had been violently displaced to make way for the new imperial capital in the second decade of the twentieth century returned to the new capital and emerged as markers of resistance against a flagging imperial state.

4

Siting and Inciting Shrines in
the City of Delhi

The Shiv Mandir Dispute

O N THE MORNING of 9 September 1938, Munawar Ali
approached a small area within Queen's Garden, a pub-
lic park located between Chandni Chowk (the old city's
commercial artery), the newly completed New Delhi Railway Sta-
tion, and the Town Hall (the seat of municipal government). The
site had gained notoriety as the "Shiv Mandir", a temple dedicat-
ed to the god Shiva. Regarded as an encroachment by the municipal
authorities, it had been established in early August by a lone san-
yasi (mendicant devotee) called Shampuri. He had established
a small makeshift structure and been joined by chelas (disciples)
who undertook puja with him. Soon after his arrival, a campaign of
Civil Disobedience had been launched by the Sri Mandir Raksha
[Defence] Committee to protest against the government's attempt
to remove the shrine. Groups of satyagrahis (civil disobedience vol-
unteers) drew on Gandhi's model of courageous resistance and
courted arrest by participating in puja at the temple site.[1] This cam-
paign of resistance had ended just days earlier, after an agreement

[1] E.M. Jenkins, Chief Commissioner, to J.A. Thorne, Sec. to Govt of India,
Home Dept, 25 August 1938, Encroachment by a Sadhu Known as Sham-
puri in the South-Eastern Corner of the Queen's Garden . . . Home Dept,

was reached under government arbitration. Under the agreement, devotional activity at the site would continue in a curtailed form: the shankh (shell horn) would not be blown and the gharhial (bell) would not be rung; no more than five people would visit the site at any one time and visitors to the mandir would not participate in worship.

It was as a member of a small group of permitted devotees that Munawar Ali made his way to the site. On reaching it, he stabbed Shampuri in the neck with a knife.[2] News of the attack spread quickly and precipitated widespread disturbances at the shrine site and in nearby Chandni Chowk, one of the city's busiest public markets. The police charged a crowd of hundreds that had gathered close to the Town Hall.[3] The army was called out and armoured cars were mobilised. At Queen's Garden seventeen devotees attempted to erect a fence to define and defend the temple, which was hurriedly dismantled and removed by the police. The Mandir Raksha Committee, organisers of the satyagraha, now declared a hartal (mass strike) in the city. In response, the chief commissioner of Delhi placed Queen's Garden under Section 144 of the Code of Criminal Procedure (1898), an emergency measure which prevented anyone from approaching or occupying the area under dispute and making illegal the gathering of five or more people in the whole of Queen's Garden. Sadhu Shampuri, who had been taken to Irwin Hospital, was banned from entering the

Political File no. 4/6/38, 1938, NAI; "22 More Arrested", *Hindustan Times*, Saturday 27/08/1938, 4, col. 4.

[2] E.M. Jenkins, Chief Commissioner, to Rai Bahadur Harish Chandra, 10 Sept. 1938, Demolition of an Alleged Temple in Queen's Garden near Municipal Committee, Delhi, Chief Commissioner's Office, Local Self Government Branch, no. 1044/1938, DSA.

[3] Copy of Notes Recorded on the 9th September 1938; Report Written by F.?. Evans, 21 Nov. 1938, Encroachment by a Sadhu Known as Shampuri in the South-Eastern Corner of the Queen's Garden . . . Home Dept, Political File no. 4/6/38, 1938, NAI.

old city. From his hospital bed, the sadhu made it clear that he regarded any arrangement for regulating devotion at the site as "nonsense".[4] On 27 September, having left hospital and attempting to return to the temple site, he was arrested in Sadar Bazar, two kilometres west of the gardens.[5] He had been accompanied from the hospital by a sub-inspector of police, Sardar Gurdit Singh, who had repeatedly reminded the sadhu of the risks of entering the limits of the old city.

After his arrest Shampuri claimed he knew nothing of the order banning him from the old city, had no recollection of his journey, indeed he remembered nothing between his departure from hospital and arrival in jail. On his release the sadhu sought and received refuge in the Hanuman Temple on Irwin Road (now Baba Kharak Singh Marg) and maintained his refusal to acknowledge the orders of the state. For over a year after his arrest and subsequent retreat into the Hanuman Temple, repeated attempts were made to issue him with the order forbidding his entry into the Delhi Municipality or Fort Notified Area. Shampuri refused to accept or sign the order, which was instead signed by compliant witnesses and pinned near his residence at the temple.[6]

Immediately after the attack, with Chandni Chowk silent and a strong police presence around the Town Hall, rumours began to circulate about what had been found at the now cleared and heavily guarded space of the temple.[7] The structure on the site was levelled, and the sadhu's belongings removed in the late afternoon of

[4] E.M. Jenkins, Chief Commissioner, to Rai Bahadur Harish Chandra, 10 Sept. 1938, Demolition of an Alleged Temple in Queen's Garden near Municipal Committee, Delhi, Chief Commissioner's Office, Local Self Government Branch no. 1044/1938, DSA.

[5] *Hindustan Times,* 30/09/1938, 5, col. 5–6.

[6] Shiv Mandir Agitation (Action under Sec. 144 C.P.C. and the Punjab Criminal Law Amendment Act 1935), Deputy Commissioner's Office, Delhi, 28/1941, DSA.

[7] E.M. Jenkins, Chief Commissioner, to J.A. Thorne, Sec. to Govt of India, Home Dept, 10 Sept. 1938, Encroachment by a Sadhu Known as Sham-

10 September, the day after Munawar Ali attacked him. The next day the *Hindustan Times* reported that upon digging at the site the police (though it is not clear why the police would have excavated) discovered four murtis (devotional idols): one marble idol of Brahma and three Shiva murtis. Jenkins, the chief commissioner of Delhi, insisted that no murti had been removed from the site while splitting hairs about what was described by the term.[8] The idols seized on 9 September were, he claimed, "'pocket pieces' a few inches high which were probably brought by visitors and some of the seventeen sadhus."[9] Jenkins' flimsy distinction between "pocket pieces" and "idol" rested on the assumption that an idol had the capacity to authenticate the existence of a temple, which mere "pocket pieces" could not. However, rumour and contestation filled the small space of Queen's Garden more effectively than the makeshift platform Shampuri had briefly assembled. The objects rumoured to have been found created a transcendent spatial claim. The rumoured presence of the idols beneath the temple site drew on the Shaivite tradition of the pindi and swayambhu – spontaneous eruptions of divinity. In the context of the dispute they also offered quasi-archaeological post-facto physical proof of the site's legitimacy as a devotional space.

The rumours of these divine emergent objects transcended the specifics of the locality – of the sadhu, the encroachment, and the municipality – to create a far greater scale of Hindu nationalist affront. Petitions, resolutions, and representations were now received from across northern India protesting against the removal

puri in the South-Eastern Corner of the Queen's Garden . . . Home Dept, Political File no. 4/6/38, 1938, NAI.

[8] R.M. Maxwell, Reply to Question by Bhai Parma Nand, Legislative Assembly, 30 August 1938, Proposed Motions for Adjournment . . . Home Dept, Political Branch File no. 24/13/38, 1938, NAI.

[9] E.M. Jenkins to J.A. Thorne, 19 Sept. 1938, Encroachment by a Sadhu Known as Shampuri in the South-Eastern Corner of the Queen's Garden . . . Home Dept, Political File no. 4/6/38, 1938, NAI.

of an idol from the site. Hindu Mahasabha members of the Leg-
islative Assembly met government officers in Simla to press for
sustained devotion at the site.[10] By 18 September, within ten days
of the attack on Sadhu Shampuri, even the Government of India
adhered to this idea of the temple when the Home Department
suggested that the chief commissioner of Delhi provide an alter-
native site for the temple – a temple which, at that moment, did
not exist.[11] Feeling his authority questioned by the Government
of India, the chief commissioner remarked, "Remember, please,
that I am dealing with fanatics and crooks."[12]

The Shiv Mandir dispute represents a climactic episode in a se-
ries of disputes over space in the rapidly expanding cities of Delhi,
both old and new, in the inter-War period. This chapter explores
Hindu shrine sites as part of an urban fabric during the two
decades that preceded the notoriety of the Shiv Mandir case, the
divine emanation of lingams, and the chief commissioner's incre-
dulity. Inter-War Delhi offers a significant case study to explore
Hindu shrines within the dynamic urban politics of an imperial
city. Delhi possesses a rich subterranean life of latent and poten-
tial pasts; ready to be rediscovered and reanimated in the present.
Here I explore a series of disputes in which community identities
were asserted in defence of devotional sites. The meaning of these
shrines was animated within new structures of municipal gov-

[10] The Mahasabha proposed a set of compromises if worship could contin-
ue: that no more than five people would attend worship; that the time for arti
be fixed after sunset to avoid coinciding with prayers at the nearby mosque,
and that the shankh and bell selected for use would be of the "'smallest size'".
R.M. Maxwell, 2 Sept. 1938, Encroachment by a Sadhu Known as Shampuri
in the South-Eastern Corner of the Queen's Garden . . . Home Dept, Political
File no. 4/6/38, 1938, NAI.

[11] H.J. Frampton for J.A. Thorne, to Jenkins, 18 Sept. 1938, Encroachment
by a Sadhu Known as Shampuri in the South-Eastern Corner of the Queen's
Garden . . . Home Dept Political, File no. 4/6/38, 1938, NAI.

[12] E.M. Jenkins to J.A. Thorne, 19 Sept. 1938, Encroachment by a Sadhu
Known as Shampuri in the South-Eastern Corner of the Queen's Garden . . .
Home Dept, Political File no. 4/6/38, 1938, NAI.

ernance, the assertion of nationalist criticisms of the legitimacy of
the imperial regime, and a politics of affront that mobilised reli-
gious identity and sensitivity in the city.

Lost temples offered spaces and materials around which com-
munity-based claims to religious property could be amplified, tran-
scending the temple's immediate urban environs and political
context to become part of a larger movement.[13] In inter-War Delhi,
the protection and recovery of the Shiv Mandir was pulled into a
larger Hindu politics that expressed itself through a defensive, be-
leaguered majoritarianism; a rhetoric of reclamation and restora-
tion of lost identity, pride, and status. The conclusion of this book
will return to the theme of lost temples using the case of the Ram-
janmabhoomi Temple in Ayodhya, now being newly constructed.

In inter-War Delhi, and subsequently in Ayodhya and elsewhere,
political movements crystallised around the idea of submerged
materials of Hindu devotion. In these movements, the rumoured
existence of such objects provides a potent currency around which
to build resistance. Displaced and concealed fragments of the
divine are used to prove the pre-existence of divinity in that speci-
fic place, sanctioning claims to these spaces as reactive and re-
demptive rather than innovative and aggressive.

A large number of disparate Hindu shrines were displaced dur-
ing the brutal and swift land clearances that preceded the plan-
ning and construction of the new city after 1913. The bureaucratic
order of colonial archaeology, in keeping with its preference for
Islamicate remains (discussed in the previous chapter), ensured that
no temples were deemed to possess the necessary historic or aes-
thetic worth to be defined as monuments.[14] In the face of this im-
perial preference, erudite attempts were made to constitute Delhi
as a "sacred city" using the place-name Indraprastha to create an
ancient Hindu genealogy for it. Banke Rai Goswami, author of the
Ancient History of Indraprastha (1911), together with Rai Bahadur

[13] For an account of the dispute see Baul, "The Improbability of a Temple".
[14] Sutton, "Gordon Sanderson's 'Grand Programme'", 78.

Lala Sheo Pershad and his father, successfully lobbied the chief commissioner for the recognition of a Vishnupad on the ridge in 1914. Delhi's chief commissioner, W.M. Hailey, agreed that a wall could be erected around the stone, creating an enclosure of 10 ft square. However, he added a condition that spoke of the anxiety over the spontaneous capacity of Hindu shrines to emerge: "no settlements of fakirs etc." were "to grow up round the stone".[15] According to Mahamahopadhyaya, the footprint was created to commemorate the Rajsuyayajna, a sacrificial rite described in the Mahabharat celebrating the god Krishna.[16] The tablet placed at the site wove together Hindu divinity, ancient Hindu sovereignty, and British authority:

> This footmark was engraved in the holy ancient and glorious land of Indraprastha (Delhi) which our Gracious Emperor George V has also been pleased to convert into the Imperial Capital once more glorious in memory of Lord Krishna, in consequence of which the whole of this hill came to be called Vishnupad [. . .] which is about 1600 years old and according to which the pillar was set up on the Vishnupada hill.[17]

The Vishnupad created a minor dispute between local antiquaries when Rai's identification of the site was disputed by Saroje Nath Bagchi, who believed the footprint to be a Bhimpad rather than a Vishnupad. The commissioner's office responded to the dispute with only faint interest, one official commenting that "this may yield us some harmless amusement."[18]

[15] W.M. Hailey, Chief Commissioner to H.T. Keeling, Chief Engineer, 27 April 1914, Walling Round of a Stone on the Ridge by Permission to Mahammahopadhya P Banke Rai, Chief Commissioners B Procs, Jan. 1914, Education Proceedings, no. 148, DSA.

[16] *Morning Post*, 24 May 1914.

[17] Discovery of the Footprint Called "Bhimpad" on the Delhi Ridge, C.C. Education, File no. 164, 1916, DSA.

[18] Notes on File, 2 May 1916, Discovery of the Footprint called "Bhimpad" on the Delhi Ridge, C.C. Education, File no. 164, 1916, DSA.

Beyond these sceptical and scholarly lobbies, by the 1930s networks had emerged within a turbulent urban politics that made prachīn (ancient) shrine sites the focus of new claims to a public politics of community. Shrines emerged, in materials and imaginaries, to become disputes that threatened public order. These shrines offer an important means to explore social antagonism over urban space during this period. The Shiv Mandir dispute, like others in the 1930s, incorporated a "communal" aspect, quarrels expressing corporatist distrust between Hindu and Muslim interests and identities. The suggestion that these sites could provoke violence between Hindus and Muslims escalated local disputes into city-wide and even national causes. The possibility of communal antagonism had immediate resonance in the ears of colonial officials convinced of the latent and perpetual state of tension between religious communities. This chapter argues that the potential for escalation, regardless of appeals made to the local government, quickly dissipated in the majority of cases as the complex energies of the city absorbed and deflected the rhetoric of one-dimensional antagonisms over a particular site. The urban poor, both Hindu and Muslim, who populated the localities in which altercation was manufactured, were generally only briefly susceptible to the rhetorical provocations occasioned by these disputes. However, the expectation of violence was a useful resource for local political entrepreneurs, who used it to focus the attention of colonial officers.

The colonial state, for its part, assumed that mere physical proximity of Hindu and Muslim created a communal tinderbox, an assumption that those political actors whose mandate depended upon the claim to represent a sensitised and beleaguered corporate identity were quick to affirm. I am particularly interested in the fluidity of Shiva's divinity. Shiva can manifest spontaneously as an eruption from the ground, as a swayambhu, a capacity that provided ample opportunities for creation and the dissipation of disputes. As a divinity, Shiva is deft, adaptable, and not especially

suited to the ironclad and inflexible predispositions of communal violence or its proponents. This imminent potential of Shaivite divinity to erupt from below the surface of the city found particular potency in Delhi, a city replete with fragmented and submerged histories.

The Cities of Delhi and Temples as Rubble: The Removal of Shrines

In 1857 Delhi, as the seat of the Mughal emperor, became the epicentre of the rebellion that swept across northern and central India. After a brief restitution of Mughal order, the British retook Delhi in September 1857 and began a counterinsurgency of extraordinary violence. The population of the old city was expelled by official orders or fled the violence unleashed by soldiers of the British government. In the subsequent urban development, security remained the pre-eminent colonial concern. In the 1860s and 1870s hundreds of inhabitants were displaced as railway lines were constructed and roads widened. The Town Hall and, nearby, Delhi's first railway station, were constructed in the 1860s in the centre of the old city, west of the Red Fort.[19]

Popular resistance had led to the movement of the capital of British India away from Calcutta, the city that had been the seat of the East India Company and later British imperial authority since the mid eighteenth century. The decision to create a new capital at Delhi had been made after decades of increasingly popular resistance in Calcutta. The new capital was completed only in 1931, a mere sixteen years before India won independence. The period in which the capital was constructed was marked by a recalibration of colonial arrogance: from a post-War determination that British authority in India could be extended indefinitely to an increasing reliance on reactive violence and suppression that, in turn, eroded the colonial state's credibility.

[19] Gupta, *Delhi Between Two Empires*, 28–30, 84.

A great number of Hindu shrines were made to disappear during the establishment of the imperial city. The creation of the capital at Delhi had been announced amidst the ostentatious ceremonial display of the Delhi Durbar of 1911, a mass ritual designed to enact and celebrate the paramount authority of the British Crown. The power required to clear the space in order to build the new city was of a more immediate kind. The project of land acquisition was a swift and brutal exercise of authority over nazul (state-owned) land. Renters on nazul land could leave voluntarily with compensation or be evicted under the terms of the 1894 Land Acquisition Act. Temples, valued at Rs 10 per square metre for the purposes of compensation, presented rather insignificant parts of the landscape being cleared for the establishment of the new capital, especially as the colonial state braced itself for litigation on a scale which, warned the deputy commissioner "cannot be foretold".[20] The clearance of land was undertaken as swiftly as possible in order to minimise the costs of mandatory compensation; a government officer warned in December 1911 that "speculation in land in the neighbourhood of Delhi has already begun, and consequently that every day's delay will result in enhanced prices."[21]

The land was divided into five blocks in order to be reconstituted for the provision of the bureaucratic, commercial, and residential sectors of the new city. Each block was surveyed and a table prepared listing "Religious Buildings Under Notified Acquisition Area".[22] This tabulation included crude assessments of

[20] Divisional Supt, North West Railway, to Land Acquisition Officer, 21 Feb. 30, "Acquisition of Shiv Temple of L. Bindraban in Paharganj by the Railway", D.C. File no. 8, 1922, DSA; Deputy Commissioner to Carlyle, 6 Short Street, Calcutta, 5 Jan. 1912, "Acquisition of Land for Imperial Delhi, Preliminary Papers Referring to the Area Notified", D.C. File 39, 1912, DSA.

[21] Sec. to GoI, Home Dept, to Chief Sec., GoP, 16 Dec. 1911, "Acquisition of Land for Imperial Delhi, Preliminary Papers Referring to the Area Notified", D.C. File 39, 1912, DSA.

[22] J. Addison, Special Land Acquisition Officer, 7 November 1912, List of

significance, based on size, repute, antiquity, whether abadi (land officially allotted for public purposes), and the size of the public which frequented these shrines. Risk was also calculated. Land acquisition officers were instructed to carefully "ascertain the amount of feeling" which might be provoked by the acquisition and removal of any temple.[23] Officers were nervous about the physical inspection of these sites, fearing that any attention paid to them would "start the people on the line of claiming religious sanctity for old ruins" for the purposes of "making money or raising difficulty".[24] In the vast majority of cases, the temples inspected and tabulated were categorised as being of only "some" or "no" importance.[25] The assigned insignificance of temples was augmented by the belief that temples were inherently moveable. The secretary of the Imperial Delhi Committee, de Montmorency, stated in 1912 that compensation and relocation would be unproblematic in the case of Hindu shrines:

> the general idea of the villagers whom I consulted seems to be that when the village is acquired the people will take away with them the object of worship in the temple, *e.g.* pingam [*sic*], idol, etc., etc. When this has been taken away the religious character of the building will disappear, and the people say that there will be no religious or sentimental feeling against our knocking down the building.[26]

Religious Buildings Under Notified Acquisition Area and Order etc. on Miscellaneous Buildings, Deputy Commissioner File no. 15, 1912, DSA.

[23] Memo, "List of Religious Buildings under Notified Acquisition Area and Orders etc. on Miscellaneous Buildings", D.C. File 15, 1912, DSA.

[24] R.H. Craddock, 26 March 1912, Preservation of the Old City Walls and Other Historical Monuments and Gardens at Delhi, Dept of Education, Archaeology and Epigraphy Branch, Procs, July 1913, nos 1–6, NAI.

[25] "List of Religious Buildings Under Notified Acquisition Area and Orders etc. on Miscellaneous Buildings", D.C. File 15, 1912, DSA.

[26] G.F. de Montmorency, 16 March 1912, Preservation of the Old City Walls and Other Historical Monuments and Gardens at Delhi, Dept of Education, Archaeology and Epigraphy Branch, Procs, July 1913, nos. 1–6, NAI.

The scenario in which de Montmorency consulted with villagers is lost to us but the official designated Land Acquisition Officer, Addison, agreed, adding that he was "not inclined to believe that the murtis cannot be removed."[27] In contrast, Muslim shrines were assumed to be fixed in place: "We may explain that as far as mosques in use and out of use and graveyards are concerned, we intend to wall them in and leave them, merely keeping them sanitary and free from brushwood, but not allowing access to them by the general public. In regard to temples where the object of worship has been removed and the building is of no aesthetic value, we intend to demolish them."[28] In either case, the sacred could be made amenable to the authority of the state; people would either move on or be shut out.

The authorities became considerably less blithe about the destruction of small shrines by the beginning of 1913, and in April, in response to "the fierce light of publicity" being thrown on demolitions, the chief commissioner forbade the demolition of any religious structure without his written orders. In a measure which could only serve to draw more light towards the possible destruction of religious sites, this official, together with "the local notables and a surveyor", would personally inspect all "graveyards, tombs, *satis*, mosques, dharmsalas, gurdwaras, shivalas and temples" scheduled for removal.[29] The process of destruction was given further bureaucratic elaboration by the separation of the "historical" and "devotional" significance of these structures. The list

[27] Note on File, J. Addison, P.A. to C.C., 26/3/13, Petition of L. Srikishandas & Others Regarding the Acquisition by Govt of Certain Temples for the New Capital, April 1913, Chief Commissioner Records, Home, no. 93, DSA.

[28] E.F. de Montmorency, 16 March 1912, Preservation of the Old City Walls and Other Historical Monuments and Gardens at Delhi, Dept of Education, Archaeology and Epigraphy Branch, Procs, July 1913, nos 1–6, NAI.

[29] W.M. Hailey to H. Wheeler, 12 August 1913, Question of the Treatment of Mosques, Temples and Tombs in Connection with Land Acquisition Proceedings at Delhi, Home, Public, August 1913, no. 36, NAI.

of "all objects of archaeological interest" was divided under three heads: "Ancient monuments which are of Historic Interest"; "Religious Buildings now in use which are of more than local repute"; and "specially sacred tombs and recognised graveyards". All other religious structures and tombs would be acquired and demolished.

The first category, "Ancient monuments which are of Historic Interest", consisted almost entirely of Islamicate structures but included one temple, "Chaudan Gupta's temple".[30] The lists were sent to Gordon Sanderson, Superintendent of Muhammadan and British Monuments, and to John Philip Vogel, Superintendent of Buddhist and Hindu Monuments. The bureaucratic structure of colonial archaeology had been formulated according to religious chronologies at the beginning of the twentieth century. Vogel's jurisdiction – objects, remains, and structures classified as Buddhist or Hindu – was subject to a chronological corset. Worthy antiquities under his remit were not generated after the fourteenth century. With a few exceptions, antiquities deemed as originating from after the fourteenth century were classified either as "Muhammadan" or British and therefore subject to separate bureaucratic oversight. Sanderson returned the list, pointing out that his purview included only the first category: "Muhammadan". Vogel reminded the Delhi deputy commissioner that he was only concerned with "ancient monuments of historic interest" and demurred to Sanderson's decision on the "official" and definitive list of monuments to be preserved.[31] And with that "Chaudan Gupta's temple" vanished from the registers of Delhi's antiquities. The impossibility of a Hindu monument in Delhi was

[30] H.C. Beadon, Dep. Commissioner, Delhi District, to A. Meredith, Commissioner and Superintendent, Delhi Division, 27 May 1912, Preservation of Certain Monuments in New Imperial City, D.C. File 44, 1912, DSA.

[31] George Sanderson, Supt Muhammadan and British Monuments, Northern Circle, Agra, to Dep. Commissioner, Delhi, 4 June 1912; J. Ph. Vogel, Supt Hindu and Buddhist Monuments, to Dep. Commissioner, 12 June 1912, Preservation of Certain Monuments in New Imperial City, D.C. File 44, 1912, DSA.

a conclusion foregone, according to the classificatory practices of the colonial state. Neither Sanderson nor Vogel was prepared to comment on the second list of "Religious Buildings now in use which are of more than local repute", which did include several temples.

The imperial tendency for tripartite division, as evident in Fergusson's classification of Hindu temples, the organisation of antiquities under the Ancient Monuments Protection Act, or, indeed, Zeffri's racialised schematics of architecture was evident in the classification of structures in Delhi. The classification of religious institutions in the notified areas of the new capital area included one of preservation; one of certain destruction; and, in between, the least certain but most significant category, "Those which we should acquire, but which we should endeavour to preserve if possible."[32] This category, and others like it that characterised the imperial administration of forests, agriculture, peoples, and politics offered the greatest latitude for discretion and inconsistency in procedures that were ostensibly based on a set of rules.

Following mandatory acquisition, destruction, or displacement, therefore, was the most common outcome for temples that lay on the land required for the new city. Land Acquisition Officer Addison assumed that all "large and important religious buildings" would be acquired by government and the majority destroyed. He allowed, however, that some might be "left intact after acquisition on account of any very special reason."[33] In these cases, the space occupied by shrines was acquired as land and the temple valued and compensated as malba – that is, the value of the standing temple as a composition of rubble.[34] The acquisition of

[32] Memo, "List of Religious Buildings Under Notified Acquisition Area and Orders etc. on Miscellaneous Buildings", D.C. File 15, 1912, DSA.

[33] J. Addison, Special Land Acquisition Officer, 7 Nov. 1912, List of Religious Buildings Under Notified Acquisition Area and Order etc. on Miscellaneous Buildings, Deputy Commissioner File no. 15, 1912, DSA.

[34] Memo, "List of Religious Buildings Under Notified Acquisition Area and Orders etc. on Miscellaneous Buildings", D.C. File 15, 1912, DSA.

land and malba is a curious articulation of the bureaucratic ima-
gination. The temple, left standing in its original location, had
been, as it were, expunged. The temple continued to exist only as
moveable malba (rubble) at the discretion of government.

This discretion was exercised over the malba of two temples
dedicated to the god Bhairon – the Kilakari Temple in Indra-
prastha which adjoins the outer wall of the fort (Purana Qila), and
another in Alipur Pilanji. Both temples stood on government land
and the malba of both structures was acquired, or at least paid for,
by government. After protests over this compulsory acquisition,
the government issued assurances that while the temples were now
wholly owned by government, no intention existed to prevent
devotion at either site.[35] Concerned petitioners were assured that
some effort would be made to preserve the structures but that no
guarantee could be made to this effect.[36] This apparent solution
made the Delhi government the landlord of both temples and led
to Addison, the official who had brokered the agreement, being
sharply reminded that the colonial government had, in 1863,
framed legislation precisely to avoid any form of control or over-
sight over religious institutions.[37] The Kilakari Temple near the
Purana Qila remains one of the largest and most significant tem-
ples in South Delhi.

In only one case did the commissioner's office not consider ap-
propriation and displacement: the Hanumanji Temple at Jai-
singhpura, which stood on land acquired from the maharaja of Jai-
pur.[38] The deal concocted between government and the maharaja

[35] Petition of L. Srikishandas & Others Regarding the Acquisition by Govt
of Certain Temples for the New Capital, April 1913, Home, no. 93, DSA.

[36] Memo, "List of Religious Buildings Under Notified Acquisition Area and
Orders etc. on Miscellaneous Buildings", D.C. File 15, 1912, DSA.

[37] Note by Special Pleader, 21 January 1913, DSA.

[38] G.F. de Montmoreney, Personal Assistant to Chief Commissioner, to
Land Acquisition Officer, Delhi, 28 March 1913, "List of Religious Buildings

for Jaisinghpura (west of Connaught Circus, now Rajiv Chowk), was complex and ambiguous. The value of the land was calculated with considerable care. Compensation was not paid directly, however, but instead the matter was passed to the Political Department, the department which oversaw the princely states, to be negotiated with the maharaja. The purchase involved the relocation of three temples and the preservation of a fourth. Following "long and delicate negotiations", the 28.12 acres and all rights associated with the Barai, Chhota Hanumanji, and Chattarguptaji temples were acquired. The temples were then demolished and relocated to government land, free of rent, in Paharganj in 1914 (where they remain).[39] As an extraordinary favour to the maharaja of Jaipur the Hanuman Temple was permitted to remain in situ and, sixteen years later, provided sanctuary to Sadhu Shampuri.

Almost as soon as the compulsory acquisition of shrines slowed in the second decade of the century, the question of the establishment of temples arose as new communities formed in the city. In 1917, the Delhi government had agreed to give rent-free grants of land to the "poorer classes" for the establishment of temples precisely because of the difficulty of identifying enduring corporate bodies which would pay rent. The deputy commissioner observed that in these cases:

> The applications often emanate from an indeterminate body [. . .] There is little continuity of interest or connection with the building on the part of any one set of persons . . . Among the richer Hindus it is possible to lease a site for a temple to a particular man and he and

Under Notified Acquisition Area and Orders etc. on Miscellaneous Buildings", D.C. File 15, 1912, DSA.

[39] Chief Commissioner's Office to Sir Edward Maclagan, Sec. to GoI, Dept of Commerce and Industry, 26 February 1914, Acquisition of Land Belonging to the Maharaja of Jaipur in Jaisinghpura and Madhoganj in the New City, C.C. Procs, Foreign Dept no. 7, 1914, DSA.

his heirs will be ready to undertake the responsibilities for ground rent; but this is not possible where a poor community . . . come forward with an application for a site for a temple.[40]

Creating Temples and Negotiating New Publics

Land grants for temples were overseen directly by the chief commissioner of Delhi, were to be inalienable, and were not to exceed Rs 500 in value. This pragmatic acceptance spoke of the anxieties and problems associated with popular religion in the city. The religious observances of the city's poor were regarded as inherently risky, unstable, riven by factionalism, and prone to disturbance. Temples would appear on unoccupied land and disused temples were subject to reoccupation and extension. The local authorities could only take lengthy legal action and the one-off event of police clearance would often, if not invariably, be followed by reoccupation.

Colonial officials encouraged the creation of management committees and preferred to settle matters relating to the occupation of temples with Hindu organisations.[41] These organisations represented bodies through which – the city authorities hoped – the ad hoc and localised occupation and extension of temples could be managed and spatially disciplined. A land settlement with one recognised body was preferable to the unregulated de facto use of the site and periodic evictions. The Sri Mandir Raksha Committee (which was to become particularly active during the Shiv Mandir dispute) and the Hindu Sanatan Dharam Sabha,

[40] G.F. de Montmorency, Deputy Commissioner to W.M. Hailey, Chief Commissioner, 18 April 1917, Scheme for a Western Extension of Delhi City, Chief Commissioner, A Procs, Education Dept, October 1917, no. 4, DSA.

[41] Young, had unsuccessfully asked Rai Sahib Madho Pershad to form a committee to oversee the Jogmaya Temple in Mehrauli, "Leasing of Land Outside Jogmaya Temple to R.S.L. Madho Pershad at Mehrauli", D.C. File no. 38, 1920, DSA.

both high-caste orthodox bodies, claimed the right to oversee all temples in the city. The superintending engineer, Mohammed Solaiman, remarked in the 1930s that his own preference was to deal with the Sanatan Dharam Sabha, the more "clubbable" association, his judgement reflecting a particular sensibility of the city: the sabha's offices were located in New, rather than Old, Delhi, and "the office bearers . . . being mostly Government servants are easily accessible and more amenable to reason."[42] This sabha and others like it offered the government a means of getting temples acquired during the land clearances off their hands. For example, the Hanuman Temple at Feroz Shah Kotla had been acquired as malba by the government in 1914 but in 1940 was given on a perpetual lease with a "peppercorn [nominal] rent" to the Delhi Hindu Provincial Sabha by the Delhi Improvement Trust.[43]

However, these organisations had a complex relationship with the city's authorities. They required recognition as the pre-eminent representative body of Hinduism and, in turn, could mobilise that authority to protest against government interference or infringement. The traction of the associations that claimed to be entitled to regulate religious architecture in the city also threatened, quite openly, to be the means through which popular religious sentiment could be mobilised to challenge government. The Hindu mahasabhas and Sanatan Dharam sabhas were keen to make mobility and sanctity incommensurate, overturning the assumptions that had guided the earlier clearances of shrines. The establishment of New Delhi Railway Station in the mid to late 1920s resulted in a series of disputes over the preservation of both sacred sites and

[42] Khan Bahadur Mohd Solaiman, Supt Engineer, to Chief Commissioner, 4 May 1938, Complaint Against Restrictions Imposed by the Land and Development Officer on the Use of the Temple Situated in Mauza Khushak, New Delhi, Chief Commissioner's Office, Local Self Govt, Branch File no. 702, 1938, DSA.

[43] Leasing of Land in Ferozshah Kotlah for Hanuman Temple, Chief Commissioner's Office, Local Bodies, File no. 1 (76), 1940, DSA.

public access to them. In 1924 the Shri Indraprastha Sanatan Dharam Mandal protested against the enclosure of *"Teliwara Shrines,* Temple, Samadhies, Well and Pipal tree within the Railway Boundary wall, [and] thus preventing free and sufficient access to the said sacred places and thereby depriving the Hindus to perform their religious rights which they had been doing on this spot from ancient times."[44] The following year, the Sri Mandir Raksha Committee lobbied the railway authorities for the protection of and permission to repair a dharamshala and sati stone (marker of the site of a historic widow immolation) which stood on *c.* 14 square feet of land due to be appropriated for a railway colony in Paharganj. The railway authorities gave permission for repairs to be carried out on the sati stone "as it is looked upon as a sacred monument (like a grave) and is to be preserved."[45]

By the 1920s, then, the civil authorities were in no position to displace temples. Instead, the government might pay for a shrine site to be walled in, ostensibly to prevent encroachment and protect its own land interests in the vicinity.[46] New claims were made to defend shrine sites in which immobility hinged on two claims: ancient usage and the evocation of a single Hindu public that was, or could be made, sensitive to any threat to a site. In 1922 Lal Brindaban, the owner of a Shiva temple on Qutab Road, successfully avoided the removal of his temple during the creation of New Delhi Railway Station. He mounted a three-pronged ap-

[44] Shri Indraprastha Sanatan Dharam Mandal, Delhi Province, Pati Ram Street, to Chief Commissioner, 14 September 1924, Applications Regarding Railway Encroachments on Temple Land in the New Capital Area, Chief Commissioner's Office, B File no. 103, Home Proceedings, 1924, DSA.

[45] "Papers Reg. Sati Mandir", D.C., 1925, File 11, DSA.

[46] Chairman, Delhi Improvement Trust, 27 August 1946, Providing Compound Wall Round Satti Mandir in Daryaganj South Scheme, Chief Commissioner's Office, L.S.G. 1(142), 1946, DSA; Complaint Against Restrictions Imposed by the Land and Development Officer on the Use of the Temple Situated in Mauza Khushak, New Delhi, Chief Commissioner's Office, Local Self Govt Branch File no. 702, 1938, DSA.

proach, appealing first to the strictures of religious practice: "the idol of Shivaji once established cannot be removed to another place"; second, to antiquity: "As our King Emperor is called the defender of faith I do not expect that the image of god Shivaji should be removed that was placed long ago by my ancestors"; and third, to the threat of public disorder: "The Hindus in general will not like that the image of Shivaji be removed from one place to another."[47]

The last insinuation, the threat of public disorder by "the Hindus in general", was pivotal in most appeals made to the state. These shrines were no longer isolated sites but instead articulated nodes in a single Hindu geography of the city. The "Hindus in general" was a category made meaningful in umbrage by organisations recognised, albeit in some desperation, by the colonial state. This appeal was premised not on an a priori social antagonism but upon a strategy of engagement with the colonial state which was nervous to the point of paralysis when dealing with the proximity of Hindu and Muslim sacred sites. For example, in May 1929, the pujari of another temple on Qutab Road agreed to move on condition that his temple was allocated a larger plot on the same road. The chief commissioner stalled this, because the allotted land was next to the grave and shrine of Takia Din Ali Shah, a Muslim shrine. The deputy commissioner urged a speedy resolution: "Each fresh site considered or selected means fresh negotiations with the railway authorities and the pujaris of the so-called mata temple, and the latter open their mouths wider on each occasion."[48] When the commissioner's office finally acquiesced it

[47] Brindaban, Government Contractor, Gowal Mandi, to Deputy Commissioner, 16 March 1922; 15 Aug. 1922 and 13 September 1922, "Acquisition of Shiv Temple of L. Bindraban in Paharganj by the Railway", D.C. File no. 8, 1922, DSA.

[48] J.N.G. Johnson, Deputy Commissioner, to Chief Commissioner, 18 Nov. 1929, Sale of Nazul Land on the Qutab Road to the N.W. Railway for the Transfer of the Mata Temple to Another Site, Chief Commissioner's Office, Railway Dept, B File no. 16, 1929, DSA.

was with the sharp proviso from the deputy commissioner that, "if for any reason whatsoever I find them troublesome in that locality I shall not hesitate to move them again."[49]

This schoolmasterly warning was spurious. In the months that had fallen between the original proposal being made and initially accepted by the pujari, the situation had changed: by the middle of 1930 the pujari refused to move the temple at all. His apparent recalcitrance was, according to the tahsildar, a senior revenue officer, due to the "present political movements".[50] In an attempt to force an agreement, the railway authorities blocked the path to the shrine which lay across North Western Railway land.[51] The dispute continued for several years and, despite the government finding proof in the land acquisition records that the temple did not predate the new city and was constructed after the land was acquired for the railway, it found no way of settling the question of the temple's ownership and laboured under the assumption that the pujari, if forced, would "induce the Hindus to create troubles".[52]

Rumour and Divine Emergence

The potency of emergent divinity found considerable opportunity amid the rapidly transforming physical and social geography of the city. During the second half of the 1930s a whole series of rumours spread of the excavation or appearance of divinity. At the

[49] J.N.G. Johnson, D.C. Note on File, 29/11/29, Exchange of Land to Behari for Temple at Qutab Road (North West Railway), D.C. Records, 1928, file 77, DSA.

[50] J.M. Mazis [?], Tahsildar: Nazul, 2/5/30, Exchange of Land to Behari for Temple at Qutab Road (North West Railway), D.C. Records, 1928, File 77, DSA.

[51] Ibid.

[52] Govt. Pleader, Note, 16/4/1934; Notes on File, 11/7/35, Exchange of Land to Behari for Temple at Qutab Road (North West Railway), D.C. Records, 1928, File 77, DSA.

close of 1935, for instance, stories circulated that the submerged remains of a Hindu temple had been unearthed during excavations for the foundations of new barracks at the city kotwali (police station) near Chandni Chowk. On 24 December a crowd of two hundred gathered around the station shouting, "Hindu dharma ki jai" (victory to Hindu dharma), and that evening between five and six hundred people gathered at a meeting at the Queen's Garden.[53] The superintendent of police maintained that the structure was a long-disused hamam or the basement of a Mughal building. However, the rapid removal of the remains, carried out on the day before, on 23 December, was asserted as proof that the structure had been a temple. The colonial authorities were accused, therefore, not only of concealing the temple but of having deliberately destroyed it to prevent worship. A petition bearing 5000 signatures was submitted, representing the "Hindu citizens of Delhi", which offered the evidence of "hundred [*sic*] of people who are prepared to swear that the building in question is a temple in their opinion."[54] The matter dissipated as quickly as it had gathered steam and no further protests took place, though it was the subject of a question in the Legislative Assembly in April 1936.[55]

The brief but dramatic kotwali "temple" case highlights two characteristics of these disputes: firstly, a pre-emergent divine dwelt in unseen substratums of the city; and secondly, the assertion of religious authority which drew on a presupposition of hostility

[53] Senior Supt of Police, 31/12/1935, Alleged Excavation of a Hindu Temple in the City Kotwali, Delhi, C.C. Office, Home Dept 1936, no. 4(96)B, DSA.

[54] Petition, submitted by Lala Vishan Swaroop Ji, Coal Merchant, Katra Barian, Delhi to C.C., 30 Dec. 1935, Alleged Excavation of a Hindu Temple in the City Kotwali, Delhi, C.C. Office, Home Dept, 1936, no. 4(96)B, DSA.

[55] Question No. 1903, April 1936, "Question in the Legislative Assembly Regarding the Remains of a Hindu Temple Discovered in the City Kotwali, Delhi", C.C. Office, Legislative Dept, C File 47, 1936, DSA.

on the part of the colonial government of Delhi towards popular sacred spaces. In 1937 a series of petitions complained that a piao (a drinking-water stall) which lay on the Chawri Bazar side of the Jama Masjid (the city's largest mosque) was being gradually and secretly converted into a temple. The *Dinnunia* newspaper reported on 26 December the "Mischief of making a Mandir under the Jamma Masjid." A petition claimed that several attempts had been made over the previous years to gradually transform the piao from a bamboo stall beneath a peepal tree to a permanently occupied temple.[56] The petition also claimed that, some years before, three days before Muharram, a picture of a pig had been drawn on the southern wall of the piao facing the Jama Masjid. Before a picture of the pig could be taken, the wall was covered over with coal tar. An image of a goddess had now been painted onto the side of a newly plastered hut, a photograph of which accompanied the petition.[57] If the authorities did not act, the petition warned, "a fierce and horrible communal clash between Hindus and Muslims of Delhi is imminent."[58] A tahsildar, Kali Ram, was sent to inspect the site. He could see no changes in the dimensions of the piao since its measurement in 1934, when a previous dispute had been

[56] Petition, Submitted by Inhabitants of the Surrounding of the Jama Masjid, Chitliqabar, Machchiwalan, Chooriwalan, Chowri Bazar, Daryaganj, Egerton Road, etc., 29 November 1937, C.C. Office, Misc/LSG, File B7, 1937, DSA.

[57] This photograph is, frustratingly, not in the Delhi State Archive file that contains the original petition. Petition, Submitted by Inhabitants of the Surrounding of Jama Masjid, Chitliqabar, Machchiwalan, Chooriwalan, Chowri Bazar, Daryaganj, Egerton Road, etc., 29 Nov. 1937, Complaint from Certain Mohammadan Citizens Regarding Encroachments at the Hindu Piao at the back of Jama Masjid, Chief Commissioner's Office, Misc/LSG File no. B 7 (1937), DSA.

[58] Petition, Submitted by Inhabitants of the Surrounding of Jama Masjid, Chitliqabar, Machchiwalan, Chooriwalan, Chowri Bazar, Daryaganj, Egerton Road, etc., 29 Nov. 1937, Complaint from Certain Mohammadan Citizens Regarding Encroachments at the Hindu Piao at the Back of Jama Masjid, Chief Commissioner's Office, Misc/LSG File no. B 7 (1937), DSA.

settled.[59] The piao, claimed the chairman of the Delhi Improvement Trust, consisted of a grassy fenced area: "there is no temple on the site, or pictures of goddesses or pigs."[60] The piao stood on land that had been confiscated by the government and converted into nazul, state-owned, land after the revolt of 1857. The mosque itself had been returned to a committee of Muslims in 1862 and the Masjid Committee had been asking for the return of the precincts for some time. This return was made more urgent, according to the committee, by the city authority's failure to prevent the conversion of the piao into a temple.[61]

At the start of 1938 a representation further escalated the dispute by introducing another structure nearby. The letter complained that a sabil (like piao, a source of drinking water associated with Islamicate architecture) had been removed from the land around the Jama Masjid.[62] The tahsildar, Kali Ram, who reported that there was no sign of a goddess on any of the walls of the piao or significant structural changes, was accused of having "a strong and secret hand in the Piao-Sabil affair."[63] The piao, a source of water for any and all regardless of faith, became a "thing of Hindus" which the government now protected at the expense

[59] A.P. Hume, Chairman, Delhi Improvement Trust, to Chief Commissioner, 15 Jan. 1938, Complaint from Certain Mohammadan Citizens Regarding Encroachments at the Hindu Piao at the Back of Jama Masjid, Chief Commissioner's Office, Misc/LSG File no. B 7, 1937, DSA.

[60] Ibid.

[61] A.P. Hume, Chairman, Delhi Improvement Trust, to E.M. Jenkins, Chief Commissioner, 5 March 1938, Piao Near the Jama Masjid, Chief Commissioner Office, 75-c, 1938, DSA.

[62] S. Abdul, to Chief Commissioner, 10 Jan. 1938, Complaint from Certain Mohammadan Citizens Regarding Encroachments at the Hindu Piao at the Back of Jama Masjid, Chief Commissioner's Office, Misc/LSG, File no. B 7, 1937, DSA.

[63] Copy of Kali Ram, Tahsildar's Report, 16 December 1937; S. Abdul, to Chief Commissioner, 10 Jan. 1938, Complaint from Certain Mohammadan Citizens Regarding Encroachments at the Hindu Piao at the Back of Jama Masjid, Chief Commissioner's Office, Misc/LSG File no. B 7, 1937, DSA.

of Muslims and at the risk of violence: "this triffle [*sic*] affair . . . will be a serious Hindu–Muslim riot in the very near future . . . the responsibility of all damages towards lives, trade and peace will be on the shoulders of the Local administration."[64]

The officers of the colonial state, indifferent to the hostility expressed towards the government by participants in each of the disputes, chose to cast their own role as that of dispirited rationalists forced to arbitrate between two fractious antagonists. Although the sensibility of the religious community "at large" and the possibility of violence became the currency of appeals to the state over disputed religious sites, communal violence was not an end point which the civil authorities sought to avoid at all cost. Violence – and particularly communal violence – strengthened the position of the state. I want to explore this point by returning to the Shiv Mandir affair, a dispute which took place soon after, and was in the locality of, the disputes at the kotwali and the Jama Masjid.

At the Shiv Mandir in Queen's Garden, the rumoured presence of a mosque, the Masjid Nawab Said-ud-Doula, transformed the religious geography of the dispute, just as the rumoured sabil had done at the Jama Masjid. Image 5.1 shows a diagram "which makes no pretence at topographical accuracy", produced for the chief commissioner's office to illustrate the proximity of the two sacred sites either side of the Town Hall. There was evidence that the mosque had existed in the early nineteenth century but that it had become dilapidated after 1857 and disappeared, leaving only "a barren plot of land".[65] Regardless, by 19 August 1938 the dispute

[64] S. Abdul, to Chief Commissioner, 10 Jan. 1938, Complaint from Certain Mohammadan Citizens Regarding Encroachments at the Hindu Piao at the Back of Jama Masjid, Chief Commissioner's Office, Misc/LSG, File no. B 7, 1937, DSA.

[65] Hafiz Mohammed Said, Advocate to Sec., Central Govt, Dept of Education, Health and Land, GoI, 15 Oct. 1938, Demolition of an Alleged Temple in Queen's Garden Near Municipal Committee, Delhi, Chief Commissioner's Office, Local Self Government Branch no. 1044/1938, DSA.

was described in the press as a "temple–mosque question".[66] Petitioners complained that "[t]he sight of a Sadhu indulging in his idol worship day and night provokes the Mussalmans to say Azan and Namaz on the site", a claim (or threat) which played very deliberately upon the Delhi government's anxieties about the occupation of public land by sacred encroachments.[67] In October 1938 an advocate, Hafiz Mohammed Said, claimed that the site was waqf property – land held in trust by an Islamic institution – and that "the Mussalman[s] of Delhi have on occasions been visiting and saying their prayers on it."[68] No credible legal claim for waqf existed, something the advocate must have known. However, Said turned waqf into a property of the land itself, a remnant and proof of the occupation of the site by a mosque. The presence of a rumoured mosque created a triangulation between the colonial state and the two mutually antagonistic communities. It was a triangulation that served, effectively and exclusively, the interests of political entrepreneurs whose claims rested on the protection of "their" communities.

As a threat, it beckoned the arbitration of the state. If violence broke out, as in the stabbing of Shampuri and the subsequent localised riots, then the state could immediately impose extraordinary measures of control. This relationship between authority and violence is not a theorisation. It was made explicit by government officers. Ten days before Shampuri was stabbed, the chief commissioner of Delhi, Jenkins, had met with representatives, or rather protagonists, of the Hindu and Muslim communities – Advocate Harish Chander and K.B. Haji Rashid Ahmed –

[66] *Hindustan Times*, Friday 19/08/1938, 4, col. 5–6.

[67] Memorial, 13 September 1938, Representation by the Muslims Against the Occupation of the Site Adjacent to the South Eastern Gate of the Queen's Garden, Delhi . . . Home Dept, Political Branch File no. 5/13/38, 1938, NAI.

[68] Hafiz Mohammed Said, Advocate to Sec., Central Govt, Dept of Education, Health and Land, GoI, 15 Oct. 1938, Demolition of an Alleged Temple in Queen's Garden Near Municipal Committee, Delhi, Chief Commissioner's Office, Local Self Government Branch, no. 1044/1938, DSA.

to broker an agreement to avoid communal violence (something he privately regarded as inevitable). Negotiations had broken down.[69] The same day, Jenkins informed the Government of India of his intention to arrest the sadhu. The government's response is revealing. It suspected that Shampuri's arrest would provide "tactical advantage" to the agitators. It was preferable to allow, in Secretary to Government Thorne's words, "some heads [to be] broken", after which the sadhu's arrest could be justified as an act of reactive arbitration.[70] In fact, no communal violence took place to reinvigorate the Delhi government's authority. But the currency of religious violence was spent on all sides.

The Delhi authorities desperately wanted the Shiv Mandir to be recognised as an illegal encroachment, assuming that this judicial decision would lead to the collapse of popular protests as the work of "fanatics and crooks". Yet at every stage the state's intervention had acted to amplify the significance of the site. The civil court case initiated by the municipality in 1938 augmented and solidified the disputed site's historical and judicial dimensions. At the court case, Shampuri was able to connect the site to a historical geography of displacement by claiming to be a descendant of the gurus who had built a thakurdwara (temple) in the Kucha Natwan that had been displaced years before.

The idea of the Shiva temple offered a space through which the credibility of the colonial authorities could be attacked. Ganpat Rai and Harish Chander, both prominent nationalist advocates, were involved in a number of temple disputes, including the Shiv Mandir, and arguably, their interest was less pious than nationalist.

[69] E.M. Jenkins, Chief Commissioner, to Rai Bahadur Harish Chandra, 10 Sept. 1938, Demolition of an Alleged Temple in Queen's Garden near Municipal Committee, Delhi, Chief Commissioner's Office, Local Self Government Branch no. 1044/1938, DSA.

[70] J.A. Thorne, Secretary to Government, Home Department, to E.M. Jenkins, 31 August 1938, Encroachment by a Sadhu known as Shampuri in the South-Eastern Corner of the Queen's Garden . . . Home Dept Political, File no. 4/6/38, 1938, NAI.

Political journalism in the city emphasised not devotional sensitivity but the consistently heavy-handed and oppressive nature of the colonial government. A *Hindustan Times* editorial contrasted the rapid and sensitive actions of a Hindu municipal commissioner at a disputed temple site in Karol Bagh, in the west of the city, to the crass, provocative insensitivity of the Delhi government in dealing with the Shiv Mandir.

The amplification and elaboration of the Shiv Mandir dispute, however, led to discord. The Mandir Raksha Committee overplayed its hand in seeking to align its protests with broader currents of nationalist resistance. The annual session of the Indian National Congress was held in Delhi in October 1938 and, after the committee's overtures to the Congress to take some position on the dispute were firmly rebuffed, the Mandir Raksha Committee threatened to disrupt the opening procession. This challenge led to a public rebuke by Subhas Chandra Bose, president of the session, who stated that the Mandir Committee had no right to describe its protest as satyagraha. The range of voices articulated through the Shiv Mandir dispute also stretched it beyond a single socio-religious movement. For example, a group of Dalits – low-caste Hindus – brought a murti of Ashtbhuja Devi from a temple that had been destroyed in Sabzi Mandi to a meeting held in early August after the Delhi authorities had first attempted to clear the land.[71] Given the feelings of the orthodox Sanatani devotees who populated the temple committees about caste and caste hierarchy, a common cause was never likely to be brokered between such different Hindu publics.

The particular and spontaneous properties of Shaivite devotion, the most common form of Hinduism in the city, played a crucial part in these stories. How do we consider the cosmic culture

[71] The hartal was held on 6th August. E.M. Jenkins, Chief Commissioner, to J.A. Thorne, Sec. to Govt. of India, Home Dept, 12 Aug. 1938. Encroachment by a Sadhu Known as Shampuri in the South-Eastern Corner of the Queen's Garden . . . Home Dept, Political File no. 4/6/38, 1938, NAI; "Another Temple Demolished", *Hindustan Times*, Sunday 7/8/1938, 6, cols 3–4.

of Shiva in historical and political terms? A murti can be understood merely as a surrogate for human agency; the association between shrines and land grabbing is urban bourgeois lore. However, this lore conflates result and purpose. Not all small shrines grow: shrines can as easily be swept aside before they can acquire any locational gravity. Spatial traction relies entirely upon a social reaction that at least matches and then defies any constraints placed upon it. The popular credibility of these emanations derived from a dynamic social fluidity of space and social information in the city. By far the most fascinating aspect of these disputes is the rapidity with which a space could be transformed and remade.

These urban conflicts in which emergent divinity challenged the official regulation of space demonstrate a significant relationship between the urban poor and what might be described as the politics of emergent divinity, or rather emergent divinity which is made political. The political tumult and the physical transformation of the city in the 1920s and 1930s provided a perfect theatre in which spontaneous divinity and popular protest could meet. But I would suggest that this meeting was specific to the time and the city itself. These disputes were also rapidly defused, suggesting that the restive energy that accumulated around them was itself fluid, ready to dissipate and move to a new space in the city. The political deployment of both the energy of the urban poor and divine emanation was brief in each incident. Neither was amenable to being controlled or curtailed by communal politics. As a very brief epilogue, the Shiv Mandir itself did not dissipate like the politics that briefly accumulated around it. A substantial Shiva temple now occupies a different corner of the gardens – now renamed Mahatma Gandhi Park.

This chapter has demonstrated the agility of public organisation based on claims of devotional rights and sensitivities. The rigid bureaucratic habits of the colonial urban authorities were necessarily forced to cede concessions by an urban public that was growing, both in terms of its size and dissatisfaction. The idea of

the temple emerged from this collision as a site of that blended devotion, community advocacy, anti-colonial agitation, and urban politics. At the beginning of the century, the colonial state made lists of shrines in order to expedite their removal, creating, for the first time, a geography of the small and disparate Shiva temples that peppered the area selected for transformation into the new cityscape. The coherence of these temples as a commensurate group, a category, came about during the 1920s, as the initial and exceptional licence to violently remove shrine sites was curtailed and the city's authorities began to court the mediation of Hindu religious organisations in the management and creation of new temples. This chapter has also emphasised the potency of the idea of the Hindu temple. The absent, but possible, temple can be made to possess redoubtable force.

The next chapter continues to explore imaginary temples – which, however, existed in a very different kind of imagination. It explores the temple as a condensed signifier of the exotic in imperial literary renditions of India, and the displacement of imperial violence into these imaginaries.

5

Dark Spaces and the Body

The Temple in Victorian and Edwardian Literature

"Do you remember those stories one used to read as a kid? The *Strand Magazine* used to be full of them."

"Which stories?"

"Those idol's eye stories. The ones where a gang of blighters pop over to India to pinch the great jewel that's the eye of the idol. They get the jewel all right, but they chisel one of the blighters out of his share of the loot, which naturally makes him as sore as a gum boil, and years later he tracks the other blighters down one by one in their respectable English homes and wipes them out to the last blighter, by way of getting a bit of his own back. You mark my words, old Bill is being chivvied by this chap Bigger because he did him out of his share of the proceeds of the green eye of the little yellow god in the temple of Vishnu, and I shall be much surprised if we don't come down to breakfast tomorrow morning and find him weltering in his own blood among the kippers and sausages with a dagger of Oriental design in the small of his back."

"Ass!"

– P.G. Wodehouse, *Ring for Jeeves*, 1954; rpntd London: Arrow, 2007, 112.

ADVENTURE STORIES about English daring and Oriental wealth have a long pedigree in British popular literature. Wodehouse's reference to "idol's eye stories" gently lampoons the pre-War era and speaks of a different, post-War world

in which the book is set, a cultural universe indelibly altered by the Second World War and the crumbling of imperial certainties. Wodehouse's satire stands a lifetime away from the sincerity and gravity with which Wilkie Collins described the plunder of the Srirangam Temple in 1799 in the prologue of *The Moonstone* (1868), or the many sensational popular literatures that spun yarns of Asiatic gore and sensuality throughout the nineteenth century and into the twentieth.

This chapter follows the genealogy of Wodehouse's "idol's eye stories", literary renditions in which the temple provided a theatre of adventure, wealth, and eroticism. The literary culture that developed around the idea of the temple travelled from India to Britain starting in the end of the eighteenth century, traversing the realms of evangelical opprobrium, imperial certainty, and eroticism. These stories offered a place and an idea through which imperial character could be celebrated and measured. A deeper reading reveals that the stories were also a means by which the inherent violence of empire could be explored. Earlier, Victorian iterations presented the temple as a space of voyeurism in which English mettle was tested in thrilling adventure. Kipling presented his readers with the raw violence of colonialism and withheld exoneration even as he celebrated his protagonists whose service sustained the British intervention in India. The chapter concludes with E.M. Forster's *A Passage to India* (1924), which explores a diffuse violence that inevitably wounds both British and Indian protagonists. As imperial confidence wobbled in the inter-War period, the idea of the Hindu temple, which had been presented with such assurance by Victorian writers as an exemplary space of Indian degeneracy, gradually regressed.

Early narratives drew on first-hand accounts of temples that reached metropolitan audiences at the close of the eighteenth century. The island of Elephanta, ten miles from the shoreline of the Bombay peninsula, and the temple of Jagannath at Puri in eastern India, for example, provided early "discoveries" that fuelled

the European imagination. These stories revelled in exoticisation and cast Hinduism as a strange religion of idolatry and brutality. First gothic and later imperial adventures made the temple an exotic theatre in which certain place-holding characters and experiences were played and replayed. The basic, formulaic ingredients of these stories – secrecy, wealth, eroticism, and danger – endured into the late twentieth century in the cinematic imagination, evident in George Stevens' *Gunga Din* (1939), Fritz Lang's *The Indian Tomb* (1959), and Steven Spielberg's *Indiana Jones and the Temple of Doom* (1984).[1]

It is in literature, however, that the life of the Hindu temple as a space of erotic, sensual danger had its fullest career, from the gothic excesses of the early nineteenth century through to the inter-War modernism of E.M. Forster's *A Passage to India*. The temple presented a bounded space through which the "barbaric" practices of India could be distilled to create distinct but thrilling imaginary encounters for the British reader. In these narratives, white protagonists were (largely naïve) interlopers in the temple's precincts. Imperial literature wrote the temple as a space of disorientation that both threatened and thrilled the white psyche, temperament, and body: Kipling deployed the temple as a container of nebulous but potent superstition, a place that both imperilled the white body and psyche and offered a definitive measure of native credulity. E.M. Forster, a fierce critic of Kipling's literary cult of empire, picked up the threads of these representations but to very different purposes at a time when the moral and civilisational convictions that underpinned imperial certainty were dramatically shaken by war and political turmoil in Europe.

This chapter traces out a variety of genres – poetry, popular, magazine fiction, literary reflections, private correspondence, scholarly accounts, and high-brow literature – across which the idea

[1] The portions of Steven Spielberg's film set within a labyrinthine temple were based on Stevens' *Gunga Din*. See Turner, "The Making of Gunga Din", 95.

of the temple was circulated. In doing so, it attempts to trace out the consistencies and limits of the temple as it was rendered in imperial fictions.

Hinduism and the British Imagination

Sati, infanticide, hook-swinging, the cult of thuggee, human sacrifice, and the discriminatory practices of caste became the representational markers of the excesses and barbarities that defined Hinduism in the metropolitan imaginary of India from the eighteenth century onwards.[2] Temple fictions emerged in this realm of association. Shrines that punctuated an imaginary Asiatic landscape provided precincts for the barbaric but compelling practices – from snake charmers to widow immolation – that marked Hinduism out as depraved, sensuous, and fatalistic.[3] The buildings themselves, in early accounts by travellers, attracted little attention. The relative plainness of the interior of the temple, in contrast to its often richly carved exterior and the flamboyance of public ritual, was met with bemused and cursory remarks. As we saw in Chapter 2, James Fergusson's compendiums of architecture had little to say about temple interiors, limiting themselves to plans, silhouettes, and the elevation of the temples' exteriors.

Fictional and factual accounts blended to constitute the place, structure, and adornments of the temple as an imaginary subject. Literature enhanced and guided encounters with temple architectures and literary accounts were mapped onto, and became a part of, ruined and living temples. Robert Southey's "The Curse of Kehama" (1810), for example, finds repeated mention in travelogues and travel-guides about the coastal temples in Mahabalipuram in the Madras Presidency. Southey had not been to India

[2] Bates, "Human Sacrifice in Colonial Central India"; Cooper and Stoler, eds, *Tensions of Empire*; Major, *Pious Flames*.

[3] Ledger, "The Suttee"; Ghosh, "The Serpent-Charmer". Ghosh's writing catered, with great style, to Orientalist tastes.

but drew upon the burgeoning scholarship that emerged from Company and missionary activity in the late-eighteenth and early-nineteenth centuries. An early poem by John Ruskin, "Salsette and Elephanta", written while he was at Oxford in the 1830s, drew on J.S. Buckingham's account of the Hindu religion.[4]

These poems were early parts of the process by which India became, in Daniel White's words, "a patchwork of texts", a pa-limpsest through which truisms were told and retold about the subcontinent.[5] Fictional and factual texts cross-fertilised and were measured both against each other and the materials they pur-ported to describe. Rev. Hobart Caunter recommended Southey's "sublime poem" as offering an enhancement of travellers' experi-ence of Mahabalipuram in the 1830s. Bishop Heber, whose travel narratives contain frequent, and often appreciative, descriptions of temple architecture and devotions, similarly endorsed Southey's work.[6] Grant Duff, writing decades later, lamented how little was known of the Mahabalipuram temples and complained that "noth-ing more in disaccord with all the ideas which they call up could well be penned than Southey's 'Curse of Kehama' which ought to give, but does not give, them an additional interest."[7]

Buchanan's evangelical *Christian Researches* (1811) provided, as mentioned earlier, ghastly and influential accounts of Hindu devo-tion. The temple of Jagannath at Puri was "a stupendous fabric . . . The walls and gates are covered with indecent emblems." The beach nearby lay "whitened with the bones of the pilgrims".[8] Buchanan's lurid descriptions of depravity provided a rich seam of materials for the febrile Western imagination. In a very obviously

[4] James Silk Buckingham (1786–1855) established the *Calcutta Journal* in 1818 and was a critic of the East India Company, and a pioneer of print jour-nalism in British India. He was expelled from India in 1823 and continued to travel, write, and publish. See White, *From Little London to Little Bengal*.

[5] Ibid., 85.

[6] Heber, *Narrative of a Journey*, 286.

[7] Caunter, *The Oriental Annual or Scenes in India*; Duff, "A Month in Southern India", 326.

[8] Buchanan, *Christian Researches in Asia*, 23.

derivative account, Charles Maturin's verbose gothic classic, *Melmoth the Wanderer* (1820), described, in front of the "dark pagoda of Juggernaut . . . the bones of a thousand skeletons, bleaching in the burning and unmoistened air. A thousand human bodies, hardly more alive, and scarce less emaciated, were trailing their charred and blackened bodies over the sands, to perish under the shadow of the temple."[9]

For Maturin and others Hinduism offered both remote exoticism and a crude synonym for the more proximate problem of Roman Catholicism. Gothic literature's anti-Catholicism has been explored in literary histories of the late eighteenth and nineteenth century.[10] Protestant anxiety diffused beyond Europe and provided familiar parameters in stranger, colonial spaces. In Sydney Owenson's (also known as Lady Morgan) *The Missionary: An Indian Tale* (1811), dark subterranean passages – modelled on the recently discovered rock-cut temple of Elephanta in western India – teemed with thinly disguised Roman Catholics. The protagonist leads his convert, the Brahman priestess Luxima, back to the temple where she officiates, and into the ritual of her excommunication. The temple, located at Srinagar, was a cave . . .

> . . . the vestibule of an ancient Pagoda: its roof, glittering with pendent stalactites, was supported by columns, forming a magnificent colonnade, disposed with all the grand irregularity which Nature displays in her greatest works, and reflecting the images of surrounding objects, tinged with the rich and purple shade of evening colouring. This splendid portico opened into a gloomy and terrific cavern, whose half-illuminated recess formed a striking contrast to the exterior lustre . . . Idols of gigantic stature, colossal forms, hideous and grotesque images, and shrines emblazoned with offerings, and dimly glittering with a dusky lustre, were rudely scattered on every side. For the Missionary had borne the Priestess of Brahma

[9] Maturin, *Melmouth the Wanderer*, vol.3, 133. See also Rudd, "India as Gothic Horror".

[10] See for example, O'Malley's *Catholicism, Sexual Deviance and Victorian Gothic Culture*; Brantlinger, *Rule of Darkness*.

to the temple in which she herself presided: the most ancient and celebrated in India, after that of Elephanta. This sanctuary of the most awful superstition, worthy of the wildest rites of a dark idolatry, was now wrapt in a gloom, rendered more obvious by the faint blue light which issued from the earth, in a remote part of the cavern, and which seemed to proceed from a subterraneous fire.[11]

The subterranean secrecy and menace of temples persisted well into the twentieth century. In one of Charles Mansford's popular tales of Eastern adventures published at the end of the nineteenth century, a temple of Hanuman emerges from the rock face and his "secret city" is entirely subterranean.[12] In "Curtis' Folly" (1896) a temple dedicated to Kali is a secret underground chamber of ritual murder from which a kidnapped Englishman and woman escape.[13] These temples serve as secret spaces, theatres in which the horrified English are engulfed by and witness the full depravity of Hindu brutality. Subterranean temples, a creation of the imperial imagination sustained in literature and later in cinema, are the concealed darker face of the Hinduism known through travelogue, scholarship, and ethnography. These voyeuristic fantasies underlined the dangers faced by the English in India and the depravity to which Hinduism had sunk, physically and figuratively.

Victorian Adventures

Later Victorian adventure literature cemented the association between popular Hinduism, depravity, sensual excess, and danger in the British public imaginary. The temple offered a fantastical space ostensibly based on a reality that was morally and geographically distant and unbound by any obligation to specificity

[11] Morgan, *The Missionary: An Indian Tale*, vol. II, 168–9.
[12] Mansford, "Shafts from an Eastern Quiver", 558; Mansford, "In Hanuman's Temple", 153.
[13] Glover, "Curtis' Folly".

or veracity. In popular fictions, temples provided a theatre of Oriental strangeness and peril in which the mettle of the dashing English hero, embodying fortitude and the morality of the colonial claim, could be tested and made to prevail. The peril that dwelt within the temple reached out into the world at large – to white domestic spaces in particular – through curses cast to punish trespass or attached to objects stolen from temples. These curses punished greed or indiscretion, the corruptions to which the white body and mind was considered particularly susceptible in India. In "The Thug's Legacy" a ring given by the leader of the Thug cult to the English officer who caught him is cursed to create – rather predictably – "an irresistible impulse or mania . . . to strangle everybody who offended him."[14] Such cursed objects were of unclear purpose (aside obviously from their narrative purpose as vehicles for the jeopardies faced by whites), and were "manufactured in the secret hidden chambers of the temples of some of the Hindoo gods . . . with many hideous ceremonies and accompaniments by unscrupulous priests deeply learned in the 'occult' sciences."[15]

These mysticisms could also be liberating. In G.A. Henty's "A Pipe of Opium" a temple-dwelling fakir grants premonitions to two English officers which subsequently save their lives during the anti-colonial rebellion of 1857. One of the premonitions reveals a secret compartment behind an idol in a temple that allows one officer and his soon-to-be-wife to escape.[16] Earlier, his wife-to-be begs him to shoot her rather than allow her to fall into the hands of the rebels, a plea that places the story into another tradition of imperial fiction marked by an obsession with the rape of white women.[17] Mansford populated his stories with murderous Brahmans, enormous hollow idols, and tigers – to the extent that a

[14] Aubrey, "The Thug's Legacy", 145.
[15] Ibid., 147.
[16] Henty, "A Pipe of Opium".
[17] Levine, "Sexuality, Gender and Empire".

contemporary critic commented on his tendency to "pile it up".[18] However, even amidst danger, he allowed his English protagonists to demonstrate their poise by coolly appraising the strangeness around them:

> [W]e saw a car fully forty feet in height, and shaped like a tower or gopuram, upon which was placed the gigantic image of a god riding upon a bull carved in black granite, and with its horns gilded. The whole of the car was covered with grotesque carvings, while before the solid wheels, on which it moved slowly along, was a crowd of pilgrims and devotees pulling with all their might at ropes as they were cheered on by the vast concourse which lined the streets.
>
> "We may as well get a nearer view of the car," said Denviers, as he rose from the chair on which he had been sitting. "The carving upon it is certainly worth closer examination."[19]

The temples in adventure stories pulled the rational gaze of protagonist and reader into an encounter with the ritualised depravity of living Hinduism. Moreover, the recurring themes of exoticism, sacrifice, and concealment allowed, indeed obliged, rational appraisal to slip into a voyeurism with a clear vein of eroticism. A particularly unsubtle rendition, "Nargisi", published in 1854, tells the story of a young girl "almost of European fairness" who is kidnapped to provide a sacrifice in "the Black Pagoda of Koladoorga". Her white rescuer, a captain in the Company regiment in the territories of a fictional raja in Central India, conceals himself in a cavity within a stone idol and watches as the eponymous object of the story, Nargisi, is brought into a secret subterranean temple, drugged, stripped to the waist, and tied to a bier. Peeping through holes that were the "eyes and mouths" of the statue, the captain watches in rapt horror as snakes are released to "crawl over and across her beautiful chest".[20] The white protagonist is exonerated as he looks, literally, through the eyes of the

[18] Hogg, Review of *Under the Naga Banner*, 623.

[19] Mansford, "Shafts from an Eastern Quiver", 558.

[20] "Nargisi", 143.

demonic Hindu god whose worship demands the titillating sacrifice. Nargisi's fair complexion signals her aesthetic appeal while her nativeness, and the captain's subsequent decent paternalism, make her violent exposure conscionable. The native priests appear as the villains of her exploitation, absolving and arousing the white male audience. The temple is a secretive space, set apart in barbarous seclusion, in which voyeurism is forced upon the hapless captain by virtue of his own bravery. The story invites the reader to submit innocently to erotic sadism set within a narrative vehicle of heroic imperial rescue.

In a similar tale of sacrifice and racial substitution, a female voyeur witnesses the sacrifice of a beautiful Brahman girl at a small temple. "The Thirst of the River God", a short story by Mrs Frank Penny, the wife of an Indian civil servant, was published in the delightfully titled *London Society: A Monthly Magazine of Light and Amusing Literature for the Hours of Relaxation* in 1889. It describes a visit to a "small wayside temple" near the Srirangam temples in the district of Trichinopoly. After her party leaves the protagonist-author alone, the temple priest, abetted by the peon ordered to protect her, reveals the temple to be filled with riches and dedicated to a bloodthirsty god. The Vaishnava priest tells the memsahib that her own presence brought "good luck to the river" and lulls her into a waking dream in which she witnesses the sacrifice of "a fair high-caste girl". The girl is decapitated and "the head rolled forward, whilst her body fell against the hideous image, that seemed to grin in stony delight at the horrible orgy. The life-blood gushed out over it, dyeing the idol crimson; and, in my fevered imagination, the devilish thing of stone appeared to drink the red human wine." On waking from her hallucination, the memsahib is convinced that she remains in danger, the intended victim of native conspirators who "had no fear of the Sircar [government]". The memsahib presents a figure of beguiled vulnerability, both tantalised and victimised by her "uncivilised" surroundings.[21] *London*

[21] Penny, "The Thirst of the River God", 336, 603–16.

Society and periodicals like it provided a diet of everyday "light and amusing" encounters in which India and Hinduism, were made available and consumable to metropolitan audiences on a regular basis.

These amenable stories of thrilling vulnerability in the face of insatiable and deviant religion speak of the masochism that John Kucich places at the heart of colonial social relations. Masochistic fantasy offered "morally simplified" worlds centred on white victimhood. That victimhood allowed imperial subjects "to fantasize about the power of annihilative wishes by projecting them onto others and exaggerating their intensity."[22] The narrative of the suffering hero or heroine therefore offered a displacement of the desire to exercise extreme violence. Kucich also suggests that victimhood in imperial narcissism authorised an entitlement "to lie, cheat, or use guile to control relationships." This observation is particularly revealing. In several chapters of this book, white protagonists express frustration and anger at their failed attempts to gather information. The oft-repeated assumption that natives were unable or constitutionally unwilling to tell the truth, making white subjects the victims of their dishonesty, was tacitly inverted to license the white coloniser to act according to a truncated moral universe in which deception and extra-judicial violence were permissible and necessary.

By the end of the nineteenth century, interest in formulaic adventure narratives set in India was declining. This decline took place against, as Anjali Arondekar points out, the increasingly fraught and straitened nature of imperial authority. Kipling heralded a reorientation of the colonial literary imagination. Unlike earlier narratives which invited the reader to look upon a flattened moral landscape in which colonial heroism encountered and vanquished native depravity, his writings reoriented readers towards male protagonists, or rather, the forment of his protagonists' masculinity

[22] Kucich, *Imperial Masochism*, 24.

within the complex and trying environment of India.[23] Whereas Victorian potboilers compelled readers and their morally stiffened heroes to gaze with them on the unbridled eroticism of Hindu ritual excess, Kipling presented men who were changed, corrupted, or annihilated by India.

Rudyard Kipling and the Hindu Temple

Temples featured in Kipling's earliest recollections of his lost Indian childhood as part of a sensory landscape, a space from which the sounds of conch shells and bells emanated. In his autobiography he recalls "little Hindu temples" with "dimly seen, friendly Gods" from a happy childhood in Bombay before his bitterly remembered exile to England.[24] Subsequently, Kipling made sterner use of the temple to underline English cultural repugnance for Indian filth and disorder. In a description of the seventeenth-century Jagdish Temple in Udaipur, Rajasthan, Kipling remarks that there "is no repose in this architecture, and the entire effect is one of repulsion; for the clustered figures of man and brute seem always on the point of bursting into unclean, wriggling life."[25] Ascending the "Tower of Victory", "most abhorrent" to the Englishman is "the slippery sliminess of the walls always worn smooth by naked men." On descending into the cave of the Gau-Mukh, "he felt their sliminess through his boot-soles. It was as though he were treading on the soft, oiled skin of a Hindu."[26] The temple became an embodiment of a repellent native corporeality: naked, unctuous, and soft. In addition to these descriptions of filth and embodiment, Kipling's temples contain another troubling potency. A persistent theme in his work is the temple as a site of

[23] Arondekar, "Lingering Pleasures, Perverted Texts", 68.
[24] Kipling, *Something of Myself*, 2.
[25] Kipling, "Touching the Children of the Sun and Their City", 55.
[26] Kipling, "Letters of Marque", 96.

adversarial authority, the abode of priests in a remote but potent dominion. Out of the temple emanates an alternative and resistant authority which, as Kipling sees it, is based on superstition, sacrifice, and degraded and perverse worship.

For Kipling the temple did not offer a place of thrilling adventure. Instead, he wrote about it as a zone of distinction between the European and the native. Rather than providing isolated theatres of exotic excess, the Hindu shrine was integrated into a landscape through which his English protagonists – both fresh and weathered – proceeded. In "The Bride's Progress" (1888), a spoilt, rich bride passing through India on her globetrotting honeymoon insists on a visit to the burning ghats at Benares and is left "sorry" for the horrors seen. As she walks through the streets of the city, she pauses to pet a dog outside "some unclean temple", before the

> lanes grew narrower and the symbols of a brutal cult more numerous. Hanuman, red, shameless, and smeared with oil, leaped and leered upon the walls above stolid, black stone bulls, knee-deep in yellow flowers. The bells clamoured from unseen temples, and half-naked men with evil eyes rushed out of dark places and besought her for money, saying that they were priests – *padris*, like the *padris* of her own faith.

Having been horrified by the burning ghats themselves, the bride demands of their mission-educated guide, "Now show us some more temples." The temples in Kipling's Benares furnish a landscape of unclean lewdness in which the bride is a misinformed naïve – "At every turn lewd gods grinned and mouthed at her" – and offer Kipling the means by which to confront the stupidity of the ignorant English in general and women in particular.[27]

He marked his protagonists' horror on their first encounter with the Hindu erotic, though with none of the indulgent revelation of early Victorian authors. In a comedic short story, "The Incarnation of Krishna Mulvaney", a drunken Irish subaltern

[27] Kipling, "The Bride's Progress", 307.

(one of the devoted trio Mulvaney, Ortheris, and Learoyd) finds himself alone in a palanquin within a temple and mistaken for one of the "big Queens praying at Benares". Peering out from the palanquin, Mulvaney is initially shocked by the eroticism, wealth, and abandonment of the devotion he sees. He narrates his experience in Kipling's version of subaltern Irish colloquial: "a great big archway promiscuously ornamented wid the most improper carvin's an' cuttin's I iver saw. Begad! they made me blush – like a – like a Maharanee." Mulvaney's blushes are misplaced, for it was maharanis (queens; noblewomen) whom he has watched dancing with abandon in front of the goddess Kali. Fearing detection, Mulavaney escapes by imitating the god Krishna: "I crooked my legs like a shepherd on a china basin, an' I did the ghost-waggle with my feet as I had done it at the rig' mental theatre' and moved across the temple, beneath the goddess, 'tootlin' on the beer bottle." The devotees, entirely taken in, prostrate themselves and allow him to escape through the back door of the temple. Realising that his incarnation had "made the miraculous reputation av that temple for the next fifty year," Mulvaney demands money for his fare back to his regiment from a priest and acquires, "[f]our hundred an' thirty-four rupees by my reckonin', *an'* a big fat gold necklace."[28] Kipling's morally ambiguous hero is less a vehicle for his reader's voyeurism than the comedy of his own self-interested greed and the gullibility of the devotees.

In another short story that features a homosocial trio of white masculinity, "The Man Who Would Be King", Daniel, Peachey, and Billy Fish find themselves initially the beneficiaries and later the victims of mistaken identity. The three establish their pretended authority within the "temple of Imbra" in which they set up a loose imitation of a masonic lodge. The village girl forcibly married to Daniel is kept in "a little dark temple" before the marriage. Later in the story, Peachey, having been crucified and cut

[28] Kipling, "The Incarnation of Krishna Mulvaney".

down, is taken to the temple to be "fed up" and it is there that
he is presented with Daniel's head before being turned out of the
village.[29] For Kipling, the Hindu temple is the definitive referent
of Indian society and, in particular, Indian authority that lies, by
mutual agreement, beyond the reach of British authority. In *The
Jungle Book*, Mowgli's hybridity and fearlessness is expressed in
his willingness to goad and face the "god of the temple's" anger.[30]

In "The Mark of the Beast", the risks of foolish transgression are
dealt with more ominously. The drunken desecration of a shrine
brings both terror to the guilty individual and disgrace to the two
Englishmen who assist him. After the "gorgeously drunk" Fleete,
newly arrived in India, grinds his cigar into the forehead of Hanu-
man, a naked leper, the "Silver Man", emerges from behind Hanu-
man to bite and curse him. One of his companions, the narrator, ex-
pects prosaic retribution – criminal charges brought against them
by the temple committee "for insulting their religion". The viola-
tion results, however, not in litigation but supernatural retribu-
tion. The symptoms are revealed gradually: as Fleete leaves the
temple he complains that he can smell blood. The next morning
he demands raw meat for breakfast, terrifies the horses, and a
circle of blotches emerge on the left side of his chest. By the next
evening, Fleete's metamorphosis is sufficient for his redefinition
in the narrative as "the beast" and he is left bound, gagged, and
foaming at the mouth by his friends. Strickland, the police officer
who knew "as much of natives of India as is good for any man",
captures the Silver Man and tortures him with a gun barrel heated
as a branding iron until, at dawn, he agrees to remove the curse.
Fleete's metamorphosis is reversed. This story performs a com-
plex and significant double manoeuvre: Strickland's unrestrained
violence is deemed necessary to save his friend. Kipling regards
friendship between white men as the foundation of imperial rule.

[29] Kipling, *The Man Who Would Be King and Other Stories*, 53, 62.
[30] Kipling, "Tiger, Tiger", in *The Kipling Reader*.

The story, however, holds violence apart from the idea of English character and English rule. Fleete's two companions, party to kidnap and torture of the "Silver Man", have by those acts "disgraced themselves as Englishmen for ever".[31] Fleete's drunken and improper defilement of an idol leads to the disgrace of his peers, who can only save him by sacrificing their characters as Englishmen, disgracing themselves in an unmanly assault.[32] After his recovery, Fleete reflects that no one (the subjective "one" being white) will believe the story: "it is well known to every right-minded man that the gods of the heathen are stone and brass, and any attempt to deal with them otherwise is justly condemned."[33] Supernatural Hinduism, unimaginable to any rational Englishman, provides the amorphous realm that creates the conditions and cordons of violence. The imperial English – Kipling's stock-in-trade characters – pay the price of silent dishonour for knowing, and acting within, these mysterious and compromised realms. The violence committed is held apart from both Englishness and, by extension, Empire.

This narrative manoeuvre resembles, indeed may well be derived from, the opening pages of Wilkie Collins' gothic detective novel *The Moonstone*. In the prologue, family papers describe the excessive violence and greed of the author's cousin, John Herncastle, during the siege and looting of the stronghold of Tipu Sultan at Srirangapatna by the East India Company in 1799. Herncastle has been driven into a "frenzy" by his desire for the moonstone, a yellow diamond that once adorned the forehead of a moon god and that is now an ornament in the handle of a dagger in Tipu Sultan's treasury. Before it reached Srirangapatna, the diamond had passed from "one lawless Mohammaden hand to another" after the loot of Benares by Aurangzeb, with little moral effect.

[31] Kipling, "The Mark of the Beast", 158.
[32] Sullivan, *Narratives of Empire*, 10.
[33] Kipling, "The Mark of the Beast", 159.

Herncastle's character crumbles at the siege and he commits murder and theft to obtain the diamond. His unhinged greed, and his failure of honour, moves the diamond from the remote realms of (imperial) history and the Hindu supernatural into the English drawing room, where it wreaks havoc. The diamond, and the Hindu supernatural forces it brings with it, could only have entered the English domestic realm through an act of (almost) unspeakable and supposedly un-English violence.[34]

While Kipling uses the temple to present the extraordinary and definitive dangers that beset the white body and character in India, in other stories the temple becomes a marker of the guileless and submissive "native mind". In "The Bridge Builders", Peroo, an Indian foreman, tells his British employer that in London he "did poojah to the big temple by the river for the sake of the God within."[35] The "temple" to which Peroo alludes are the Houses of Parliament. In a short story, "In the Presence" (1912), a Sikh subadar-major remembers King Edward VII's death and lying in state in Westminster Hall in London: "the new King – the dead King's son – gave commandment that his father's body should be laid, coffined, in a certain Temple which is near the river. There are no idols in that Temple; neither any carvings, nor paintings, nor gildings. It is all grey stone, of one colour as though it were cut out of the live rock . . . It is the Sahibs' most sacred Temple."[36] Kipling used the temple as a vessel of authority in the Indian mind that could slide seamlessly to encompass, and accept, British institutions, aligning the simplicity of native perception with axiomatic British authority.

Kipling's India presented a quicksand of ultimately impenetrable and corruptive custom from which his protagonists, with varying degrees of knowledge, wisdom, and guile, were obliged

[34] Collins, *The Moonstone*, 5–10.

[35] The "big temple" alludes to the Houses of Parliament. Kipling, "The Bridge Builders", 12.

[36] Kipling, "In the Presence", 228.

to either retreat or perish. Within this landscape, temples offered short-cuts over which the array of differences between the British and Indian could be demonstrated through humour, disgust, or peril. The temple was physically grotesque; its form repelled any right-thinking Englishman. It could also be a space of coarse exploitation, as in Mulvaney's farcical adventures, which did more to lampoon than affirm the earlier straight-laced and straight-faced adventure stories from which they derived their form. More than anything, however, Kipling's temple was a seat of supernatural and earthly authority that embodied and bound the dangers and strangeness of India. The temple's boundaries were barriers that the British crossed at their peril.

Gods in History: E.M. Forster, Civilisation, and War

Like Kipling, Forster thought about India as a place and experience that could transform those who presumed to govern it. India was not, however, for Forster a space in which the white capacity for mastery ought to be cultivated and tested. He despised the cult of rugged imperial masculinity celebrated by Kipling; he satirised the racist and petty presumptions of the Anglo-Indian official and his imperious and often unseemly attempts to "know" India. Forster wrote about the Hindu temple in a number of ways: in sensory accounts of living temples he visited and as subjects of scholarly study. (His interests and reflections on the form and meaning of the Hindu temple create a link between the second and sixth chapters of this book.) The temple as a place and an idea clearly informed his understandings of the imperial encounter and his damning expositions of the pretensions of the imperial state. However, the ambitions of his appraisals of the Hindu temple did not, ultimately, extend much beyond its disorientating effect on British sensibilities.

Forster travelled in India for sixth months in 1912 and 1913,

accompanied by his friends Goldsworthy Lowes Dickinson and Robert Calverley Trevelyan. He returned in 1921 when he took the position of private secretary to the maharaja of Dewas, a principality in Central India. Forster's descriptions of temples in correspondence and in the diary he kept during his first stay in India are brief and ambiguous. Neither text was written for a public audience though they appear to have been informed by earlier literary accounts that presented the Indian temple to metropolitan audiences. Forster made frequent passing mention of temples as elemental parts of the landscape, enjoying their noise and light. Writing to his mother from Agra, and on hearing she was finding her own travelling companions in Italy somewhat trying, he remarked: "I was wishing so much for you yesterday at Agra, to look at the Taj . . . with me, and again this morning when I was down at the river among Temples and monkeys."[37] His staccato summaries of the interior of temples, for example in Allahabad, give the impression of a disorientating, dark experience, both physically and visually: "A catacomb temple full of gods and saints – Ganesh, Trimurti, the Man Lion Vishnu rending the blasphemer. Lingams with garlands. King snakes, An eternal tree. A passage leading to Benares. Lighted by small wicks lolling in oil. All this was disgusting, and the Jumna, pale blue, seemed the lovelier after it."[38]

His reflections on the temple are fairly perfunctory. "Benares: Lights and clanging inside, perceived through a hole." And: "The temples are very wonderful but nightmares – all exactly alike and covered with sculptures from top to toe. There are about 30 in all, mostly deserted."[39]

[37] E.M. Forster to his mother, Alice Clara Forster (Lily), Muthra, 13/2/13, Papers of E.M. Forster.

[38] Indian Journal, 1912–1913, opp. p. 44, Papers of E.M. Forster.

[39] E.M. Forster to his mother, Alice Clara Forster (Lily), Chhatarpur, 9/12/12, Papers of E.M. Forster; Indian Journal, 1912–1913, opp. p. 45, Papers of E.M. Forster.

Time and again, Forster touched on a general sense of the sensory discomfort involved in looking at temples. At Mount Abu, in Rajasthan, early in 1913, he describes his unease when looking at Jain and Hindu places of worship: "The central shrine, with its cold splendour & elaborate emptiness, bored and amused; a marvel of patience and not in bad taste, nor unimpressive. Yet one didn't want to look at it. Is Indian decoration bad or ill arranged? I cannot decide, but the eye never 'dwells'."[40] He went to some trouble to visit Khajuraho in Central India and his diaries reveal his keen anticipation of visits to medieval temples. However, once encountered, his reflections on them are perfunctory and appear to be derivations of earlier literary representations.

His comments on Hindu devotion and rituals are also cursory and dismissive. At a fair in Allahabad he describes "the boats with golliwog statues of gods on board" as "a great nuisance"; his remarks about Hindu ritual call attention to the fondness of Brahmans for baksheesh (tips), and the apparent brevity of worship. His servant, Baldeo, accompanied him to the temples at Brindavan, to which he was not allowed entry: "Baldeo came with me to perform his devotions. I don't know what they were but as soon as he was in he was out again."[41]

After his first visit to India, Forster maintained an interest in temples, reading and reviewing reports produced by the Imperial Archaeological Department. A keen critic of the official Anglo-Indian, Forster nicely parodied the terse, irritated tones of the work of archaeological identification and conservation of temples as monuments:

Anglo-Indian officials such as will stand no nonsense, have penetrated the jungle, and demanded plain answers to plain questions . . . Pointing with his switch, the official mutters: "Clear away those

[40] Forster's Indian Journal, 1912–1913, Papers of E.M. Forster, 71.
[41] E.M. Forster to his mother, Alice Clara Forster (Lily), Aligarh, 15/2/1913, Papers of E.M. Forster.

custard apples so that we can have a look at the beastly thing . . . seventeenth century Vaishnavite! Exactly. And I was told it was Jain . . . And look here: the women are not to pat cow-dung on it. If they do they'll get fined." He rides on, and the Temple is cleaned up, and is photographed, looking sulky and spruce . . .[42]

Despite believing the temple was ill-served by the attentions of the Anglo-Indian archaeologist, he himself was uneasy and ambivalent about it: in the same 1919 review of an *Annual Report of the Survey of India* he remarked that "the general deportment of the Temple is odious. It is unaccommodating, it rejects every human grace, its jokes are ill-bred, its fair ladies are fat, it ministers neither to sense of beauty nor to the sense of time, and it is discontented with its own material. No one could love such a building. Yet no one can forget it."[43] The Indian reports, he noticed, contained none of the "high consecrated fervour that inspires similar publications about Egypt and Greece."[44] This lack of care, however, was what had excited Forster when he first arrived in Bombay in 1912: "The Egyptian East has been Royal Academised, but not the Indian."[45] In 1919 he writes that

> When we tire of being pleased and of being improved, and of the other gymnastics of the West, and care, or think we care, for Truth alone; then the Indian temple exerts its power, and beckons down absurd or detestable vistas to an exit unknown to the Parthenon. We say "Here is truth," and as soon as we have said the words the exit – if it was one – closes, and we fly back to our old habits again.[46]

Forster reflected carefully on the nature of the English reaction to temples, both his own and that of his travelling companion Lowes Dickinson: "I remember how he used to cower away from

[42] Forster, "The Temple', 947.
[43] Ibid.
[44] Ibid.
[45] Indian Journal, 1912–1913, opp. p. 8, Papers of E.M. Forster.
[46] Forster, "The Temple", 947.

those huge architectural masses, those pullulating forms."[47] Both men's appraisals of the temple reflect the apparent discordance between Christianity and Hinduism. Time was enshrined in the fabric of churches, in the regularity of worship, in engraved tombs and plaques; specific earthly lives, glories, and deaths were marked out in sculpture and inscription. By contrast, neither man could perceive orderly time or space in Hindu temples. Pujas appeared to be without order, enactments of an apparently random liturgy initiated by a visit and offer of baksheesh.

Lowes Dickinson, for his part, was volubly uneasy about Hindu architecture, his unhappiness possibly heightened by his correspondence with Roger Fry.[48] He described Indian architecture and sculpture as "disquieting and terrible to a western mind."[49] His short monograph, *An Essay on the Civilisations of India, China and Japan* (1914), had been written for the trustees of the Albert Kahn travelling fellowships which had funded Lowes Dickinson's travels to India in Forster's company.[50] This *Essay* is a grandiose statement of certitude about Western rationality and civilisation and, on that basis, of his own ability to make sense of the world in its entirety, a confidence that resonates with the appraisals of James Fergusson. Having also briefly evaluated the religions of China and Japan, he concludes that the "real antithesis . . . is not between East and West, but between India and the rest of the world."[51] Indian civilisation was, he believed, "antithetical to that of the West" where "life in time is the real and important

[47] Forster, "The Art and Architecture of India", 419–21.

[48] In a letter to Lowes Dickinson, Fry remarked that "Hindu architecture is clearly abominable". Letter to G.L. Dickinson, 31 May 1913, in Sutton, ed., *The Letters of Roger Fry*, 367.

[49] Lowes Dickinson, *An Essay on the Civilisations of India, China and Japan*, 10.

[50] Many of his reflections had already been published in *Appearances: Being Notes of Travel* (London, 1914) and in letters to the *Manchester Guardian*.

[51] Lowes Dickinson, *An Essay on the Civilisations of India, China and Japan*, 16.

life."[52] Hinduism, to Lowes Dickinson, was a religion beyond historical and therefore meaningful time, and as a result it placed nature, rather than man, at its centre: "the Indians never had or have not now a God in history."[53] It was no coincidence that no Hindu wrote history: "How can you write a history of a nightmare?"

His arguments drew on nineteenth-century imperial convictions about the inadequacy of Indian literature and art. Hindu sculpture and architecture, he wrote, embodied the lack of progress and humanity, time, and life: "I have examined it from north to south, and from east to west – it is disquieting and terrible to a western mind. It expresses the inexhaustible fertility, the ruthlessness, the irrationality of nature; never her beauty, her harmony, her adaptability to human needs."[54] The sculptural architecture of temples embodied this spiritual confusion: Lowes Dickinson echoed Fergusson and his ilk's appraisal of Hindu architecture: "[T]here is no fine architectural form, but everything is overloaded and overloaded with crude sculpture of Shiva legends, partly grotesque, partly horrible."[55] He shared Forster's dislike of the comportment of imperial officers but was in no doubt that "the religious consciousness of India will be transformed by the methods and results of positive science, and its institutions by the economic influences of industrialisation."[56]

Forster's and Lowes Dickinson's accounts of temples were conditioned by far broader imperial meditations on identity, civilisation, and aesthetics. Their reflections were, somewhat modified, reinscriptions of earlier aesthetic tropes that can be traced back to more remote romantic and gothic works.[57] They take their place

[52] Ibid., 40.

[53] Quoted in Proctor, *The Autobiography of G. Lowes Dickinson*, 180.

[54] Lowes Dickinson, *An Essay on the Civilisations of India, China and Japan*, 10.

[55] Quoted in Proctor, *The Autobiography of G. Lowes Dickinson*, 178.

[56] Lowes Dickinson, *An Essay on the Civilisations of India, China and Japan*, 40.

[57] I would like to thank Katherine Baxter for this observation.

within a far longer lineage in which the temple was deployed as a creature of the Western imagination, an imperial place-marker of cultural, moral, and aesthetic difference.

This imperial certainty was itself very much a thing in time. Lowes Dickinson's short monograph was published at the start of 1914, shortly before the outbreak of the Great War. Years later, in light of that war, he reflected on the unbreachable divide he had believed to exist between India and the West: ". . . now, after the Great War and all that has followed, the West begins to seem to me a mere horror, fit for nothing but extermination. Which also, no doubt, is nonsense – a gust of rage, such a one as is always sweeping over one."[58]

Lowes Dickinson died in 1932, before the imperial certainties and their concomitant brutalities had returned to Europe as fascism and before the outbreak of a second, transformative world conflict. The brutalities of the First World War more than sufficed, all the same, for Cambridge liberal humanists such as Lowes Dickinson and Forster to express their loss of faith in the inevitability of gradual universal enlightenment. In Forster's case, one such expression is the cosmic disillusion in the final lines of *A Passage to India*; in Lowes Dickinson's, the utterance takes shape as a loss of faith in everything he had believed India was not: a civilisation progressing in time built around a humane faith. Dickinson did not return to re-evaluate India or Hinduism, so in his case the damage done to the certitudes of Western civilisational superiority – and all its associated diminutions of Indian culture, society, and art – was permanent. Soon enough, with Gandhi's return to India in early 1915 and the start of large-scale mobilisations against British rule, the country was increasingly regarded as a political problem. The easy command with which earlier texts had organised fragments of India's culture and materials retreated. Forster's own subsequent ambivalence about the temple,

[58] Proctor, *The Autobiography of G. Lowes Dickinson*, 181.

to which this chapter will return, came later – as first Europe, and then the world, was engulfed by a second war.

E.M. Forster's *A Passage to India*

In *A Passage to India* (1924),[59] Forster's premise – that the imperial Westerner in India was out of place – found its perfect expression in the temple.[60] The Hindu temple has a subdued but significant presence in the novel. Ruth Brown notes that its first part, entitled "Caves", "is packed with suggestive remarks that point forward to the temple and the Hindu faith."[61] The Marabar Caves, the site of Adela Quested's hallucinatory panic, are revealed to be Jain during the trial of Aziz, the man she falsely accuses of assault.[62] The caves serve as a narrative epicentre, a focal point for Quested's naïve curiosity and subsequent disorientation. For both Lowes Dickinson and Forster, the temple was a manifestation of a disquieting cultural essence, the form of the formlessness that characterised India, less a place than a space definable through absence: of form, of history (Dickinson's "God in time"), and order; the epicentre of European confusion. After Cyril Fielding, friend to both the wrongly accused Aziz and his accuser, Quested, leaves the fictional town of Chandrapore, Forster has him travel to Venice. Unlike Ruskin, who saw parallel degeneracies of architecture in Italy and an Orient that encompassed India, Forster

[59] Forster's title is taken from Walt Whitman's 1869 poem of the same name. Forster admired Whitman but his use of the title appears to be gently ironic about the earlier work in at least some of its aspects. Whitman's "Passage to India" lionises "captains, voyagers, explorers . . . engineers . . . architects, machinists" in the creation of the Suez Canal and, in that respect, owes more to Kipling's mythologisation of the masculinist imperial intervention.

[60] David Lean's 1984 adaptation makes much more explicit use of the Hindu temple in a scene in which Adela Quested comes across a ruined temple and gazes at fragments of erotic sculpture before being chased away by a troop of monkeys.

[61] Brown, "Rhythm in E.M. Forster's *A Passage to India*", 153.

[62] Parry, "Passage to More than India", 165.

presents Venice as comparable but essentially different. Fielding therefore sees Venice as a concentrated counterpoint to what he knew "poor India" to be.[63] Venice represent to him a "civilisation that has escaped muddle . . . [and] Writing picture postcards to his Indian friends, he felt that all of them would miss the joys he experienced now, the joys of form." In this antithesis of India, Fielding forgot "the beauty of form among idol temples and lumpy hills; indeed, without form, how can there be beauty." In India, he realises on his return to Europe, "everything was placed wrong."[64] In its conclusion, therefore, *A Passage to India* reinstates the preeminence of European order and the subjectivity of Europeans within it. As Fielding – the most sympathetic of the novel's English characters – remembers Europe, India recedes as a space of "wrong"; untranslatable and disorientating.

The Marabar caves provide an allegorical space for Forster's reading of the quandaries created by the English cultural encounter with India: these caves are a distillation of the sensory, intellectual, and psychological disorientation of that encounter. Adela Quested is distressed to the point of hallucination by a "terrifying echo", a noise described by Forster as "'bou-oum', or 'ou-boum' – utterly dull."[65] This echo given out by the caves works as a leitmotif, connected to the influence of Proust's fiction and Beethoven's music on Forster's writing.[66] It occurs at various points in the novel, sometimes unexpectedly, to stir submerged memories and stray associations, working in Adela Quested's mind to create the hallucination of an assault. The caves, not unlike the Hindu temple, are the means by which Forster amplifies, both literally and symbolically, the disorientation and confusion felt by Anglo-Indians who lived elevated lives in a country and with a people they did not understand.

[63] Ogden, "The Architecture of Empire", 114.
[64] Forster, *A Passage to India*, 275.
[65] Ibid., 145.
[66] I owe this insight to Rukun Advani.

The device of the caves used by Forster closely resembles an account of the adventures of an army subaltern, J. Flyn, in the Kailash Temple, first published in the *Bombay Telegraph and Courier* and then subsequently as a book in 1856. This account features an antecedent to Forster's sonic mysteries. Flyn claims that, spending the night in the temple, he and his companions experienced a "waking dream. All the Hindu deities suddenly entered the field of our vision . . . Beautiful goddesses and Apsarás (i.e. heavenly nymphs), proud princes, stern warriors, and passionless ascetics, all crowded together promiscuously upon our excited imagination, and peered at us as if inquiring how we had dared to make a hostelry of their time-hallowed retreat."[67] After the deities had appeared to them,

> there came a sound, – deep prolonged, and melancholy, – and our vision instantly dispelled. We started to our feet. We looked around us, but saw nothing . . . We listened. The sound was repeated. It resembled the Hindu mystical sacred monosyllable *Om*, which issued we knew not whence, three successive times, and struck the ear with a gradual musically-undulating cadency. As the third triple series, *Oum! Oum! Oum!* Swelled forth, and, pervading the silent vacancy of the temple, became unmistakably audible . . . Looking toward the sanctuary we discovered a light within it, and thinking that some solitary devotee might be there performing his midnight devotions, we softly approached the doorway; but when we looked in we could not see any living being. The colossal statues ranged outside frowned upon us, as if chiding us for our unseasonable intrusion.[68]

Flyn's account resembles the Victorian adventures in which the white imagination submitted itself to some form of changed state that allowed a temporary suspension of the rational, allowing the lines between rational and irrational, past and present,

[67] Anon., *Notes on the Rock-Cut Temples*, 25.
[68] Ibid., 25–8.

savage and civilised to be blurred. Forster's caves are situated within this genealogy but offer a dramatic deviation. The caves present a far more profound and perilous disorientation, the effects of which eclipse the space of the temple and endure to endanger both the European and Indian.

Forster's feelings about temples were developed and reorientated over a forty-year period. Belying his initial excitement at the uncurated, un-"Academised" antiquities of India, Forster's interest in temples, when he was back in England, developed to combine both scholarly familiarity and spiritual longing. His most explicit and profound reappraisal of the temple came as Europe was ripped apart by war. In 1940, the Warburg Institute in London held an exhibition of photographs curated by the art historian Stella Kramrisch, entitled "Aspects of Indian Art".[69] The exhibition was described as "an unpredictable expansion" of the Warburg Institute's work by Gertrud Bing: until then, the institute had been "exclusively concerned with the Mediterranean cultural sphere." It was also the first of a series of exhibitions at the institute intended to fill the cultural gap left by the evacuation of the treasures of the London museums.[70] Forster reviewed the exhibition for *The Listener*, a weekly magazine published by the BBC for which he wrote frequently:

> Besides our war against totalitarianism, we have also an inner war, a struggle for truer values, a struggle of the individual towards the dark, secret place where he may find reality. I came away thinking, "Yes, the people who built these temples, the people who planned Khujraho and Orissa and Madura – knew about that. They belonged to another civilisation, but they knew, they knew that the community cannot satisfy the human spirit."[71]

[69] Kramrisch's reading of the Hindu temple's form and meaning are explored fully in the next chapter of this book.

[70] Schoell-Glass, "An Episode of Cultural Politics During the Weimar Republic", 114, fn. Bing was sending Mann photographs from the exhibition.

[71] Forster, "The Individual and His God", 801–2.

After the war Forster continued to reflect on Kramrisch's significance for his own understanding of the temple and returned to the discomfort – expressed in his 1912 diaries – experienced by the uninitiated Westerner encountering temples:

> The beginner . . . may be better advised to look quietly at the plates [in Kramrisch's *The Art of India*], and not to look at too many of them at once. Indian art is not the westerner's natural food. It is desirable that he should eat of it, and it is disgraceful that the British, who controlled the peninsula for over a hundred years, should have deterred him from eating, and should even have asserted that the food was rubbish or muck. All the same, little and often may be a sensible policy. It has worked in my own case.[72]

The temple could be visually consumed, but now more sensibly in morsel-sized bites of a new art history. Whereas Khajuraho had been unpalatable to Forster in 1912–13 as part of a landscape in which he was submerged during his first visit to India, Kramrisch had provided the intellectual means to make the temple meaningful and palatable. What Forster could now digest was the idea of the temple. The unbridgeable gulf between Hindu and Western sensibilities was for him overcome by Kramrisch's consummate summary of the meaning of the former and by the violent disruption of the latter by the war. Despite having been apparently disappointed with Khajuraho in 1913, forty years later he used the temples there to describe his new understanding of Hindu worship:

> I became easier with the Indian temple as soon as I realised, or rather as soon as I was taught, that there often exists inside its complexity a tiny cavity, a central cell, where the individual may be alone with his god . . . [At Khajuraho] the exterior of each temple represents the world-mountain, the Himalayas. Its topmost summit, the Everest of the later days, is crowned by the sun, and round its flanks run all the complexity of life – people dying, dancing, fighting, loving – and

[72] Forster, Review of *The Art of India*, 977–8.

creatures who are not human at all, or even earthly. That is the exterior. The interior is small, simple. It is only a cell where the worshipper can for a moment face what he believes. He worships at the heart of the world-mountain, inside the exterior complexity. And he is alone. Hinduism, unlike Christianity and Buddhism and Islam, does not invite him to meet his god congregationally; and this commends it to me.[73]

Forster maintained a relationship, albeit glancingly, with India throughout his career. India was at first the site of youthful travel and adventure and later the *mise-en-scène* for one of his most significant books. Kramrisch's exhibition provided an opportunity for him to return to and refine his understanding of the temple as a site through which India could be encountered by the Westerner.

Forster's writing sat amidst a change in English writings about India in which the materials of India were replaced with the more metaphysical concerns of inter-War thinkers. In the 1930s, L.H. Myers' meditative (perhaps ponderous) trilogy, *The Root and the Flower*, made slight, if significant, use of the temple as a site of erotic and sensual excess in a courtly soap opera set in the seventeenth century. The "religious orgies" in it, accompanied by "human sacrifice" that were a rumoured aspect of the sketchily defined "Vamachri" cult, purportedly took place in temples. A temple provided the setting in which Jali, the young prince and principal protagonist of the second book, meets Gunevati, the young, low-caste woman who embodies unrestrained sensuality.[74] The explicit identification of temples with religious orgies sits within a family tree that links eighteenth-century sensuality with the fantastic, voyeuristic accounts of a Frenchman, Louis Jacolliot. Myers pushed Indian materials back into a more diffuse background for literary tales that revolved around Indian characters. The idea, as a

[73] Forster, "The Art and Architecture of India", 420.
[74] Myers, *The Root and the* Flowers, 43, 257.

materially distant referent, was now a shadowy reminder of the latent danger of these spaces and their sense of peril to the rational imagination.

Conclusion

British literary fictions made the temple, literally and figuratively, both exotic and accessible. The literary career of the temple combined the fantastical – wealth, magic, and peril – with banal evocations of filth, noise, and boredom. The temple offered a means to contain and explain violence, whether to exonerate its necessity to the imperial enterprise, or, in later fictions, to describe the violent disorientation of the English mind in India. These literary representations maintained a complex relationship with imperial reality, drawing on narrative accounts of actual temples to renew the symbolic and figurative meaning of the temple. The Hindu temple was never whole in British literary representations. It was presented in fragments: a purloined diamond, the sound of bells, dimly seen lights, and a place from which danger emanated. These parts were vague enough to be subdued within a larger narrative and drew their credibility from a bank of imperial cultural credulity about India. From early-nineteenth-century gothic romance to Forster's post-war introspection, the Hindu temple was constituted as a potent idea through which the white Anglophone literary imagination could exercise itself.

The Hindu temple became in a sense a literary creature through which the entitlements of colonisation could be asserted, tested, or, latterly, doubted. The next and final chapter considers the realm of art history and returns to the materiality of the temple. Art-historical analysis in the inter-War period departed from both the distant typologies of nineteenth-century architectural interpretation and the exasperated custodial mutterings of archaeological authorities. Instead, the Hindu temple became a resource for metaphysical abstraction.

6

The World Mountain
Stella Kramrisch and the Hindu Temple

THIS CHAPTER examines the most esoteric of the imperial imaginaries of the temple. These perceptions dissociated the Hindu temple from its devotional publics, from Fergusson's rigid taxonomies, and from its immediate physical and political landscapes. Instead, art-historical scholarship of the inter-War period created a definition of the temple that was both comprehensive and reductive – the temple as a physical manifestation of spiritual energy and meaning. At the centre of this reframing of the Hindu temple is the remarkable work, and life, of the Czech-born Austrian art historian Stella Kramrisch (1896–1993). This chapter places the temple in a broader theatre of art-historical thought by charting its development and currency in Kramrisch's career as an art historian.

Ronald Inden, in his insightful survey of the scholarly constitution of India, identifies Kramrisch's work, like that of her peer and contemporary Ananda Coomaraswamy, as belonging to "idealist views of India".[1] Kramrisch's reading certainly departed from and rejected the hierarchical evaluations of temple form and style discussed in the second chapter. Her interpretations eclipsed Fergusson's comparative schematics of emergence, zenith, and decline. She rejected the supremacist hierarchy that lay at the heart of his work, but her own work maintained his ethnic and architectural

[1] Inden, "Orientalist Constructions of India", 432.

categories. And while she, too, was interested in comparison between European and Asian form, she emphasised the material emanation of devotional meanings and practice in objects and architectures.

This chapter explores the pivotal position occupied by the idea of the Hindu temple, and materials drawn from it, in Kramrisch's professional biography and scholarship. The trajectory of her career traces out a transformation of the Hindu temple, and visual and physical fragments of it, in global art-historical scholarship and art markets. Her career allows us to chart both the residual power of the British imperial establishment, which resolutely kept her outside its institutions, and the ascendancy of new and enduring readings of the Hindu temple that eclipsed and transcended the jealous curations created during the colonial period. Kramrisch's work came out of a complex network which combined aesthetic approaches that emerged from Central European Indology in the late nineteenth century.[2]

Kramrisch formulated her immense reading of the temple in the 1920s and 1930s and published her two-volume study, entitled *The Hindu Temple*, in 1946. She placed spirituality as the cardinal point of the temple's meaning. The opening dedication of *The Hindu Temple* set the tone of an analysis that blurred the distinction between devotion and scholarship: "We honour as much as we can the founders [of temples] (sthāpaka) and the architects (sthapati) too."[3]

Stella Kramrisch and Indian Art

Stella Kramrisch's was a life of the twentieth century, spanning empire, three nationalities, two world wars, the Holocaust (in

[2] Singh, "German-speaking Exiles"; Manjapra, *Age of Entanglement*, 238–75.

[3] "Sthāpakān sthapatīṃścāpipūjayāmaḥ svaśaktitaḥ" – Sanskrit on the opening page of *The Hindu Temple*. This translation was kindly provided by David Smith.

which her mother was killed), repeated financial ruin, and personal survival as a self-made émigré. She was educated in Vienna and completed her doctorate on Indian Buddhist art at the University of Vienna in 1919. Image 6.1 is a photographic portrait of Kramrisch as a young woman, most likely taken in Vienna, the elegance of which belies the stresses she must have experienced in wartime Central Europe.[4] In 1920 she travelled to England to give a series of lectures and, while in London, was recruited to Visva-Bharati, Rabindranath Tagore's university, which the poet had founded just around this time, in Santiniketan in Bengal.[5] When speaking in England, Kramrisch remembered that she "spoke extemporaneously, filling in with French, Latin and Italian where I didn't know the English."[6] Having moved from Visva-Bharati to Calcutta University in 1923, she remained there until the suicide of her husband, Laszlo Nemenyi, a Hungarian economist, in Pakistan in 1950. Kramrisch then moved to the United States, using grants from the Bollingen Foundation to secure short-term work at the University of Pennsylvania. In 1953, while in the USA, she resigned from the University of Calcutta before being appointed as Curator of South Asia Collections at the Museum of Art in Philadelphia in 1954, where she remained, also holding appointments at New York and Philadelphia universities and teaching widely in the United States, until her death in 1993.[7]

[4] "Untersuchungen zum Wesen der frühbuddhistischen Bildnerei Indiens" (Investigations into the Nature of the Early Buddhist Artistry of India), PhD dissertation, University of Vienne, 1919.

[5] "By the time he laid the foundations of Visva-Bharati in 1918, he [Tagore] seems to have scaled up this grand dream, imagining it as a centre of learning which would be primarily, though not exclusively, for research; in it, he believed, the streams of ancient and traditional forms of knowledge in India might be brought together." Ganguly, *Tagore's University*, 3. See also idem, 38, for Tagore's chance recruitment of Kramrisch.

[6] Sozanski, "A Meeting of Art, India and Devotion".

[7] "Kramrisch, Stella as Indian art curator", Correspondence re grant application, folder 2, Fiske Kimball Records Box 138; Employment negotiations,

Originally employed at Visva-Bharati to teach Western art, Kramrisch resumed her research on Indian art at Calcutta University. As a lecturer in art history at the university, editor of the *Journal of the Indian Society of Oriental Art*, and contributor to the art journal *Rupam*, she was a key figure in Calcutta art circles. She exercised influence in the exhibition of Bauhaus paintings in Calcutta in 1922 and was an important interlocutor for Western art in India.[8]

The precise nature of the intellectual influences on her thinking in Calcutta is elusive. Kramrisch did not maintain a personal archive through which her relationship with her academic peers in Calcutta might be traced. Ordhendra Coomar Gangoly, with whom Kramrisch collaborated as a university colleague and in editing the *Journal of the Indian Society of Oriental Art*, leaves hints in his biography of Kramrisch's unattributed intellectual debts.[9] Kramrisch's personal relationships were often intense and short-lived, a characteristic which, combined with her personal and intellectual ambition, results in an impressionistic and unreliable biographical landscape in which to map out the network of informal influences which must have contributed to her work. In the early 1970s she was reconciled with her former student Niharranjan Ray – decades after Raymond Burnier apparently sabotaged their relationship by telling Kramrisch that Ray "hated her".[10] The art historian and founding editor of *Artibus Asiae*, Alfred Salmony, reportedly remarked in 1954 that "I have heard Stella Kramrisch accused of everything but murder."[11]

Kramrisch, Stella as Indian art curator, Correspondence re grant application, folder 2, FKR Box 138, PMA.

[8] Chatterjee, "Circa 1922"; Manjapra, "Stella Kramrisch and the Bauhaus in Calcutta".

[9] I would like to thank Rituparna Basu for this information from Gangoly's Bengali autobiography.

[10] Stella Kramrisch to Niharranjan Ray, 20 June 1973, Series VI: Personal Papers, 1930s–1998, Box 94, folder 33, Stella Kramrisch Papers, PMA.

[11] Campbell, ed., *Baksheesh and Brahman*, 217.

In contrast to her scant biographical archive, Kramrisch's scholarly output was prodigious. Her interest in the arts of South Asia, which she refused to distinguish from crafts, was extensive; she wrote on paintings, embroideries, metalwork, scrollwork, sculpture, and architecture.[12] She travelled widely in India, exploring remains in situ and in museum collections. Though few personal records exist from the period she spent in India, field notes which testify to her extensive travels after 1950 survive in her archive at the Philadelphia Museum of Art.

Kramrisch arguably possessed the greatest familiarity of any individual with the diversity of Indian architecture, sculpture, and crafts.[13] Those who knew her commented on her extraordinary connoisseurial sensibility.[14] Through shrewd collecting and dealing, she accumulated a significant collection of sculpture, *kantha* embroideries, and paintings which played a significant role in her career (as did a similar collection for Kramrisch's contemporary and peer Ananda Kentish Coomaraswamy).[15]

Kramrisch was an outsider in both India and England. Her life raises a set of themes in twentieth-century art historiography: the subtle survival of imperial aesthetics within ostensibly new registers of art-historical analysis, the role of institutions and patronage in the creation of art-historical careers, and the endurance of spiritual and devotional frames in the analysis of Indian art. This chapter argues that Kramrisch's analysis of the Hindu temple was pivotal to her vast corpus of writing. Ultimately, I suggest that the

[12] Miller, ed., *Exploring India's Sacred Art*, contains a bibliography (to 1983) and Barbara Stoler Miller's important biographical essay.

[13] Mason, "Interwoven in the Patterns of Time", 159–68.

[14] Guy Welbon, Dale Mason, and Michael Meister, pers. comm.

[15] Ananda Kentish Coomaraswamy (1877–1947) was a key figure in the promotion of the metaphysical interpretation of Indian art and found far greater favour in the British art-historical establishment. In 1916 he was appointed as curator at the Museum of Fine Arts in Boston. Kramrisch and Coomaraswamy were mutually respectful peers though they appear to have avoided sustained contact or collaboration. See the two-volume collection of selected works and Roger Lipsey's three-volume biography.

most profound transformation she wrought within the art histo-
riography of the Hindu temple was the creation of a new scale –
that of the discrete sculptural tableaux – through which the temple
could be fixed by the art-historical gaze.

Kramrisch's attentions to the medieval Hindu temple contrast
starkly with the aesthetic evaluations which emerged during
the nineteenth century in the British imagination and which had
undoubtedly conditioned Forster's response (discussed in Chap-
ter 5). By the first decade of the twentieth century, there were chal-
lenges to the aesthetic certainties and hierarchies imposed upon
imperial riches. Before the First World War, modernists chal-
lenged illusory naturalism and allowed Hindu sculpture to pro-
vide a source of inspiration and emulation, removing it from the
jealous but judgemental curation of archaeology. European art-
ists had begun to defy the formal, comparative, and hierarchical
aestheticism which had diagnosed Hindu sculptural form as
curtailed and degenerate.[16] For example, Jacob Epstein employed
the sculptural convention of *tribhanga*, a posture uniquely asso-
ciated with Indian dance and sculpture, in the (controversial and
now lost) "Ages of Man" sculptures prepared for the exterior of
the British Medical Association building in London in 1907 and
1908.[17]

As discussed in the previous chapter, conventional certainties
and hierarchies were further shaken by the First World War –
as noted, the war had caused Goldsworthy Lowes Dickinson
to question the imperial and civilisational convictions that had
conditioned his reactions to Hindu architecture during his travels
with E.M. Forster. Kramrisch, who was never beholden to imperial
triumphalism, appraised the war with a cooler eye. She regarded
it as a pivotal moment in the relationship between aesthetics and

[16] Turner, "The 'Essential Quality of Things'".
[17] *Tribhanga* means bent three times, curving the body into an "S" shape.
See Arrowsmith, "Jacob Epstein – the Indian Connection".

humanity, commenting in 1922 that "Finally Europe has survived its own ruin, and art always a true witness, has become abstract. The artists of to-day appreciate Indian art."[18] In explicating the movements that had characterised European art from the Impressionists, Kramrisch awarded her highest accolade to German Expressionist artists who had "almost reached the level of Indian art, where the artist cannot create anything unless he identifies himself completely with the object."[19] Her discussion of Western art, however, suggested an art disorientated by the war. Describing the return to conventional painting forms embraced by, among others, Pablo Picasso, she said that "now the war is over with a despondent but gracious smile we clasp the fetters which we had willingly thrown off and put them as ornaments round our novel experience."[20] By contrast, Indian art provided Kramrisch and others with a certainty and constancy of form and meaning that European art had lost, or indeed never possessed. The quality that Kramrisch regarded as the defining characteristic of Indian art – the constancy of inner meaning expressed through (and despite) changing exterior form – was now being gradually acquired by Western art, through, she argued, successive stages of modernist abstraction's retreat from imitative naturalism. The latter, she felt, saw only the exterior of a thing and lacked an appreciation of inner, essential qualities. It was these inner meanings, she argued, that Indian art had long prioritised in its plastic arts.

Kramrisch and the Hindu Temple

Kramrisch's work is unified by her recurring claim that an "essence" subsists in all the art she describes. This thesis is elaborated most fully in *The Hindu Temple* (1946) – the book, she claimed,

[18] Kramrisch, "Indian Art in Europe".
[19] Kramrisch, "Recent Movements in Western Art", 77.
[20] Ibid., 78.

"into which I put all that I know."[21] The first volume contains a detailed description of the form and meaning of the Hindu temple using the northern Indian medieval Nagara style as the definitive form for all Hindu sacred architecture. While earlier comparative chronologies of the medieval Hindu temple regarded it as representative of a culturally degenerate phase in Indian history following the decline of Buddhism and preceding the Islamic conquest, Kramrisch constructed a reading based upon the existence of an unending genius emanating through the art of South Asia from the third millennium BCE. In her analysis the Hindu temple is not an entity in history but a space of thought in which the extraordinary architectural diversity of 1200 years of temple construction could be encapsulated. Her archetypes were the temples created between the ninth and twelfth centuries: these temples were no less, or more, than the culmination of three millennia of art in the subcontinent, a continuity in which Buddhist and Jain traditions were accommodated as tension or reform within the whole of Hinduism. Kramrisch saw a commonality of expression in this art, regardless of its provenance, which she believed reflected unifying principles of form.

This stress on the continuity of attributes and meaning in Hindu sacred art excluded the arts that could not be categorised broadly as either Buddhist or Hindu. South Asian Islamic arts and architecture are outliers in her analysis. Her separation of Hindu and Muslim (and the elision of the latter) resonates with the scholarly division of Indian history into religious epochs during the British colonial period. Kramrisch inverted the colonial British preference for the symmetry and geometry of (selected) Islamicate form and invested her reading of Indian art in a similarly selective distillation of Hindu sacred art.

The origins of the "essence" which animates and unifies her analysis lie in formative intellectual encounters experienced by

[21] Kramrisch to Richter, 13 June 1945, Letters to and from Dr Stella Kramrisch, Mss. Eur. F147/70, OIOC.

Kramrisch before she left Europe. Her work is located within the scholarly genealogies of German romanticism's idealisation of Indian art and religion, though her first-hand encounters with India place her work significantly beyond the frames of text-based German Indology.[22] More subtly, Kramrisch's readings of the temple register the influence of European cultures in art and dance, in particular, the notion of embodiment. Kramrisch had danced publicly in Vienna. A poster found in Vienna after her death by friends (Image 6.2) attests to her giving public performances though her repertoire – whether ballet, folk, or Ausdruckstanz (expressionist dance), of which Vienna was a centre – is less certain.[23] Rumours circulated that while in London she danced privately for an audience which included Rabindranath Tagore, though such gossip may well be the result of misogyny and xenophobia. What seems more certain is that Kramrisch's evocative descriptions of the kinetic potential of Hindu sculpture – of movement dwelling in one moment – are intellectual manifestations of her experience as a dancer.

The esoteric thought of Theosophy, a philosophy popular in the Vienna circles in which she moved during her student life, undoubtedly exercised a formative influence on Kramrisch's thought, though she explicitly denied it any importance.[24] She may never have embraced the spiritual practices or convictions of Theosophy, but her emphasis on energies contained within and communicated by physical form resonate quite profoundly with Theosophical writings. The Theosophist Claude Bragdon, writing on architecture at the beginning of the century, described "correspondences not altogether fanciful between the animate body of flesh and the inanimate body of stone."[25] Kramrisch's description

[22] Willson, *A Mythical Image*.

[23] This poster is reproduced with the permission of Marguerite Dove, who found the poster, and Helen Drutt-Smith, who provided the image.

[24] Miller, *Exploring India's Sacred Art*, 6.

[25] Bragdon, *The Beautiful Necessity*, 52.

of the temple as the purusa (body) and the domain of god – a central tenet of her analysis in *The Hindu Temple* – chimes with Bragdon's observation that during "periods of mystical enlightenment, men have been wont to use the human figure, the soul's temple, as a sort of archetype for sacred edifices."[26] The relationship between these ideas should not be understood reductively. However, they provide the connective tissue between Kramrisch's thought and the schools of European experimental thought – and in particular those explicitly influenced by "the East" – from which her career as an art historian emerged.

Just as Kramrisch's analysis owes a debt to schools of European thought, her intention as an art historian was to disseminate readings of Indian art that broached and dismantled European discomfort with Indian art forms. The superabundance of Indian art, the "endless curves of wavy motion as the life-gestures of Indian art," created a "family likeness" which, to the outsider (and tacitly of course to the European outsider) could appear as "tremendous monotony". Equally alienating was the absence of "ethics" from Indian art:

> Contrast and excitement, tragedy and struggle, do not enter the texture of an Indian work of art; it never serves as a stage for conflicting emotions; it does not exhibit anything; it stands as impartial expression for a totality of emotions which, however contradictory they be, are fused into one whole, of which the taste is beyond reproach. It is so rich that the wonder of its simplicity almost becomes a matter of course. The ethical moment which means distinction, and therefore limitation, loses its value and no part is taken for God or for Demon. Both are aspects of one creative force, and the plus or minus sign is given to it without emphasis.[27]

Implicit in this description is a comparison with the Judaeo-Christian frame of European art. Kramrisch assures her readers that the narrative tensions and morality of Western art could

[26] Ibid., 53.
[27] Kramrisch, "The Significance of Indian Art", 1–7.

be neither found nor expected in Hindu sculptural art. Her descriptions render the Hindu temple as the manifest eternal, restrained by particular qualities of form but ever subject to the complementary processes of either elaboration or dissolution. Her ideas are expressed in fluid, vivid, and evocative terms, in a style within which literary suggestion occasionally eclipses analytical precision.[28]

Kramrisch regarded all Hindu art as indivisible from the divine. Divinity radiates out of the temple, through the forms of figurative sculpture on the exterior, as devotion is poured in through the inner sanctum. The divine is held within the temple by virtue of its construction; of the mantras, rituals, and investments made while the temple takes form. Once constructed, the divine is a manifest energy and property inherent in the temple, indivisible from it. Her analysis captures not only the meaning but also the being of the temple, merging the transitory manifest, dṛsta, and the eternal unmanifest, adṛsta, as the source of the temple's fortitude. The strength of the temple lies in its conceptual endurance and the rhythms of its form, not in the properties of its materials. Indeed, Kramrisch emphasises the necessity of the temple's impermanence. Provided that "the Essence imbues and impresses the form", the temple could be made of any material; stone simply allowed the craftsman to create a permanence which had been unrealisable in clay, bamboo, or brick.[29] The "Essence" – which made the temple conceptually meaningful – was necessarily transcendent. This transcendence allowed, not unproblematically, the diversity of both structure and traditions of temple building in India to be elided. All temples provided variants of the same all-encompassing thesis: the temple as the articulated body of the divine, even if the temple can seem an elusive, distant referent. Her analysis is fixed on something beyond or ephemeral to the temple's material form.

[28] Meister, Review of *The Hindu Temple*, 180–2.
[29] Kramrisch, *The Hindu Temple*, vol. ii, 125.

The symbolic referents in Kramrisch's analysis also pushed the social, political, and economic contexts of temple construction, in any given period, to a very distant horizon obscured by the immediacy of devotion. For Kramrisch there was no tension between sacred sculpture revered as art and living devotion; indeed, in *The Hindu Temple*, the two are given as facets of the temple's meaning: "The atmosphere of the Mandapa is charged not only with the scent of flowers, burning oil lamps, and the incense coming from the sanctuary, but is tense with the impact of the pillars and carvings."[30]

Kramrisch reversed the late Victorian formulations which regarded sculpture as obscuring and therefore corrupting structural form, to present sculpture as the perfection of architectural form. She used temple sculpture to create a contradistinction between the form and meaning of European and Indian plastic art. Whereas in Europe "[the] notion of sculpture, i.e. of giving form by detached movements to a hard and unyielding material is valid," in India sculptural form is characterised by fluid, meditative modelling; the planes of movement flowing seamlessly into one another in a plasticity which she describes as "accentless": "In India, on the contrary, marble or wood appear as if kneaded in a continuity, as if the hand were never separated from the mass and were never losing touch with the material. There is something fluid in his [the craftsman's] rendering; a peculiar perpetual balance of up and down that does not admit any halt, any accent, any emphasis."[31] She sees the apsaras (guardian deities), celestial lovers, divine and semi-divine figures as essential sculptural components inseparable from the form of the temple. The sculptural exterior was animated, or in her terms "innervated", energised by divine breath from within.[32]

[30] Ibid., 299.

[31] Kramrisch, *Indian Sculpture*, 131.

[32] Ibid., 5; Bhuvanendran, *Interpretation of Indian Art*.

The carved figures on the surface of the temple are thus at different distances from the centre. They are part of it, not only ritually and iconographically but also in their position in space. They appear projected from the centre through the thickness of the wall [. . .] This closely enmeshed dynamic mass, its impact coming from the centre, whence every figure derives its power and name, meets the gaze and movement of the devotee as he circumambulates it. Profile after profile meets his vision, each a fresh leaf in the book of revelation of which every temple is a copy.[33]

Kramrisch's texts are embedded within and embrace Indian devotional and spiritual sensibilities. However, contrasts with European and particularly Christian form – as will be seen in the subsequent discussion of the Warburg Exhibition of 1940 – provide both tacit and occasionally explicit frameworks of description and analysis. Her analysis is both a reaction to the aesthetic discomfort which characterised European reactions to Indian art and to the dominant, if pre-Expressionist, properties of European art: naturalism and portraiture.

Her emphasis on contrast rather than comparison is at variance with the views of Ananda Kentish Coomaraswamy, the more eminent contemporary interpreter of South Asian art who explicitly sought equivalence for Asian art within the given parameters of Euro-American art history. Coomaraswamy published his first analysis of Sinhalese art, *Medieval Sinhalese Art*, in 1908 and later turned to Indian art, befriending, as did Kramrisch, the Tagore family. The registers of Coomaraswamy's interpretations were far more amenable to the British art-historical establishment.[34] Unlike Kramrisch, he explicitly broached political questions in his work and co-founded the India Society in 1910, appealing to the mildly dissident English art elite through both politics and aesthetic

[33] Kramrisch, *The Hindu Temple*, vol. II, 301.

[34] Mitter provides a brief and cogent summary of Coomaraswamy's tendency to fix his analysis in European thought: Mitter, *Much Maligned Monsters*, 283–6.

sensibilities.[35] His approach owed much to the anti-industriali-
sation of the Arts and Crafts movement, placing Sinhalese and
Indian art within familiar frames of aesthetic reference. Kramrisch,
on the other hand, avoided any reference to politics or, indeed,
an Indian present. Her analysis combined mystical (Theosophi-
cal) relationships between matter and energy with explications of
form that were deeply embedded in the linguistic and devotional
registers of South Asia. In 1947 Coomaraswamy described *The
Hindu Temple* as "magnificent" and endorsed Kramrisch's singu-
larising approach to "*the* Hindu temple, irrespective of period or
relative complexity or simplicity." His own analysis of the temple
repeated, in general and literal terms, Kramrisch's interpretation
of the temple as purusa (body) and emphasised the immaterial
and even iconoclastic purpose of the temple as a portal to ultimate
liberation of the self. For Coomaraswamy, the analogous rela-
tionship between body, architecture, and cosmos was not simply
Indian but a "world-wide" pattern of sacred form.[36]

Kramrisch's explication of Hindu sacred art avoided reduc-
tive comparison and her ideas were presented in dense prose
laden with technically complex terms, factors which undoubtedly
rendered her work less palatable to the British art-historical imagi-
nation. Coomaraswamy was well known in British art circles by
the inter-War period, a factor which undoubtedly left Kram-
risch at a disadvantage as she attempted to establish herself in Eng-
land. As we shall see below, she did enjoy a relationship with William
Rothenstein, director of the Royal College of Art and Coomara-
swamy's intimate friend. Her failure to enter the European art-
historical establishment lay in a breach of ideas, however, rather
than of personal relationships.

[35] Coomaraswamy, *Essays in National Idealism* and *Art and Swadeshi*. For
a fascinating analysis of the context and insights of Coomaraswamy's work,
see Linda, "Zimmer and Coomaraswamy".

[36] Coomaraswamy, "An Indian Temple", 105.

The Search for Acceptance: Stella Kramrisch, William Rothenstein, and British Art History

Kramrisch carefully avoided passing comment on the politics of anti-colonial resistance which surrounded her during her career in India. She did, at the end of her life, speak of the uncertainty and anxiety of the period and in the 1930s sought a return to London, where she had stayed briefly before her departure for India in 1921. The uncertainty was not limited to the vibrant nationalist politics of inter-War Calcutta. Sir Ashutosh Mukherjee, as the vice chancellor of Calcutta University, had been a friend, as also a patron of Kramrisch's career. After he died, in 1924, just a year after her appointment, she faced hostility from his son, Syama Prasad Mukherjee, whose nationalism was expressed through the cultural politics of Hindu chauvinism.[37] She described the problems she faced working in Calcutta: "My former pupils have been given positions far above my own and the facilities given to them they do not use. It is not stimulating to be compelled in a cramped position to go on fighting – always on the defence. This is all that can be done here and it would be useless to hope or try for more."[38]

In 1931, amidst the political turmoil of the satyagraha (Gandhian peaceful mass resistance), militant nationalism, violent state repression, and the Round Table Conferences, Kramrisch, an astute and enterprising dealer in antiquities, made a loan of forty-two sculptures to the Victoria and Albert Museum.[39] These sculptures

[37] Miller, "Stella Kramrisch: A Biographical Essay", 11.

[38] Saxl claimed to have spoken to Lord Lawrence Dundas, former Secretary of State for India, and Sir Neill Malcolm, in connection with Kramrisch's suitability for a post in the proposed "Oriental Museum" in London: Kramrisch to Rothenstein, Calcutta, 25 January 1938, TGA 962/1/4/198, William Rothenstein Correspondence, Tate Archive, London.

[39] Kramrisch to Maclagan, 9 January 1931, Registry, Kramrisch, Dr Stella, MA/1/K1072, VAMA.

formed a new, coherent core to the India collections of the museum which had been so disparaged by the art historian and advocate of Indian art, E.B. Havell.[40] This loan, and a subsequent, smaller loan made to the Indian Institute in Oxford, was undoubtedly an attempt by Kramrisch to create a presence within the British art establishment. She had approached William Rothenstein, director of the Royal College of Art, to arrange the loan. In orchestrating the temporary loan of the sculptures to the Burlington Club in 1931, Rothenstein recognised the particular value of the collection at a time when tastes in Indian art were changing: "The Collection [. . .] is a remarkable one, including just the things that the older school did not care for and which appeal particularly to us today."[41] Rothenstein was a powerful figure in British art circles, a factor which undoubtedly influenced Kramrisch's decision to seek his mediation. He had an interest in Indian art, having also been involved in the foundation of the India Society in 1910 as an institutional space for the study and patronage of the Indian arts after Sir George Birdwood's belligerent and oft-cited dismissal of Indian sculpture.[42] He had both painted and collected during his visit to India in 1910.[43] Initially Rothenstein showed little favour to Kramrisch. His advice to Rabindranath Tagore not to recruit Kramrisch for Santiniketan was a misogynist underestimation of her abilities: "One wants more than a single meeting, on either side, in such important affairs. Perhaps I am unduly suspicious of the softer sex. But when great things have to be carried through, I doubt whether it is wise to encumber yourself with

[40] Turner, "The 'Essential Quality of Things'", 245.

[41] W. Rothenstein, RCA, to Russell, Burlington Fine Arts Club, 30 January 1931, Victoria and Albert Museum, Registry, Kramrisch, Dr Stella, MA/1/K1072, VAMA.

[42] Birdwood, *Journal of the Royal Society of Arts*, 4; *The Times* (London, England), Monday, 28 February 1910, 6.

[43] Arrowsmith, "'An Indian Renascence'".

almond-eyed ladies, however devoted to stupas & Boddhisa-
tras [*sic*]."[44]

Rothenstein did subsequently help Kramrisch to obtain a visa
to travel from Britain to India and had, he claimed, taught her at
the National Art Library and Victoria and Albert Museum while
she awaited permission to travel.[45] Their relationship developed
subsequently by correspondence and Kramrisch appears to have
held Rothenstein in considerable regard. She sent at least two pieces
of sculpture as gifts from India, an act of judicious generosity
which marked Rothenstein's attraction to Hindu art and his power
within the networks and institutions Kramrisch sought to en-
ter.[46] Soliciting a contribution from him for an early issue of the
Journal of the Indian Society of Oriental Art, she flattered him as a
"leading artist who is most profoundly in touch with the plastic
quality of Indian sculpture."[47] By the 1930s Rothenstein returned
the compliment in acknowledging Kramrisch's talents, albeit indi-
rectly, in a letter to Rabindranath Tagore: "To my mind she [Kram-
risch] has the profoundest understanding of Indian plastic art of
anyone I have met."[48]

As much as Rothenstein latterly acknowledged Kramrisch's
gifts, he appears to have done little to assist her in obtaining an
English appointment. When the Royal Academy planned a Winter

[44] Rothenstein to Tagore, 23 April 1921, in Lago, ed., *Imperfect Encounter*,
281.

[45] Memorandum, India Museum, A.J.D. Campbell, 1931, Victoria and
Albert Museum, Registry, Kramrisch, Dr Stella, MA/1/K1072, VAMA.

[46] Kramrisch gifted Rothenstein a "shivastric head" in 1931 and a "carved
apsaras" in 1935: Kramrisch to Rothenstein, 10 July 1931, Letters to William
Rothenstein, Houghton Library, Harvard; Rothenstein to Tagore, 25 June 1935,
in Lago, ed., *Imperfect Encounter*, 354.

[47] Stella Kramrisch to William Rothenstein, 7 June 1932, Letters to Wil-
liam Rothenstein, Houghton Library, Harvard.

[48] Rothenstein to Tagore, 27 October 1934, in Lago, ed., *Imperfect En-
counter*, 352.

Exhibition on Indian Art for 1939–40, Kramrisch asked Rothenstein directly whether she could be entrusted with the selection of exhibits: "Almost every object in the various museums, collections and in the field throughout the country is known by me . . . I shall feel happy if I can be of help to the exhibition by selecting the exhibits in India. Would you care to suggest that I may be entrusted with this task?"[49] When the Winter Exhibition Committee did meet to plan an exhibition, it was decided that no exhibits would be brought from India. Kramrisch's name was never mentioned.[50] The exhibition was cancelled when war broke out. When it was mounted in 1947, Kramrisch was on the Indian executive committee. However, her name was not raised in connection with the publications and lectures associated with the exhibition. The experts whose opinions were courted on Indian sculpture were Ananda Coomaraswamy, Dora Gordine, Kenneth de Burgh Codrington, John Conran Irwin, and Frederic Henry Gravely, none of whom possessed Kramrisch's exceptional familiarity with the materials.[51]

Many factors may have accounted for Rothenstein's reluctance to act as a patron for Kramrisch's career. His suspicion of her abilities as a woman art historian may have endured, regardless of her talents and generosity towards him. However, Rothenstein also developed his own theories about Hindu sculpture during the 1920s and 1930s. These ideas, and their relationship both with existing aesthetic dogmas and Kramrisch's thinking, provide some understanding of why Rothenstein was not prepared to assist Kramrisch's search for an English appointment.

In 1926 Rothenstein set out a thesis of Indian sacred sculpture which stood starkly at odds with Kramrisch's work. For him, the greatest phase of Indian art belonged to the centuries

[49] Stella Kramrisch to William Rothenstein, 28 August 1937, Letters to William Rothenstein, Houghton Library, Harvard.

[50] Minutes of Winter Exhibition Committee, Royal Academy, 1947–48, RAA/PC/6/13/1, RAA.

[51] Ibid., RAA/PC/6/13/2, RAA.

between 200 BCE and *c.* CE 600–700. He closely followed British antiquarianism in celebrating the Buddhist stupas of Sanchi, Bharhut, and Amaravati; the sculptural remains of Mathura; the rock-cut temples of Elephanta, Ellora, and Karli; and the sculptural art and shrines associated with the Gupta dynastic period (*c.* CE 400–600). The stupa sculptures showed, he claimed, "a freedom of execution, and often a bold and secular spirit of adventure."[52] This early freedom of expression was gradually but definitely eroded not by the displacement of Buddhism but by the concomitant rise of Brahmanical priestly authority and the proliferation of Sanskrit texts on art and architecture. Rothenstein still waxed lyrical about the aesthetic qualities of the later medieval temples he had seen in Bhubaneswar and Khajuraho: "I doubt whether anything lovelier has been made by the hand of man than the Indian mediaeval temples late in date though they be."[53] However, his thesis plots hieratic literature and priestly authority against aesthetic decline. He imagined the rise of a priestly class both able and inclined to impose their authority, through texts, over artisans and, through them, temple art. He evoked Coomaraswamy's comparative pan-medievalism to question the role and significance of devotion in the work of Indian artists.[54] "It is doubtful whether the Indian carver had more purely spiritual ends in view than other artists in Europe and Asia. He shared the faith, common among all artists, that by subjecting his will to the discipline of appearance, something of the unknowable reality, of which appearance is the symbol, may fecundate his handiwork."[55]

Rothenstein's ideas aligned closely with those of Kenneth de Burgh Codrington, keeper of the Indian Collection at the Victoria

[52] Rothenstein, "Prefatory Essay on Indian Sculpture", 2.

[53] Ibid., 5.

[54] "Apart from the erotic tendency, this later Hindu art has much in common with our own medieval sculpture; indeed we ask ourselves too who were the craftsmen who carved the noble figures at Chartres, and Amiens, and Wells?", William Rothenstein, "The Genius of Indian Sculpture", 783.

[55] Rothenstein, "Prefatory Essay on Indian Sculpture", 3.

and Albert Museum and, later, professor of Indian archaeology. Throughout his career, Codrington advocated an interpretation of Indian art which was primarily historicist; promoting the archaeological ordering of Indian material over interpretation. He repeated the thesis of hieratic ascendancy and aesthetic decline. The later works, "made according to priestly rule, are not beautiful, possibly because the artist was no longer free, but bound by verbiage."[56] To Rothenstein, the mere fact of hieratic authority inhibited the free expression of the sculptor. Codrington went further, charging the decline of beauty to the nature of Vedanta philosophy. The anti-materialism of Vedanta, he claimed, prohibited meaningful art. Rothenstein and Codrington provided a new, or rather recalibrated, rhetoric for the aesthetic evaluation of Indian art, and in doing so renewed the disappointment felt by Western aesthetes at the decrepitude of Indian art after Buddhism.

Rothenstein and Codrington's theories were at odds with Kramrisch's commitment to the use of Sanskrit texts in understanding Indian art. Their views represent a continuity of British analysis that began with the rejection of Ram Raz's work and the ascent of James Fergusson as the pre-eminent arbiter of Indian architectural form. Whereas Rothenstein regarded texts as constituting impediments to the "artist's intuitive faith",[57] Kramrisch regarded texts as essential tools in the analysis of Indian art. She distils each part of the temple, and the relational dynamics of temple architecture, into a symbolic formulation based on texts. She maintains the centrality of the object and the artist, and is convinced that the principal mode of tradition was oral, but imagines a very different relationship between text and artist:

> [The artist is] at his best when the subject which he is going to form, the mantram which he knows by heart, has become so familiar to him that he does not know of it any longer as existing outside himself so that he could depict it. It has sunk into him; and he creates it

[56] Codrington, *The Study of Indian Art*, 15.
[57] Rothenstein, "Prefatory Essay on Indian Sculpture", 2.

afresh, detaches it from himself by infusing his Self into the sacred prescription. Then his inmost life and the deepest meaning of the prescribed formula become one. The limbs of his new-born God are made to carry their splendour borrowed from another world; rocked in the safe cradle of his vision.[58]

For Kramrisch, therefore, texts provided an indispensable repository of meanings and form. In fact, since she saw no decline in the post-Gupta period, for her Hindu art came to an apogee by the tenth and eleventh centuries, and the accumulated wealth of texts during the same period offered a bounty of interpretative opportunity.

In the 1920s she began her work on the *Visnudharmottara-purana* (dated to the 6th/7th century CE) and published translations in 1924 and 1928.[59] Her translation was challenged by Coomaraswamy, who published a translation of the forty-first chapter of this Purana in 1942 and described Kramrisch's earlier translation as "by no means satisfactory".[60] Her use of Sanskrit texts has remained controversial, not least among those Sanskritists who abhor any usage which could be interpreted as instrumental. Her interpretation drew on an eclectic and extraordinary range of texts to create narratives of conception and structural generation in which documented architectural examples played a smaller role than abstractions drawn from and seen to lie upon the authority of texts. In *The Hindu Temple* she refers to specific texts far more than to specific temples. In describing the plan of the temple – the vāstupuruṣamaṇḍala – for example, she weaves together the essence of the temple through abstract measures of geometry and cosmology with no reference to actual sites or structures.[61]

At the heart of Kramrisch's analysis lies the origin of the temple

[58] Kramrisch, "The Significance of Indian Art", 7.

[59] Kramrisch, "The Visnudharmottaram"; idem, *The Viṣnudharmottaram (Pt III)*.

[60] Coomaraswamy, "Visnudharmottara, chapter XLI".

[61] From vāstu (dwelling place), puruṣa (cosmic man), and maṇḍala (closed polygon): Kramrisch, *The Hindu Temple*, vol. 1, 21.

as a Vedic fire altar. The impermanence of the mud brick of which the altar was constructed is not incidental but fundamental to her reading. The medieval temple's variant forms were an "articulation of the perimeter of the temple" but did not change its essence and core meanings.[62] In other words, she asserts that her interpretation of the temple's essence is equally applicable to all of the vast diversity of these architectural and iconographic forms in India. Her alignment of devotion, text, and form stands in contrast to more recent analysis in which the increasing elaboration of temple structures in the early medieval period are regarded as an attempt to challenge the scriptural, exegetical authority of the Brahman priestly class.[63] In Kramrisch's interpretation, as in that of her peers, Coomaraswamy and Heinrich Zimmer, sculptural form, text, myth, and devotion exist as a single and harmonious matrix in which meanings were made.

A Better Alliance: Kramrisch and the Warburg Institute Exhibition, 1940

Between 1936 and 1940 Kramrisch undertook a gruelling annual calendar of teaching in both India and England, leaving Calcutta each May to spend the summer teaching at the Courtauld Institute in London and returning in October. It was during the years she taught at the Courtauld that she developed a close relationship with Fritz (Friedrich) Saxl, the director of the Warburg Institute, and Gertrud Bing, the institute's assistant director (and Saxl's life-partner). Unlike Rothenstein, Fritz Saxl enthusiastically undertook to act as patron to Kramrisch's career in England, though it was a role to which he was less suited.[64] Her relationship with the

[62] Ibid., 103.
[63] Willis, *The Archaeology of Hindu Ritual*.
[64] In 1944 Saxl claimed to have lobbied the Courtauld Institute to keep her position open and to have convinced Kenneth de Burgh Codrington that Kramrisch should take over from him as keeper of the India collections

Warburg Institute, although brief, shows a confluence of ideas which emerged from common roots of thought in Central Europe. Saxl had become Aby Warburg's librarian and research assistant shortly before the outbreak of the First World War and had taken charge of the library after Warburg's breakdown. Bing was Warburg's personal research assistant in 1924 until his death in 1929. Saxl and Bing transformed the library in Hamburg into a research institute, according to Warburg's vision, and oversaw the institute's transfer, or rather escape, to London in 1933.[65] Correspondence in the Warburg archive between Saxl and Kramrisch begins in 1939, though the circumstances of their first encounter in London are unclear. They had much in common. Both had encountered India through Central European Indology: Kramrisch claimed to have read the Bhagavad Gita while at the gymnasium; Saxl had, claimed Bing, acquired Sanskrit alongside Greek and Latin while young at the insistence of his father.[66] Both studied art history at Vienna University, and both under Max Dvořak, another migrant from Bohemia to Vienna.[67] The intensity of the personal relationship they shared is indicated in a will left by Kramrisch at the institute, witnessed by Saxl, in which she bequeaths her collections of Indian art – then held on loan by the Victoria and Albert Museum, the Indian Institute in Oxford, the Watts Gallery Compton Surrey, and Codrington – to Charles Mitchell (1912–1995), a young scholar associated with the Warburg Institute.[68]

Kramrisch expressed an intellectual debt she felt she owed to

at the Victoria and Albert Museum: Saxl to Kramrisch, 14/3/1944, Correspondence, Stella Kramrisch, WIA.

[65] Bing, *Fritz Saxl*.

[66] Ibid., 2; Miller, *Exploring India's Sacred Art*, 5–6.

[67] Kramrisch was born in Nikolsburg (now Mikulov); Saxl grew up in Vienna but his grandparents lived in Senftenberg, part of what became known, and disputed, as the Sudetenland.

[68] The will is made in the context of the war; an exceptional and terrifying

Saxl, who commissioned "Aspects of Indian Art" as part of the institute's series of photographic exhibitions. Her acknowledgement drew on the idiom of Buddhist sacred texts, though the ascription of the roles she evokes – that of Bodhisattva (an enlightened being) and Vidyadhara (a mythic demi-god) – is not entirely clear:

> I do hope this exhibition will open the eyes of some people to see things afresh; things of which they were not aware and which matter. If it does, please take it as a symbol of return to you. You have made real to me a work in which I always had believed and of which I had come to think as unattainable. In the sustained "ceremony of opening the eye" which you have performed on me during these months you have made me see and know the kindness which comes from understanding, the thoroughness of application which comes from consistent thought and their results. Perhaps I will be able to contribute to them. This is how it should be when a Bodhisattva is near and a Vidyadhara passes by.[69]

The Warburg Institute exhibition in London in 1940 was a key moment in both Kramrisch's career and in that of the Hindu temple in the metropole. It was also the culmination and endpoint of Kramrisch's unsuccessful attempt to find permanent employment in England. Her prolific work on Indian sacred art had found gradual recognition, and yet, by 1940, crucial divergences between her interpretations and those developed by British art historians led her to abandon her attempts to find work in Britain and made her turn her attention to the United States.

"Aspects of Indian Art", co-sponsored by the India Society, ran

time not least for Jewish migrants from Central Europe. The will was composed shortly after Kramrisch's mother died in the Loetz ghetto in Poland, having been transported from Vienna in October 1939: Mason, "Interwoven in the Patterns of Time". The will is dated, London, 27/5/40, Correspondence, Stella Kramrisch, WIA.

[69] Kramrisch to Saxl, Liverpool, 13 November 1940, Correspondence, Stella Kramrisch, WIA.

from 14 November to 29 December 1940 and was visited daily by thirty to fifty people.[70] The exhibits consisted of 300 photographs, displayed on thirty-five boards, and divided into three sections.[71] It was considered a popular success, remaining open for six weeks – through the bombardment of London.[72] It was also incongruous among the other exhibitions held at the Warburg, which reflected more closely the institute's principal concerns with European culture.[73]

The evacuation of the artefacts from London museums (which Kramrisch anyway regarded as mere fragments) gave her a freedom to organise the exhibition in an unprecedented way, foregrounding photographs as the means to display both artefact and

[70] Bing to Kramrisch, 3 December 1940, Correspondence, Stella Kramrisch, WIA.

[71] The original panels from this exhibition are now lost. Only photographs taken of each panel in order to compile a catalogue of the exhibition remain. SECTION I: I. The Setting of the Indian Temple; II. The Spire of the Temple Represents the World Mountain; III. The Wall of the Temple and the Symbolism of its Figures; IV. The Sanctuary Represents the Cave in the World Mountain: "The Womb of New Birth", Garbhagyha; V. Symbols of Initiation, Lustration and Dedication; VI. The Poise of the Body; VI–VII. Symbolism of the Human Body; VII. The Lightness of the Body; VIII. Images of the Main Hindu Divinities; IX. Main Images of the Religious Reform Movements; X. The Superhuman Face; xi. Recurrent Themes of Reliefs; XII. The Animal as Seat of the Divine Presence "Vahana" and the Anthropomorphic Image of Divinity; XII. The Animal and Divinity; XIII. The Reliefs on the Wall. SECTION II: I. The Rock-Cut Buddhist Temple "Stupa-Hall" 1st Cent. BC – 6th Cent. AD. Out of the Seclusion of the Monk's Cell Grows the Rock-Cut Buddhist Monastic Establishment; III. Early Monastic Reliefs; IV. Late Buddhist; V. Rock; VI–VII. Images Carved in Recesses of Rock-Cut Walls; VIII. Cave Pillars; IX. Legends Carved on the Surface of Rocks. SECTION 3: I–IV. Early Buddhist Art. No Anthropomorphic Images. Symbols Suggest Presence of the Buddha; VI. The Anthropomorphic Image of the Buddha with Its Consistent Symbolism; VII–XIII. Contacts of the Classical Art of the West and Indian Art.

[72] Lowden, "Hugo Herbert Buchthal", 322.

[73] Kramrisch's exhibition was preceded in 1939 by exhibitions on "The Visual Approach to the Classics" and "Donatello", and followed in 1941 by an exhibition on "English Art and the Mediterranean".

analysis. Kramrisch's exhibition begins with images of what she regarded as the most artistically accomplished temples dating from the ninth to the fourteenth centuries. Using these examples, she establishes the cosmological principles of Hindu temple architecture. The second section begins with Buddhist rock-cut temples dating from the first century BC to the fifth century CE and moves from these to the later Hindu rock-cut temples. The earlier period is not made, therefore, to provide an earlier developmental stage, but is instead a non-sequential elaboration on the already established principles of Hindu art. Both Buddhism and Jainism are accounted for, rather problematically, as "Religious Reform Movements" – as episodes subsumed within the whole of Hinduism. Within this unity, the exhibition emphasised visual association and, in particular, foregrounded movement. The spectator was invited through the exhibition space to begin to imagine the importance of devotional movement within the cosmology and physical space of the temple.

Kramrisch's analysis required a new way of not just seeing the temple but also of physically mediating it. The 1940 exhibition heralded a new mode of representing Hindu sacred art through the photograph. The photograph had been critical to Warburg's Mnemosyne project – an art history which sought to avoid any reliance on text.[74] Kramrisch's arrangements of photographs placed carefully on boards resonated with Warburg's visual encyclopaedias – displays of images which could be moved in relation to each other in order to explore the significances and connections of sculptural and pictorial form. In the second half of the nineteenth century, the representative techniques of line drawings, axonometric diagrams, and photographs had dissected the temple and lessened its exotic, and erotic, menace. These techniques straightened and dignified the temple as a subject of scholarly study, countering the excesses of the literary imagination and allowing its structure to be broken down into sections and properties which

[74] Michaud, *Aby Warburg and the Image in Motion.*

could then be coolly appraised. In contrast, Kramrisch's exhibition embraced the photograph as the means to communicate the cosmology of the temple through carefully arranged fragments of form and line. Each fragment was an articulation of a whole, and in each photographic image the lines of connection, association, and variance could be drawn out.

The careful arrangement of photographs presented new configurations of sacred medieval form. Kramrisch contrasted architectural and sculptural examples from Christian cathedrals within the panels with little explanatory text. Images 6.3 and 6.4 show the arrangement of images she used to compare form, between temples and cathedral architecture and sculpture, and the minimal text that accompanied the photographs. She had expressed an interest in this connection earlier, in 1922, soon after she began work at Santiniketan. In the art journal *Rupam* she had written of the "inner affinity" of the temple and the Gothic cathedral; both were, she wrote, "entirely *formed*. There is not the smallest space left free, everything is form, invention, life."[75] Having borrowed books on the medieval cathedral from the Warburg Institute's library, she made more in 1940 of the distinctions between the two. "The form of the archivolt leads the devotee into the church whereas the Indian temple projects its sculptures towards the devotee [. . .] the façade [of Reims Cathedral] with its carved door openings leads the devotee into the church. The Indian Temple has no façade. Its carvings project in all directions from its mass."[76]

The horizontal lines of the cathedral, the doors within a decorative façade, and the internal emphasis on directed movement were all placed in contrast to the temple. The temple created a model for a pilgrimage in which the devotee was alone, and engaged in preparatory, transitional, and cumulative aspects of a devotional journey around and within the temple. Kramrisch saw

[75] Kramrisch, "Indian Art in Europe", 84.
[76] Section I, photograph, II.4. and III.4, Catalogue of the Photographic Exhibition of Indian Art at the Warburg Institute, 1940, WIA, I. 24.I.

figurative sculpture on cathedrals as load-bearing, as weighed down by structural mass. The sculpted exterior of the temple, by contrast, was driven upwards and outwards by the energy within. In her preparatory notes for the exhibition, she described the contrasting cultural animation of temple and cathedral: "The Christian House of God rises above the resting place of the dead and points its spire towards Heaven. While, the Indian temple rising in the midst of nature or town leads from the profusion of life near its base to the ultimate point of union symbolised by the point of its tower."[77]

These connections between sacred architectures raise further questions about Kramrisch's analysis in *The Hindu Temple*, published six years after the exhibition. The descriptive and prescriptive terms she employed derive from an eclectic range of Sanskrit texts studied throughout her career. However, the interpretative dynamics and much of her vocabulary appear to emanate from deeper within her own life history and draw on the spatial relationships derived from a corpus of Judaeo-Christian concepts and forms. She refers, for example, to the tabernacle, iconostasis, and cincture of the temple.[78] The subtle comparison of form between temple and cathedral in the exhibition panels was noted by the philosopher, art critic, and curator Herbert Read – though, unlike Forster, he received them as an affirmation of his own confessional position.[79]

The first section of the Warburg exhibition, which orientated the exhibition as a whole – and which represents the portion to

[77] Notes for Warburg Exhibition, Undated, Stella Kramrisch Papers, Box 37, folder 11, PMA.

[78] Kramrisch, "Reflections on the House and Body of the Gods", 8.

[79] "A revealing contrast is made with the Gothic Cathedral: the contrast between the darkness of the womb, into which the introspective individualist of the East returns for meditation and rebirth, and the open spatial freedom of the Western church, where God is worshipped in community and aspiration." Read, "Indian Art", 779–80.

which Kramrisch was most devoted – contained forty photographs taken by Raymond Burnier, the Swiss photographer whom Kramrisch had known in India in the second half of the 1930s.[80] Burnier, Alain Daniélou, and Kramrisch, along with Alice Boner (another wealthy patron and analyst of Indian art), had spent summers together in Almora in the lower Himalaya, a hill station associated with the cultural and nationalist elite in the inter-War period.[81] Burnier's photographs play a pivotal role in Kramrisch's analysis of the temple. His photographs dissected the sculptural richness of the temple's exterior, creating the fragments that Forster, as discussed in the previous chapter, found more digestible for the Western palette.[82]

There is extraordinary drama in Raymond Burnier's photographs. Earlier photographs and line drawings were made in order to "show" the sculpture and to accompany expositional texts. Burnier's photographs are authored and titled works of art, a dramatic change from earlier periods in which photographs simply allowed a remote exposition of sculpture.[83] Burnier laboriously defied the intentions of the temple's builders to produce images which were never intended to be communicated from the point of view of the devotee standing at the base of the temple's walls. Before being photographed using scaffolding and ladders, the

[80] Burnier, based in Benares, acted as Publications Secretary for the *Journal of the Indian Society for Oriental Art*, co-edited by Kramrisch.

[81] Burnier had grown up in Algeria and, later, Lausanne in Switzerland. An heir to an aristocratic family enriched by the Nestlé business fortune, he had considerable financial resources at his disposal, a fact amply demonstrated by his lifestyle and resources, and of his life-partner of thirty-eight years, Alain Daniélou: Aldrich, *Colonialism and Homosexuality*, 282–3.

[82] Forster, Review of *The Art of India*, 977–8.

[83] Burnier's photographs were exhibited separately several times: an exhibition held at the University of Calcutta entitled "The Hindu Temple" in 1941 was described by Kramrisch as "Burnier's exhibition". Burnier's photographs were exhibited by the Metropolitan Museum of Art (1949), and in Paris (1950) by Pierre Bérès: Burnier, *Visages de l'Inde médiévale*.

sculptures were cleaned, rubbed with oil, and lines of fresh plas-
ter spread to accentuate their form as it emerged from the temple.
Alain Daniélou described the extent of the intervention in his
autobiography: "The work was very difficult. We had to clean the
sculptures, remove wasp nests, and carefully scrape off the re-
mains of lime which coated the temples. Then we had to build
scaffolding, wait under the burning sun for the perfect light, and
adjust the mirrors to enhance it."[84]

Kramrisch described these carefully engineered images as in-
timate glimpses of the artists' intention, downplaying the extent
of Burnier's physical intervention and visual authorship. That
which could not be seen (by the devotee) was, for Kramrisch,
still an "artistic fact"; Burnier's photographs communicated "the
living process of figured shape detaching itself from the monu-
mental mass."[85] Art history presents the sculpture as it could never
be seen by a devotee circumambulating the temple. Figure 6.6
shows a photograph of a dancing apsara, taken at the Jain Adi-
nath Temple in Khujaraho. The stone is oiled and illuminated to
highlight the curves of the apsara's torso, breast, jewellery, and
draped cloth adornments. The lens is level with the lower torso,
capturing the upward tilt of the apsara's chin and the dramatic
movement of her elbow and leg. Kramrisch's displays of photo-
graphs created an opportunity to re-present the temple in a way
which emphasised visual association and, in particular, fore-
grounded movement.

The exhibition at the Warburg Institute was opened by Sir
Francis Younghusband and the Secretary of State for India, Leo-
pold Amery. Neither shared Forster's interest in Indian contem-
porary cultural affairs. Younghusband's introduction combined
inaccuracy (describing Kramrisch as a "talented artist and photo-
grapher") with a meanness of tone over the exhibition's sig-
nificance. After mentioning the abandoned plans for a Royal

[84] Daniélou, *The Way to the Labyrinth*, 174.
[85] Kramrisch, "Reflections on the House and Body of the Gods", 9.

Academy winter exhibition, he rather grudgingly remarked that, until those plans could be revived, "we have to make do as best we can" with the photographic exhibition.[86] Younghusband's lack of enthusiasm can perhaps be indulged as the effects of age (he was then seventy-seven years old) and his attendance being a formality on behalf of the India Society rather than any great personal interest. It is also suggestive of the particularly British milieu which combined to keep Kramrisch from ever entering England's art-historical establishment.

The reception of the exhibition shows little appreciation of Kramrisch's principal interest in the conceptual ordering of the Hindu temple. As originally conceived by Kramrisch, the Hindu temple constituted the undiluted focus. In the notes on the exhibition, written in Calcutta, no mention is made of the exhibition's final thirteen sections entitled "Contacts of the Classical Art of the West and Indian Art".[87] These additions mark concessions to two sets of sensibilities not shared by Kramrisch: the British preoccupation with Buddhist architecture and sculpture, and Saxl's own obsession with classicism in all its forms.

Reviews tended to dwell on the Graeco-Buddhist section.[88] In lectures held by the India Society to link with the exhibition, the sculptor Dora Gordine, lauded as an expert on Indian art, presented an assessment of Indian sculpture that was in stark contrast, if not opposition, to Kramrisch's analysis. Echoing Victorian aesthetic sensibilities which regarded the Hindu temple as overly elaborate, she described the religious aspects of Hindu art as "the defects rather than the qualities of Indian sculpture; for in overloading the form with symbols and decorations they often mar its unity."[89] The Warburg exhibition distilled the fundamental aspects of Kramrisch's interpretation of the Hindu temple. It also

[86] Text of Younghusband, "Opening Address".

[87] Notes for Warburg Exhibition, Undated, Stella Kramrisch Papers, Box 37, folder 11, PMA.

[88] Exhibition of Indian Art: Reviews, WIA.

[89] Gordine, "The Beauty of Indian Sculpture", 43.

marked the closing of a chapter in her career and preceded the re-orientation of her ambitions away from Britain and towards the United States of America.

Kramrisch returned to India immediately before the Warburg exhibition opened in November 1940 in a state of despair and depression. She believed, or rather accepted, the extant divine in the materials of her work and summarised her own feelings about the divinity incarnate in the temples in a letter to Gertrud Bing, written from Liverpool as she waited to depart: "I wish I could mobilize some of the protecting forces on view in your exhibition to act against the noise of guns and bombs. They will do it in their own way, I am sure, 'merely by being looked at'."[90] After her return to Calcutta, she continued to correspond with Bing, Saxl, and the European medieval art historian Adelheid Heimann, with whom she had worked on the exhibition.[91] At Saxl's request, she had begun collecting photographs of Graeco-Buddhist sculpture. Willingly serving Saxl's obsession with the Euro-Asian edges of classicism, she promised to acquire photographs of "every trace of classical antiquity in the indigenous schools."[92] This labour resulted in the Warburg Institute's vast and still significant collection of photographs of sculpture from North Western India. No mention is made of this work in Bing's memoir, though much is made of the collection itself.[93]

Revealingly, none of Kramrisch's books are held in the library of the Warburg Institute. The correspondence between Kramrisch, Saxl, and Bing was disrupted by the war and dwindles in 1944. Though there is no direct evidence of a quarrel, Kramrisch wrote

[90] Kramrisch, London, to Gertrud Bing, 13 November 1940, Correspondence, Stella Kramrisch, WIA.

[91] Kramrisch to Heimann, 15 October 1941, Correspondence, Stella Kramrisch, WIA.

[92] Kramrisch to Saxl, Liverpool, 13 November 1940, Correspondence, Stella Kramrisch, WIA.

[93] Bing, *Fritz Saxl*, 32–3.

to a third party that she had received a "very curt note" from Saxl in 1945.[94] In the same year, both Kramrisch and the Warburg Institute found recognition: Kramrisch was awarded a chair in Art History at the University of Calcutta, and the Warburg Institute was made a part of the University of London.

Conclusion

After the war, Kramrisch reconsidered her options. In 1948 she removed her collections of sculpture from London and Oxford, transferring both to the Philadelphia Museum of Art. This clearly signalled her desire to pursue a career in North America and an abandonment of her attempts to find employment in Europe. The move was much to the chagrin of the director of the Victoria and Albert Museum, Sir Leigh Ashton, who believed the collection was now as good as permanent and who asked, unsuccessfully, that the museum be given the opportunity to buy the sculptures.[95] Powerless to prevent the transfer, Ashton pointed out to Fiske Kimball, the director of the Philadelphia Museum of Art, that, "a large proportion of the groups represent couples engaged in the sexual act . . . I am merely underlining this in order that you may be perfectly clear as to what you are getting . . ."[96]

Despite the limited British response to Kramrisch's work, her analysis and Burnier's photographs presented a new and enduring way of looking at Hindu sacred art. The exterior sculpture which so unnerved Victorians, now placed within discrete frames, has become the defining mode of visualising India's sacred art. There is an arch paradox in Kramrisch's contribution and legacy. Her

[94] Kramrisch to Richter, 11 December 1945, Letters to and from Dr Stella Kramrisch, Mss. Eur. F147/70, OIOC.

[95] Sir Leigh Ashton to Kramrisch, 8 November 1948, Victoria and Albert Museum, Registry, Kramrisch, Dr Stella, MA/1/K1072, VAMA.

[96] Sir Leigh Ashton to Fiske Kimball, Director, Philadelphia Museum of Art, 8 November 1948, Victoria and Albert Museum, Registry, Kramrisch, Dr Stella, MA/1/K1072, VAMA.

analysis makes the temple a whole, an architectural body uni-
fied and animated by divine energy. Her analysis captures the
extraordinary qualities of the temple as a palimpsest of material
and devotional forms in which a complex of divine and temporal
authority coexist. Yet the visual vehicles and principal referents
for this analysis – Burnier's striking portraits and the collections
of objects owned and mobilised by Kramrisch – were disembod-
ied from the temple. Both images and objects were necessarily
detached to become art: moveable, desirable commodities. Re-
moved from the temple, these fragments of Hindu sculptural art
have been reduced to almost random signifiers of an exotic erot-
ica. The de-contextualisation and de-sacralisation of these frag-
ments is remote from Kramrisch's intention. However, they can
be understood to be a powerfully resonant legacy of her work.
Her exhibitions, relying on Burnier's exceptional photographs,
aesthetisised Hindu sculpture while the networks of collecting,
dealing, and curation of sculpture in which she participated, and
which were paramount in her career, created a desire for the ob-
ject separated physically and conceptually from the divine and
energising temple complex.

Conclusion

THIS BOOK HAS described the tensions that characterised the relationship between imperial custody – whether regulatory, investigative, or fetishistic – and popular devotion across a century and a half of British colonial rule in South Asia. At the start of the nineteenth century, the British authorities sought to profit from the Hindu temple. The considerable wealth was a profound temptation but the colonial authorities also sought to absorb the temple into a narrative of benign and improving governance.

The subsequent withdrawal of official involvement in the governance and assets of the temples in South India at the beginning of the 1840s, driven by evangelical pressure, reprieved the Company government from its erratic and occasionally bewildered supervision of complex temple establishments. The metropolitan pressure to distance the colonial government from Hindu institutions was based on a moralistic condemnation of the Hindu temple generated by melodramatic, and often implausible, first-hand accounts that were amplified in fictional representations. These literary fictions grew lives and lineages of their own which flourished in the nineteenth and twentieth centuries. In them, the temple was fashioned into a thing that separated the imperial self, governmentally and morally, from a native sphere of subjecthood.

The colonial imagination created the Hindu temple as its own creature; a familiar thing deployed to embody strangeness. By the middle of the nineteenth century these edifices, hundreds of years old, were organised and ranked in archaeological and architectural scholarship. This work abandoned the wilder exaggerations

of evangelical Christianity (which continued to be propagated in the literary imagination) and instead sought to create definitive interpretations of the temple's materials and appearance. Intensive empirical study made the temple into a thing in history that was diagnostic of the nature and deficiencies of the peoples who created and inhabited it. Subsequent formulations in art history made the temple into a self-generating thing, amenable to fragmentary representation. Inter-War art-historical readings of the form of the Hindu temple removed it from the histories and landscapes in which it was built and instead emphasised the interplay of abstractions: divine power and hieratic authority.

Temples that emerged into living landscapes were regarded as unruly intrusions in spaces that the colonial state sought to organise, order, and improve. The idea of the temple in the colonial imagination was made in accordance with the characteristic delinquencies of Hindu society more generally: native recalcitrance, corruption, depravity, and aesthetic vulgarity.

My key argument is that none of the successive reformulations of the relationship between government and Hindu temple ever comprehended or harnessed the dynamic potential of the divine. Whether manifest as a many-walled, wealthy, and populous temple, or as a wooden platform around a modest clay Shiva swayambhu, the temple was, and remains, an expression of divine sovereignty. It was around this sovereignty that devotees, sevaks, and trustees arranged themselves, and it was this authority that the colonial state could neither reconcile nor control.

Divine sovereignty was a dynamic force that existed in the breach between devotional attentions and the rules created by the colonial state. This dynamic was not only the spiritual energy that Kramrisch lauded as the vitality that drove the structure of the temple upwards and outwards in ever more elaborate formations. Kramrisch's Hindu divinity was immense but always amenable to her analysis; her marshalling of temple form and meaning was untroubled by mortal interlocutors or devotional counterclaims.

The living divine which lay at the centre of a temple was created by a matrix of devotion and donation. It was this matrix that could pull the colonial state towards temples, a pull that the colonial state had variously embraced and resisted from its beginnings. Temples were, and remain, subject to the overlapping regimes of central and localised custody in legislation, institution, ownership, and management.

The temples described in this book have included a range of different forms and types, but have in each case been characterised by a dynamic capacity to emerge, enlarge, and change. The dynamic potential of the temple can accommodate multiple claims; indeed, a Hindu temple of any scale depends, first and foremost, on the negotiated balance between divine sovereignty and its earthly trustees. This dynamic renders the fixing of the material attributes of a temple – whether in extent or form – a persistent challenge to governmental regimes or political claims that depend upon the structure as a fixed and immoveable subject.

The Shiv Mandir described in Chapter 4, for example, was a potent idea inserted into a contested urban landscape. Its power relied on the imminence of its emergence and, most importantly, the assertion of that immediate potential as an act of resistance to an array of obstacles and opponents. The idea of a temple can exert a more powerful force than even – and perhaps especially – the oldest and most elaborate physical architectures. The temple as idea has an agility and malleability that no living, tangible temple possesses.

The potency of the idea of the temple brings us to one Hindu temple which emerged from the strained custodies of the colonial state to create a violent political and complex legal maelstrom: the Ram Mandir in Ayodhya. The history of religious structures and custodies in the northern Indian town of Ayodhya offers a case study of the complex post-colonial relationship between the materials of Hinduism, law, and politics. At the heart of the dispute is the idea of a temple destroyed in the sixteenth century

and then submerged under the construction of the Babri Mosque. The interpretation of archaeological remains excavated during the 1970s, or the repeated truism that centres of religious devotion tend to be discovered in the same place, found little if any purchase in the popular debates. The absent temple was made painfully manifest in the politics of Hindu nationalism. The Ramjanmabhoomi (birthplace of the deity Ram) located his mythical birthplace and, more pointedly, the idea of a temple once built to mark it. The movement combined outrage, that the temple that had marked his birth had been deliberately removed, and vengeance, a conviction that culpability for that destruction could be fixed in India's present. The movement gained momentum during the 1980s and called for the restoration of a sacred place to a wronged people, projecting a national and religious affront into the confines of a locality in a northern Indian city. The Ramjanmabhoomi movement culminated in the destruction of the Babri Masjid in December 1992 by a politically organised mob of Ram sevaks.

In the aftermath of the destruction, the Indian state acquired the disputed land in 1993, beginning twenty-seven years of a complex judicial process. The Supreme Court delivered a final verdict in November 2019, when the judgment handed the 2.77 acre site into the hands of the god Ram (a named litigant in the case) and created a trust, Shri Ram Janmabhoomi Teerth Kshetra, charged with building the new temple. An alternative plot of land was awarded to the Uttar Pradesh Sunni Central Waqf Board for the construction of a mosque to replace the Babri Masjid.[1]

The nature and interpretation of the physical remains found in various phases of archaeological excavation, before and after the destruction of the mosque, have been richly described and sharply contested.[2] Since construction of the Ram Mandir began, the Shri

[1] The Supreme Court Judgment. *M Siddiq (D) Thr Lrs v. Mahant Suresh Das & Ors.*, judgment https://www.sci.gov.in/pdf/JUD_2.pdf, retrieved 11 June 2021.

[2] For a brief summary, see Lal, *The History of History*, 150–3; for a com-

Ram Janmabhoomi Teerth Kshetra has announced the discovery of a large quantity of sculpted stone remains. The existence of the remains was announced on social media in May 2020, and, more recently, another social media post carried a photograph of a number of stone carvings described as the remains of "an ancient temple".[3] The discovery of such a wealth of materials – after archaeological excavations during the 1970s and in 2003 found scant evidence – is remarkable. Whatever their provenance, these objects – placed into the public realm with remarkable alacrity – remind us, like the objects "found" in Queen's Garden in 1938, of the potency of the submerged divine. The Ram Janmabhoomi movement was always greater than the materials whose meanings it transformed. Materials can always be found and assembled to serve the idea of a temple.

The idea of the Ram Mandir was a potent nationalist and internationalised symbol of religious offence. The temple lent itself to a range of purposes and expositions; it was retrieved and constructed many times over in many formats before the destruction of the Babri Masjid in 1992. Tens of thousands of bricks inscribed with Ram's name were sent to India as symbolic donations from across the world. A substantial and conspicuous collection of materials accumulated around the site immediately after the mosque's destruction. Material and digital models that have made the Ram Mandir manifest have proliferated and circulated for decades. In 2020, for example, a large model of the temple was constructed in a mall in West Delhi during Diwali celebrations.[4]

prehensive description, see Ratnagar, "Archaeology at the Heart of a Political Confrontation".

[3] @ShriRamTeerth, on twitter, 20 May 2020; @ChampatRaiVHP, on X (formerly twitter), 13 September 2023.

[4] *The New Indian Express*, 24 October 2020, https://www.newindianexpress.com/cities/delhi/2020/oct/24/with-replica-of-ayodhyas-ram-temple-west-delhispacific-mall-mall-showcases-faith-2214428.html. Accessed 11 June 2021.

Very much a creature of the political state, the Ram Mandir has been forced, through land acquisition and lengthy judicial process, into and beyond the place where the Babri Masjid once stood. Construction of the temple began in March 2021 and its first phase, a vast ground floor, was inaugurated on 22 January 2024. The final design of the Ram Mandir, a three-storeyed shikhara with multiple domed mandapas and ancillary shrines, is considerably larger than the initial plans created by the architect Chandrakant Sompura in 1989. Plans for the temple precincts have expanded in extent and architectural elaboration to fit the land provided by the 2019 Supreme Court judgment. When completed, the imposing architecture and landscaped grounds of the Ram Mandir will entirely redefine its locality. The temple structure will attempt to harness and, literally, enshrine the immense symbolic power of materials and images of an unbuilt temple that preceded and accompanied the destructive violence of December 1992. The foundations, for example, will incorporate the bricks sent from around the world during the Ramjanmabhoomi movement. When finally constructed, however, the Ram Mandir will inevitably stultify the extraordinary energy associated with the movement itself – a vast international lobby built on the non-existence of a temple.

Other movements emerged, parallel with the Ramjanmabhoomi movement, in the 1950s to assert spatial custody and divine authority in relation to submerged divinity. Recent court orders have required a survey of the Shahi Eidgah mosque and the Gyanvapi mosque in the northern Indian cities of Mathura and Varanasi, respectively. As the Ayodhya case makes clear, however, only modest claims can or need be affixed to excavated materials or documentation. The complex webs of court litigation are only juridical place-markers and prompts within a far larger and more diffuse political imaginary.

In its relationship to violence, religious exclusivity, and state power, the Ram Mandir has little in common with the agile shrines and devotional formulations that evaded and frustrated imperial

authority. The Ram Mandir will be a vast, singular physical edifice that embodies a monotonous iteration of Hinduism.

In order to explore the capacity of the temple to contain multiple claims and expressions of devotion and service, I want to turn to a more everyday example in which divinity exceeds and accommodates competing earthly claims: the Kalkaji Temple in Delhi. The earliest surviving architecture at the Kalkaji Temple complex emerged in the mid nineteenth century, though the site has been inhabited for centuries.[5] The donations to augment the shrine and build guest houses for devotees flowed from wealthy merchants in the old city, and the court of Akbar Shah II, fourteen kilometres to the north.[6] The dharamshalas represent the changing decorative and structural idioms favoured by these donors across 200 years of construction, adaptation, and renewal. The changing styles of expression are mirrored in the plaques which document the donations – in Hindi, Farsi, Sanskrit, Urdu, and occasionally English – across the site. The temple complex consists of multiple shrines around the central domed shrine dedicated to Kalka-ma, alongside habitations and a large number of stalls selling puja paraphernalia and now covers over thirty-five acres. The boundaries of the shrine are porous and indefinite and at present are subject to contestation with the Delhi Development Authority, the latter claiming that parts of the temple complex have spilled onto land owned by the municipality.

The shrines, dharamshalas, shops, and pathways are organised and controlled through an intricate overlapping patchwork of usage, custody, and property. Two committees of temple trustees coexist: the Sri Sidpreet Ma Kalkaji Mandir Committee and the Sri Kalkaji Mandir Parbandak Sudhar. The control of the ritual functions of the shrine and of offerings made to Kalkaji are divided between two principal groups – the Brahman pujaris (priests) and the ascetic jogis. Some of the dharamshalas are locked and

[5] Chakrabarti, "The Archaeology of Hinduism".
[6] Stephen, *Archaeology and Monumental Remains of Delhi*, 27.

some decrepit. The majority, however, are occupied by individuals, families, and groups of single male labourers who pay, by the standards of New Delhi, extremely low rents to the pujari proprietors. There is a web of litigations in Delhi courts over rights around the complex. However, injunctions tend to have the effect of further separating the differing parties and, in particular, limiting the ability of pujaris to articulate the property rights which all agree they possess.

Equilibrium at Kalkaji is maintained by, and not in spite of, uncertain and overlapping rights. This historically deep-rooted and complex palimpsest of claims is maintained because competing or contested rights are never articulated simultaneously. Stability is maintained by holding information, appropriately, within specific and discrete spheres of relevance and through the universal acknowledgement of the divine sovereignty of the resident and presiding goddess. Any attempt to fully disclose, compare, and calculate would be a direct questioning of the bounty of Kalka-ma.

No credible argument can be made that the temple at Kalkaji is "typical". However, the subtlety and intricacy of rights, both claimed and exercised, at Kalkaji is instructive. This complexity is of the same order that confounded the claims of the Company kacheri over the temples in the district of Trichinopoly in Madras Presidency in the early nineteenth century. The English collectors regarded the coexistence of different claims as evidence of either corruption or conflict. They insisted on definitive accounts of singular, proven, and absolute rights as a precondition of their arbitration over the temples' operation. Despite the fascinating nature of the materials that it contains, the uncertain custodies of the Kalkaji Temple make it an inconvenient monument for the authorities. In the early 1990s, its protection as a monument was proposed by the Delhi Circle of the Archaeological Survey of India. However its notification under the 1956 Act was quickly abandoned. Conservationist legislation requires certainty of custody, not negotiable and shifting rights.

Once it has been constructed as an orderly and expansive tourist and heritage site, the Ram Mandir complex is unlikely to allow any of the accommodations and ambiguities that characterise a shrine like Kalkaji. The Ram Mandir in Ayodhya will be a redoubtable edifice that will embody the politics of ascendant and triumphalist Hinduism. It will not replace the roadside shrines, the medieval temple complexes, or the hybrid monuments at which secular and devotional pieties combine. The temple's potency, as ever, will continue to be its richness, its evasiveness, and its variety.

Bibliography

Archival Collections

Archaeological Survey of India Files, Kolkata, Eastern Records Centre, Bhubaneswar.

Chief Commissioner Correspondence Files, Delhi State Archives.

Deputy Commissioner Correspondence Files, Delhi State Archives.

Government of Bengal and Orissa, Education Department (Archaeology), State Archives of Orissa.

Government of India, Home Department (Archaeology and Epigraphy), OIOC.

Home Department (Political), National Archives of India.

Lutyens' Letters, Royal Institute of British Architects

Proceedings of the Legislative Department, National Archives of India.

Proceedings of the Govt of Bombay, General Department, Archaeology, OIOC.

Papers of E.M. Forster (1879–1970), King's College Library, Cambridge.

Royal Society Archives, London.

Victoria and Albert Museum Archives, London.

Newspapers

Hindustan Times
Times of India
Morning Post
New Indian Express

Unpublished Sources

Chatterjee, Sria, "Circa 1922: Stella Kramrisch and the Bauhaus in Calcutta", unpublished paper presented at Divine Artefacts: Stella Kramrisch and Art History in the Twentieth Century symposium, Courtauld Institute, 7–8 December 2012.

Kasturi, Malavika, "Sadhus, Sampraday and Hindu Nationalism in the Early Twentieth Century: The Dasnamis and the Bharat Dharma Mahamandala", Nehru Memorial Museum Library Occasional Papers, August 2015.

Kramrisch, Stella, "Untersuchungen zum Wesen der frühbuddhistischen Bildnerei Indiens" (Investigations into the Nature of the Early Buddhist Artistry of India), PhD dissertation, University of Vienne, 1919.

Orr, Leslie, "What is a Temple and Who Does it Belong To? Answers for Colonial Madras", unpublished paper, Annual Conference on South Asia, Madison, October 2008.

Raub, Cymbre Quincy, "Repairing the Tower of Babel: Notes on the Genesis of James Fergusson's 'Historical Inquiry into the True Principles of Beauty, More Especially with Reference to Architecture' (Volumes I and II)", Princeton University ProQuest Dissertations Publishing, 1993.

Saville-Smith, Katherine Julie, "Cumbria's Encounter with the East Indies, *c.* 1680–1829: Gentry and Middling Provincial Families Seeking Success", PhD, University of Lancaster, 2016.

Supreme Court Judgment, *M Siddiq (D) Thr Lrs v. Mahant Suresh Das & Ors.*, Judgment https://www.sci.gov.in/pdf/JUD_2.pdf, retrieved 11 June 2021.

Anonymous

"Some Account of a Hindu Temple, and a Bust", *The European Magazine*, and *London Review*, December 1802, 42, 448–50.

"Second Report of the Committee of Correspondence . . .", *Transactions of the Royal Assiatic Society*, 1, 1830.

Review, "Essay on the Architecture of the Hindus", by Rám Ráz, Native Judge and Magistrate of Bangalore, Corresponding Member

of the Royal Asiatic Society of Great Britain and Ireland, London, 1834, *The Architectural Magazine and Journal of Improvement in Architecture, Building and Furnishing . . .*, 1834, vol. 1, 273.

Review of *Travels in Western India*, by James Tod, London: Allen and Co., 1839, *The Literary Gazette,* 3 August 1839, no. 1176, 484.

"Madura", *All the Year Round,* 12 January 1895, vol. 13, 35.

"Nargisi", *Tait's Edinburgh Magazine*, March 1854, vol. 21, 135–46.

Review of Theodore Hope's "The Rationale for Railways in India", *British Architect*, 4 July 1890.

Review of *A Journal of a Residence in India* by Maria Graham, *Theatrical Inquisitor, and Monthly Mirror,* vol. 2, April 1813, 159–60.

"Tribute to Mr Cousens: Archaeology in Western India", *The Times of India,* 10 December 1919, 11.

Secondary Sources

Ahmed, Hilal, *Muslim Political Discourse in Postcolonial India: Monuments, Memory, Contestation*, Delhi: Routledge, 2014.

Aldrich, Robert F., *Colonialism and Homosexuality*, London: Routledge, 2002.

Appadurai, A., "The Globalization of Archaeology and Heritage: A Discussion with Arjun Appadurai", *Journal of Social Archaeology*, vol. 1, no. 1, 2001, 35–49.

Arondekar, Anjali, "Lingering Pleasures, Perverted Texts: Colonial Desire in Kipling's Anglo-India", in Philip Holden and Richard J. Ruppel, eds, *Imperial Desire*, Minnesota: University of Minnesota Press, 2003.

Arrowsmith, Rupert Richard, "'An Indian Renascence' and the Rise of Global Modernism: William Rothenstein in India, 1910–11", *The Burlington Magazine*, 2010, vol. 152, no. 1285, 228–35.

Arrowsmith, "Jacob Epstein – the Indian Connection", *The Burlington Magazine*, 2008, vol. 150, no. 1268, 742–8.

Aubrey, Frank, "The Thug's Legacy", *The English Illustrated Magazine*, May 1910, vol. 86, 145.

Bacon, Thomas, *The Oriental Annual, Containing a Series of Tales, Legends and Historical Romances. With Engravings by W. and E. Finden from Sketches by the Author*, London, 1839.

Basu, Shamita, *Religious Revivalism as Nationalist Discourse: Swami Vivekananda and New Hinduism in Nineteenth Century Bengal*, New Delhi: Oxford University Press, 2002.

Bates, Crispin, "Human Sacrifice in Colonial Central India: Myth, Agency and Representation", in C. Bates, ed., *Beyond Representation: Colonial and Postcolonial Constructions of Indian Identity*, New Delhi: Oxford University Press, 2006.

Baul, D., "The Improbability of a Temple: Hindu Mobilization and Urban Space in the Delhi Shiv Mandir Agitation of 1938", *Studies in History*, 2020, vol. 36, no. 2, 230–50.

Bhuvanendran, N., *Interpretation of Indian Art*, New Delhi, 1991.

Bing, Gertrud, *Fritz Saxl (1890–1948). A Biographical Memoir*, London, 1998.

Birdwood, George, Letter to the Editor, *The Times*, Monday, 28 February 1910.

Birla, Ritu, *Stages of Capital: Law, Culture and Market Governance in Late Colonial India*, Durham: Duke University Press, 2009.

Black, Henry Campbell, *Black's Law Dictionary*, 1891; 6th edn 1990.

Blakiston, J.F., *Annual Report of the Archaeological Survey of India, 1924–1925*, Calcutta: Government of India Central Publication Branch, 1927.

Bloch, T., *Archaeological Survey Annual Report, 1902–1903*, Calcutta: Government of India Press, 1905.

Boulting, Nikolaus, "The Law's Delays: Conservationist Legislation in the British Isles", in Jane Fawcett, ed., *The Future of the Past: Attitudes to Conservation 1174–1974*, London: Thames and Hudson, 1976.

Bragdon, Claude, *The Beautiful Necessity. Seven Essays on Theosophy and Architecture*, Rochester, 1910.

Branfoot, Crispin, "Remaking the Past: Tamil Sacred Landscape and Temple Renovations", *Bulletin of the School of Oriental and African Studies*, vol. 76, no.1, 2013, 21–47.

Brantlinger, Patrick, *Rule of Darkness: British Literature and Imperialism, 1830–1914*, Ithaca: Cornell University Press, 1988.

Breckenridge, Carol A., and Peter van der Veer, eds, *Orientalism and the Postcolonial Predicament: Perspectives on South Asia*, Philadelphia: University of Pennsylvania Press, 1993.

Brown, E.K., "Rhythm in E.M. Forster's *A Passage to India*", in Malcolm Bradbury, ed., *Forster: A Collection of Critical Essays*, New Jersey: Prentice-Hall, Inc.: Englewood Cliffs, 1966.

Brown, Percy, *Indian Architecture (Buddhist and Hindu Period)*, Bombay, 1942.

Buchanan, Rev. Claudius, *Two Discourses Preached &c. and a Sermon Preached, &c. to Which are Added, Christian Researches in India*, London, 1811.

Buchanan, Rev. Claudius, *Christian Researches in Asia*, Boston, 1811.

Burnier, Raymond, *Visages de l'Inde médiévale: 79 photographies originales*, Paris, 1950.

Campbell, Joseph, ed., *Baksheesh and Brahman: Asian Journals – India*, San Francisco: New World Library, 2002.

Caunter, Rev. Hobart, *The Oriental Annual, or Scenes in India Comprising Twenty-two Engravings from Original Drawings by William Daniell and a Descriptive Account by the Rev. Hobart Caunter*, London: Bull and Churton, 1835.

Chadha, Ashish, *Bureaucratic Archaeology: State, Science, and Past in Postcolonial India*, Delhi: Cambridge University Press, 2022.

Chakrabarti, Dilip Kumar, *A History of Indian Archaeology: From the Beginning to 1947*, Delhi: Munshiram Manoharlal, 2001.

Chakrabarti, Dilip, "The Archaeology of Hinduism", in Timothy Insoll, ed., *Archaeology and World Religion*, London: Routledge, 2001, 33–45.

Chakrabarty, Dipesh, "Remembered Villages: Representations of Hindu-Bengali Memories in the Aftermath of the Partition", *South Asia: Journal of South Asian Studies*, vol. 18, no. 1, 1995, 109–29.

Chancey, Karen, "The Star in the East: The Controversy over Christian Missions to India, 1805–1813", *The Historian*, vol. 60, issue 3, March 1998, 507–22.

Cherry, Deborah, ed., "The Afterlives of Monuments", *South Asian Studies*, vol. 29, no. 1, 2013.

Codrington, Kenneth de Burgh, *Ancient India from the Earliest Times to the Guptas with Notes on the Architecture and Sculpture of the Medieval Period*, London: Ernst Benn, 1926.

Codrington, Kenneth de Burgh, *The Study of Indian Art . . . Being an Informal Talk Given Before the Tagore Society on March 9th, 1944*, London, 1944.

Cole, H.H., *Preservation of National Monuments, Bombay Presidency. Ahmedabad. Poona. Karli. Ambarnath. Elephanta*, Simla: Government Central Branch Press, 1881.

Cole, H.H., *Preservation of National Monuments. The Madras Presidency*, Simla: Government Central Branch Press, 1881.

Cole, H.H., *Temples at Trichinopoly, Preservation of National Monuments, India*, Calcutta: Superintendent Government Press, 1884.

Collins, Wilkie, *The Moonstone*, London: Tinsley Brothers, 1868.

Committee Society for the Protection of Ancient Buildings, *Notes on the Repair of Ancient Buildings, Issued by the Society for the Protection of Ancient Buildings*, London, 1903.

Coomaraswamy, Ananda K., "Visnudharmottara, chapter XLI", *Journal of the American Oriental Society*, vol. 52, no.1, 1932, 13–21.

Coomaraswamy, Ananda Kentish, "An Indian Temple: The Kandarya Mahadeo", in M.W. Meister, ed., *Ananda K. Coomaraswamy: Essays in Architectural Theory*, Delhi, 1995, 102–7.

Coomaraswamy, Ananda Kentish, *Essays in National Idealism*, Madras, 1911.

Coomaraswamy, Ananda Kentish, review of *Chalukyan Architecture* by H. Cousens, Archaeological Survey of India, New Imperial Series, vol. XLII , Calcutta, 1926, *Journal of the American Oriental Society*, vol. 49, 1949, 331.

Coomaraswamy, Ananda Kentish, *Art and Swadeshi*, Madras, 1912.

Cooper, Frederick, and Ann Laura Stoler, eds, *Tensions of Empire: Colonial Cultures in a Bourgeois World*, Berkeley: University of California Press, 1997.

Cousens, Henry, "Chalukyan Temples", *The Journal of Indian Art*, vol. 2, no. 17, October 1888, 1–2.

Cousens, Henry, "Ancient Chalukyan Stone Carvings", *The Journal of Indian Art*, vol. 3, no. 28, 1890, 23.

Cousens, Henry, "Ancient Temples of Aihole", *Archaeological Survey of India Annual Report, 1907–8*, Calcutta: Superintendent of India Press, 1911, 189–204.

Cousens, Henry, *Progress Report of the Archaeological Survey of Western India, 1908–1909*, Bombay, 1909.

Cousens, Henry, *The Architectural Antiquities of Western India*, London: The India Society, 2nd edn, 1926.

Cousens, Henry, *The Chālukyan Architecture of the Kanarese Districts*, Calcutta: Government of India Press, 1926.

Cumming, Sir John, ed., *Revealing India's Past: A Co-operative Record of Archaeological Conservation and Exploration of India and Beyond*, London: The India Society, 1939.

Dalrymple, Alexander, "Account of a Curious Pagoda Near Bombay Drawn Up by Captain Payke . . . 1712", *Archaeologia or Miscellaneous Tract Relating to Antiquity*, vol. VII, 1785, 323–36.

Dalton, Charles, *Memoirs of Captain Dalton, Defender of Trichinopoly, 1752–1753*, London: W.H. Allen and Co., 1886.

Daniell, Thomas, *Oriental Scenery. Twenty Four Views in Hindoostan Drawn and Engraved by Thomas Daniell, and with Permission Respectfully Dedicated to the Honourable Court of Directors of the East India Company*, London, 1795.

Daniélou, Alain, *The Way to the Labyrinth. Memories of East and West.* New York: New Directions, 1987.

Davis, R., *Lives of Indian Images*, Princeton: Princeton University Press, 1999.

Davis, R. *The "Bhagavad Gita": A Biography* (Lives of Great Religious Books), Princeton: Princeton University Press, 2014.

Desai, Madhuri, "Interpreting an Architectural Past: Ram Raz and the Treatise in South Asia", *Journal of the Society of Architectural Historians*, vol. 71, no. 4, Special Issue on Architectural Representations 2 (December 2012), 462–87.

Dewan, Deepali, and Deborah Hutton, *Raja Deen Dayal: Artist-Photographer in 19th-century India*, Ahmedabad: Mapin, 2013.

Dirks, Nicholas, "The Policing of Tradition: Colonialism and Anthropology in Southern India", *Comparative Studies in Society and History*, vol. 39, issue 1, 1997.

Duff, M.E. Grant, "A Month in Southern India", *Contemporary Review*, vol. 60, September 1891.

Duff, P.W., "The Personality of an Idol", *The Cambridge Law Journal*, vol. 3, 1929, 42–8.

Effros, Bonnie, and Guolong Lai, eds, *Unmasking Ideology in Imperial and Colonial Archaeology: Vocabulary, Symbols, and Legacy*, Los Angeles: Cotsen Institute of Archaeology Press, 2018.

Elwall, Robert, "James Fergusson (1808–1886): A Pioneering Archi-

tectural Historian", *RSA Journal*, vol. 139, no. 5418, May 1991, 393–404.

Farooqui, Amar, "Bahadur Shah Zafar and the 1857 Revolt", in S. Yechury, ed., *The Great Revolt: A Left Appraisal*, New Delhi: People's Democracy Publications, 2008.

Farooqui, Amar, *Zafar and the Raj: Anglo-Mughal Delhi, c. 1800–1857*, New Delhi: Primus, 2013.

Fergusson, James, *Archaeology in India, with Especial Reference to the Works of Babu Rajendralala Mitra*, London: Trübner & Co., 1884.

Fergusson, James, *History of Indian and Eastern Architecture*, London: John Murray, 1876.

Fergusson, James, *History of Indian and Eastern Architecture*, vol. I, London: John Murray, 1910.

Fergusson, James, *History of Indian and Eastern Architecture*, vol. II, London: John Murray, 1910.

Fergusson, James, *Illustrations of the Rock-Cut Temples of India: Selected From the Best Examples of the Different Series of Caves at Ellora, Ajunta, Cuttack, Salsette, Karli, and Mahavellipore. Drawn on Stone by Mr. T.C. Dibdin, from Sketches Carefully Made on the Spot, with the Assistance of the Camera-Lucida, in the Years 1838–9*, London, 1845.

Fergusson, James, *The Illustrated Handbook of Architecture: Being a Concise and Popular Account of the Different Styles of Architecture Prevailing in All Ages and Countries*, London: John Murray, 1855.

Fergusson, James, "The Study of Indian Architecture", read at a meeting of the Society of Arts, Wednesday, 19 December 1866, Delhi: Indological Book House, 1977.

Forster, E.M., "The Individual and His God", *The Listener*, 5 December 1940, 801–2.

Forster, E.M., "Message to India", Eastern Service, Friday, 15 August 1947, 1615–1630 GMT, in Mary Lago, *et al.*, eds, *The BBC Talks of E.M. Forster, 1929–1960*, Columbia and London: University of Missouri Press, 2008.

Forster, E.M., "The Art and Architecture of India", a review of *The Art and Architecture of India* by Benjamin Rowland, Penguin Books, in *The Listener*, 10 September 1953, 419–21.

Forster, E.M., Review of *The Art of India*, by Stella Kramrisch, *The Listener*, 2 December 1954, 977–8.

Forster, E.M., "The Temple", A Review of the *Annual Reports of the Survey of India*, *Athenaeum*, 26 September 1919.

Forster, E.M., *A Passage to India*, Harmondsworth: Penguin Classics, 1969.

Fry, Roger, *Last Lectures*, Cambridge: Cambridge University Press, 1939.

Fry, Roger, *Transformations. Critical and Speculative Essays on Art*, New York: Chatto & Windus. 1927.

Fryer, John, *A New Account of East India and Persia in Eight Letters. Being Nine Years Travels, Begun 1672 and Finished 1681*, London: R. Chiswell, 1698.

Frykenberg, Robert, "Christian Missionaries and the Raj", in Norman Etherington, ed., *Missions and Empire*, Oxford: Oxford University Press, 2009.

Fullarton, William, *A View of the English Interests in India. An Account of the Military Operations in the Southern Parts of the Peninsula, During the Campaigns of 1782, 1783, and 1784*, London: T. Cadell, 1787.

Furbank, P.N., *E.M. Forster: A Life, Volume One: The Growth of the Novelist (1879–1914)*, London: Secker and Warburg, 1977.

Ganguly, Swati, *Tagore's University: A History of Visva-Bharati 1921–1961*, Ranikhet: Permanent Black, 2022.

Gardner Cassels, Nancy, *Social Legislation of the East India Company: Public Justice versus Public Instruction*, Delhi: Sage, 2011.

Ghosh, A. Sarath Kumar, "The Serpent-Charmer", *Strand Magazine: An Illustrated Monthly*, November 1900, vol. 20, no. 119, 547–52.

Glover, Francis, "Curtis" Folly", *Belgravia: An English Magazine*, October 1896, 155–73.

Goldsmid, Major-General Sir Frederic, "Obituary of James Fergusson", *Proceedings of the Royal Geographical Society and Monthly Record of Geography*, vol. 8, no. 2, February 1886, 113–15.

Gordine, Dora, "The Beauty of Indian Sculpture", *Journal of the Royal Asiatic Society*, vol. 73. no. 1, 1941, 42–8.

Goswami, Banke Rai, *Ancient History of Indraprastha*, Delhi, 1911.

Graham, Maria, *Journal of a Residence in India*, London, 1812.

Guha-Thakurta, Tapati, *Monuments, Objects, Histories: Institutions of Art in Colonial and Postcolonial India*, New York: Columbia University Press, 2004.

Gupta, Narayani, *Delhi Between Two Empires, 1803–1931: Society, Government and Urban Growth*, Delhi: Oxford University Press, 1981.

Guy, John, "The Mahābodhi Temple: Pilgrim Souvenirs of Buddhist India", *The Burlington Magazine*, vol. 133, no. 1059, June 1991, 356–67.

Hardy, Adam, "Form, Transformation and Meaning in Indian Temple Architecture", in Giles Tillotson, ed., *Paradigms of Indian Architecture: Space and Time in Representation and Design*, Collected Papers on South Asia, vol. 13, Richmond, Surrey: Curzon, 1997, 107–35.

Heber, Reginald, *Narrative of a Journey Through the Upper Provinces of India: From Calcutta to Bombay, 1824–1825 (With Notes upon Ceylon)* [and] *An Account of a Journey to Madras and the Southern Provinces, 1826, and Letters Written in India*, London: J. Murray, 1828.

Hemingway, F.R., *The Madras Gazetteers, Trichinopoly*, Madras: Superintendent Government Press, 1907.

Henty, G.A., "A Pipe of Opium", *The Dark Blue*, March 1872, vol. 3, 27–42.

Hodges, William, *Select Views in India, Drawn on the Spot, in the Years 1780, 1781, 1782, and 1783, Executed in Aqua Tinta*, London: J. Edwards, 1786.

Hodges, William, *Travels in India During the years 1780, 1781, 1782 and 1783*, London: J. Edwards, 1793.

Hogg, John, Review of *Under the Naga Banner* (1896), *The Spectator*, 7 November 1896, 623.

Hosagrahar, Jyoti, "City as Durbar: Theater and Power in Imperial Delhi", in Nezzar Al Sayyad, ed., *Forms of Dominance: On the Architecture and Urbanism of the Colonial Enterprise*, Aldershot, 1992, 83–105.

Hunter, William, "An Account of Some Artificial Caves in the Neighbourhood of Bombay", read 1 July 1784, *Archaeologia or Miscellaneous Tract Relating to Antiquity*, vol. VII, 1785, 286–302.

Idolatry (India), Return to an Order of the Honourable the House of Commons, dated 21 June 1849, "Communications in Relation

to the Connexion of the Government of British India with Idolatry, or with Mahometanism", Parliamentary Paper, no. 664, of session 1845.

Inden, Ronald, "Orientalist Constructions of India", *Modern Asian Studies*, vol. 20, no. 3, 1986, 401–46.

Jenkins, Daniel, "A Protestant Aesthetic?: A Conversation with Donald Davie", *Journal of Literature and Theology*, vol. 2, September 1988, 153–62.

Jones, Owen, *The Grammar of Ornament*, London: Bernard Quaritch, 1910.

Kasturi, Malavika, "'This Land is Mine': Mahants, Civil Law and Political Articulations of Hinduism in Twentieth Century North India", in G. Tarrabout, D. Berti, and R. Voix, eds, *Filing Religion, State Hinduism and the Court*, Delhi: Oxford University Press, 2016.

Kavuri-Bauer, Santhi, *Monumental Matters: The Power, Subjectivity, and Space of India's Mughal Architecture*, Durham: Duke University Press, 2011.

Kipling, Rudyard, *Letters of Marque*, New York and Boston: H.M. Caldwell Company, 1899.

Kipling, Rudyard, "In the Presence", in idem, *A Diversity of Creatures*, New York: Doubleday, Page and Company, 1917.

Kipling, Rudyard, "The Bride's Progress", in *Letters of Marque* [also in idem, *The Smith Administration*, 1891], New York: The Lovell Company, 1899.

Kipling, Rudyard, "The Bridge Builders", in idem, *The Day's Work*, New York: Doubleday and McClure, 1898.

Kipling, Rudyard, "The Incarnation of Krishna Mulvaney", in idem, *The Courting of Dinah Shadd and Other Stories*, New York: Andrew Lang, 1890.

Kipling, Rudyard, "The Mark of the Beast", in Roger Luckhurst, ed., *Late Victorian Gothic Tales*, Oxford: Oxford University Press, 2005.

Kipling, Rudyard, "Touching the Children of the Sun and their City", in idem, *From Sea to Sea and Other Sketches: Letters of Travel*, New York: Doubleday & McClure Company, 1899.

Kipling, Rudyard, *Something of Myself: For My Friends and Unknown*, London: Macmillan & Co., 1937.

Kipling, Rudyard, *The Kipling Reader. Selections from the Books of Rudyard Kipling*, London, 1900.

Kipling, Rudyard, *The Man Who Would Be King and Other Stories*, New York: Dodge Publishing, 1890.

Kohane, Peter, "From Scotland to India: The Sources of James Fergusson's Theory of Architecture's 'True Styles'", *Abe Journal: Architecture Beyond Europe*, 2019, https://doi.org/10.4000/abe.5551.

Kramrisch, Stella, "The Significance of Indian Art", in *Indian Art and Art-Crafts (Five Lectures Given in Connection with the Arts and Art-Crafts Exhibition Held During the Theosophical Society's Annual Convention, in December 1922, at Adyar, Madras)*, Madras: Theosophical Publishing House, 1923.

Kramrisch, Stella, "Recent Movements in Western Art", *Indian Arts and Crafts*, Madras, 1923.

Kramrisch, Stella, "Reflections on the House and Body of the Gods", in Mulk Raj Anand and Stella Kramrisch, *Homage to Khajuraho*, Bombay, 1959, 7–10.

Kramrisch, Stella, "The Viṣṇudharmottaram: A Treatise on Indian Painting", *The Calcutta Review*, vol. 10, no. 2, February 1924.

Kramrisch, Stella, *Indian Sculpture,* Calcutta and London: YMCA Press, 1933.

Kramrisch, Stella, *The Hindu Temple*, vol. ii, Delhi: Motilal Banarsidass, 1976.

Kramrisch, Stella, *The Viṣṇudharmottaram (Pt III): A Treatise on Indian Painting and Image-Making*, Calcutta, 1928.

Kramrisch, Stella, "Indian Art in Europe", *Rupam*, 11 July 1922, 81–6.

Kucich, John, *Imperial Masochism: British Fiction, Fantasy, and Social Class*, Princeton: Princeton University Press, 2007.

Lago, Mary M., ed., *Imperfect Encounter: Letters of William Rothenstein and Rabindranath Tagore, 1911–1941*, Cambridge, 1971.

Lahiri, Nayanjot, "Bodh Gaya: An Ancient Buddhist Shrine and Its Modern History (1891–1904)", in Timothy Insoll, ed., *Case Studies in Archaeology and World Religion*, Oxford: BAR International Series 755, 1999, 33–43.

Lahiri, Nayanjot, *Finding Forgotten Cities: How the Indus Civilization Was Discovered*, Delhi: Permanent Black, 2005.

Lahiri, Nayanjot, *Marshalling the Past: Ancient India and Its Modern Histories*, Delhi: Permanent Black, 2012.

Lal, Vinay, *The History of History: Politics and Scholarship in Modern India*, Delhi: Oxford University Press, 2005.

Ledger, W., "The Suttee", *Court and Lady's Magazine*, January 1845, vol. 15, 20–32.

Levine, Philippa, "Sexuality, Gender and Empire", in idem, ed., *Gender and Empire*, Oxford: Oxford University Press, 2007, 134–55.

Linda, Mary F., "Zimmer and Coomaraswamy: Visions and Visualizations", in Margaret H. Case, ed., *Heinrich Zimmer: Coming into His Own*, Princeton: Princeton University Press, 1994, 119–41.

Lipsey, Roger, *Ananda Coomaraswamy, Selected Papers, Traditional Art and Symbolism*, vol. 1; idem, *Selected Papers, Metaphysics*, vol. 2; idem, *His Life and Work*, vol. 3 (Bollingen Series LXXXIX), Princeton: Princeton University Press, 1977.

Lorenzen, David N., "Who Invented Hinduism?", *Comparative Studies in Society and History*, vol. 41, no. 4, 1999, 630–59.

Lowden, John, "Hugo Herbert Buchthal, 1909–1996", *Proceedings of the British Academy*, vol. 105, 2000, 308–36.

Lowes Dickinson, Goldsworthy, *An Essay on the Civilisations of India, China and Japan*, London and Toronto: J.M. Dent & Sons, 1914.

Lowes Dickinson, Goldsworthy, *Appearances: Being Notes of Travel*, London, 1914.

Lübke, Wilhelm, *History of Sculpture, from the Earliest Ages to the Present Time*, London: Smith, Elder, & Co., 1876.

Major, Andrea, *Pious Flames: European Encounters with Sati 1500–1830*, Delhi: Oxford University Press, 2006.

Manjapra, Kris K., "Stella Kramrisch and the Bauhaus in Calcutta", in Siva R. Kumar, ed., *The Last Harvest: Paintings of Rabindranath Tagore*, Ahmedabad: Mapin, 2010, 34–40.

Manjapra, Kris, *Age of Entanglement: German and Indian Intellectuals Across Empire*, Harvard: Harvard University Press, 2014.

Mansford, Charles J., "In Hanuman's Temple", *The Pall Mall Magazine*, vol. 8, no. 33, January 1896, 153.

Mansford, Charles, J., "Shafts from an Eastern Quiver, iv: The Hindu Fakir of the Silent City", *Strand Magazine*, 4 July 1892, 558–65.

Mantena, Rama Sundari, *The Origins of Modern Historiography in India: Antiquarianism and Philology, 1780–1880*, New York: Palgrave Macmillan, 2012.

Marshall, John, *Conservation Manual: A Handbook for the Use of Archaeological Officers and Others Entrusted with the Care of Ancient Monuments*, Calcutta: Superintendent Government Printing, 1923.

Mason, Darielle, "Interwoven in the Patterns of Time: Stella Kramrisch and Kanthas", *Kantha: The Embroidered Quilts of Bengal from the Jill and Sheldon Bonovitz Collection and the Stella Kramrisch Collection of the Philadelphia Museum of Art*, Philadelphia Museum of Art, 2009, 159–68.

Mathur, Saloni, *India by Design: Colonial History and Cultural Display*, Berkeley: California University Press, 2007.

Maturin, Charles, *Melmouth the Wanderer*, Edinburgh, 1820.

Mayer, Peter, "Tombs and Dark Houses: Ideology, Intellectuals, and Proletarians in the Study of Contemporary Indian Islam", *The Journal of Asian Studies*, vol. 40, no. 3, 1981, 481–502.

Meister, Michael, Review of *The Hindu Temple by Stella Kramrisch* and *The Hindu Temple, An Introduction to Its Meaning and Forms* by George Michell, *The Art Bulletin*, vol. 62, no. 1, 1980, 180–2.

Michaud, Philippe-Alain, *Aby Warburg and the Image in Motion*, translated by Sally Hawkes, New York, 2007.

Miele, Christopher, "The First Conservationist Militants: William Morris and the Society for the Protection of Ancient Buildings", in Michael Hunter, *Preserving the Past: The Rise of Heritage in Modern Britain*, Stroud: Alan Sutton, 1996, 17–37.

Miele, Christopher, "'A Small Knot of Cultivated People': William Morris and Ideologies of Protection", *Art Journal*, vol. 54, no. 2, 1995, 73–9.

Miller, Barbara Stoler, ed., *Exploring India's Sacred Art: Selected Writings of Stella Kramrisch*, Philadelphia: University of Pennsylvania Press, 1983.

Missions to the Heathen. Mission of Sawyerpooram in the District of Tinnevelly and Diocese of Madras, Society for the Propagation of the Gospel, 1847.

Mitra, Rajendralala, *The Antiquities of Orissa*, vol. 1, Calcutta, Wyman & Co., 1875.

Mitter, Partha, *Much Maligned Monsters*, Oxford: Clarendon Press, 1977.

Morgan, Lady Sydney Owenson, *The Missionary*, New York: Franklin, 1811.

Morris, William, *The History of Pattern-Designing. A Lecture Delivered in Support of the Society for the Protection of Ancient Buildings*, 1882,

Collected Works of William Morris, vol. xxii, London: Routledge/ Thoemmes Press, 1992, 206–34.

Mudaliar, C.Y., *The Secular State and Religious Institutions in India: A Study of the Administration of Hindu Public Religious Trusts in Madras*, Wiesbaden: Franz Steiner Verlag GMBH, 1974.

Myers, L.H., *The Root and the Flower*, New York, 2001.

Nagarch, B.L. *et al.*, eds, *Encyclopaedia of Indian Architecture: Hindu, Buddhist, Jain & Islamic (Hindu)*, Delhi: Bharatiya Kala Prakashan, 2007.

Notes on the Rock-cut Temples and Rock-cut Palaces near Ellora, by a Recent Tourist, Bombay: Bombay Gazette Office, 1856.

Ogden, Daryl, "The Architecture of Empire: 'Oriental' Gothic and the Problem of British Identity in Ruskin's Venice", *Victorian Literature and Culture*, 1997, vol. 25, no. 1, 109–20.

O'Malley, Patrick R., *Catholicism, Sexual Deviance and Victorian Gothic Culture*, Cambridge: Cambridge University Press, 2006.

Parry, Benita, "Passage to More than India", in Malcolm Bradbury, ed., *Forster: A Collection of Critical Essays*, New Jersey: Prentice-Hall, Inc.: Englewood Cliffs, 1966.

Peggs, James, *India's Cries to British Humanity, Relative to Infanticide, British Connection with Idolatry, Ghau Murders, Suttee, Slavery, and Colonization in India*, London, 1832.

Pelizzari, Maria Antonella, ed., *Traces of India: Photography, Architecture, and the Politics of Representation, 1850–1900*, Yale: Yale University Press, 2003.

Penny, Mrs Frank, "The Thirst of the River God", *London Society: A Monthly Magazine of Light and Amusing Literature for the Hours of Relaxation*, vol. 56, December 1889, 336, 603–16.

Pevsner, Nikolaus, "Scrape and Anti-scrape", in Jane Fawcett, ed., *The Future of the Past: Attitudes to Conservation 1174–1974*, London: Thames and Hudson, 1976.

Pinch, Trevor, *Stark India*, London: Hutchinson & Co., 1930.

Presler, Franklin A., *Religion Under Bureaucracy: Policy and Administration for Hindu Temples in South India*, Cambridge: Cambridge University Press, 1987.

Proctor, Dennis, *The Autobiography of G. Lowes Dickinson and Other Unpublished Writings*, London: Duckworth & Company, 1973.

Rajagopalan, Mrinalini, *Building Histories – The Archival and Affective Lives of Five Monuments in Modern Delhi*, Chicago: University of Chicago Press, 2017.11

Rám Ráz, *Essay on the Architecture of the Hindús Pub. for the Royal Asiatic Society of Great Britain and Ireland*, London: J.W. Parker, 1834.

Raman, Bhavani, *Document Raj*, Chicago: University of Chicago Press, 2012.

Rao, V.N. Hari, *History of the Śrirangam Temple*, Tirupati: Sri Venkateswara University, 1976.

Rao, V.N. Hari, *The Srirangam Temple: Art and Architecture*. Tirupati: Sri Venkateswara University, 1967.

Ratnagar, Shereen, "Archaeology at the Heart of a Political Confrontation: The Case of Ayodhya", *Current Anthropology*, vol. 45, no. 2, April 2004, 239–59.

Read, Herbert, "Indian Art", *The Listener*, 21 November 1940, 779–80.

Reddy, D., and Zavos, J., "Temple Publics: Religious Institutions and the Construction of Contemporary Hindu Communities", *International Journal of Hindu Studies*, vol. 13, no. 3, 2009, 241–60.

Roberts, William, ed., Article IX, *Hindu Infanticide. An Account of the Measures for Suppressing the Practice of the Systematic Murder by Their Parents of Female Infants. The British Review, and London Critical Journal*, vol. 2, no. 3, September 1811, 227–70.

Roopesh, O.B., "Educating 'Temple Cultures' Heterogeneous Worship and Hindutva Politics in Kerala", *Sociological Bulletin*, vol. 70, no. 4, 2021, 485–501.

Rothenstein, William, "Prefatory Essay on Indian Sculpture", in Kenneth de Burgh Codrington, *Ancient India from the Earliest Times to the Guptas with Notes on the Architecture and Sculpture of the Medieval Period*, London: Ernst Benn, 1926.

Rothenstein, William, "The Genius of Indian Sculpture", *Journal of the Royal Society of Arts*, 24 June 1938, 772–87.

Rudd, Andrew, "India as Gothic Horror: Maturin's *Melmoth the Wanderer* and Images of Early Nineteenth-Century Missionary Writing", in Shafquat Towheed, ed., *New Readings in the Literature of British India, c. 1780–1947*, Stuttgart: Ibidem Verlag, 2007.

Said, Edward, *Culture and Imperialism*, London: Penguin, 1993.

Schoell-Glass, Charlotte, "An Episode of Cultural Politics During the Weimar Republic: Aby Warburg and Thomas Mann Exchange a Letter Each", *Art History*, vol. 21, no. 1, March 1998.

Sengupta, Indra, "Culture-keeping as State Action: Bureaucrats, Administrators, and Monuments in Colonial India", *Past and Present*, 226/Issue suppl. 10, 2015, 153–77.

Sengupta, Indra, "Monument Preservation and the Vexing Question of Religious Structures in Colonial India", in Astrid Swenson and Peter Mandler, eds, *From Plunder to Preservation: Britain and the Heritage of Empire, c. 1800–1940*, Oxford: Oxford University Press, 2013, 171–85.

Singh, Devika, "German-speaking Exiles and the Writing of Indian Art History", *Journal of Art Historiography*, vol. 17, December 2017.

Singh, Upinder, *The Discovery of Ancient India: Early Archaeologists and the Beginnings of Archaeology*, Ranikhet: Permanent Black, 2004.

Smith, Vincent, *A History of Fine Art in India and Ceylon*, Oxford: Oxford University Press, 1930.

Sonnerat, Pierre, *A Voyage to the East-Indies and China, Performed by Order of Lewis IV. Between the Years 1774 and 1781. Volume 1*, translated by Francis Magnus, Calcutta: Stuart and Cooper, 1788.

Sontheimer, Günther-Dietz, "Religious Endowments in India: The Juristic Personality of Hindu Deities", *Zeitschrift für vergl. Rechtswissenschaft*, vol. 67, 1964, 45–100.

Sozanski, Edward J., "A Meeting of Art, India and Devotion", *Inquirer*, January vol. 24, 1986, http://articles.philly.com/1986-01-24/entertainment/26055249_1_indian-art-indian-painting-stella-kramrisch (accessed 20 July 2011).

Spooner, D. Brainerd, *Annual Report of the Archaeological Survey of India, 1922–1923*, Simla: Government of India, 1923.

Stein, Burton, "The Economic Function of a Medieval South Indian Temple", *The Journal of Asian Studies*, vol. 19, no. 2, 1960, 163–76.

Stein, Deborah, *The Hegemony of Heritage: Ritual and the Record in Stone*, Berkeley: University of California Press, 2018.

Stephen, Carr, *Archaeology and Monumental Remains of Delhi*, 1876; rpntd Allahabad: Kitab Mahal, 1967.

Sullivan, Zohreh T., *Narratives of Empire: The Fictions of Rudyard Kipling*, Cambridge: Cambridge University Press, 1993.

Sutton, Deborah, "Sacred Architectures as Monuments: A Study of the Kalkaji Mandir, Delhi", *Architectural Research Quarterly*, vol. 26, issue 1, 2022, 47–56.

Sutton, Deborah, "'Gordon Sanderson's Grand Programme': Architecture, Bureaucracy and Race in the Making of New Delhi, 1910–1915", *South Asian Studies*, vol. 36, no. 1, 2020, 72–87.

Sutton, Deborah, "Devotion, Antiquity and Colonial Custody of the Hindu Temple in British India", *Modern Asian Studies*, vol. 47, no. 1, 2013, 135–66.

Sutton, Denys, ed., *The Letters of Roger Fry. Volume 1*, London: Chatto & Windus, 1972.

Taneja, Anand Vivek, *Jinnealogy: Time, Islam, and Ecological Thought in the Medieval Ruins of Delhi*, Stanford: Stanford University Press, 2017.

Tartakov, Gary Michael, *The Durga Temple at Aihole: A Historiographical Study*, Delhi: Oxford University Press, 1997.

Thevenot, Jean de, *The Travels of Monsieur de Thevenot into the Levant in Three Parts viz. into I. Turkey, II. Persia, III. The East Indies. Newly Done Out of French*, London: H. Faithorne, J. Adamson, C. Skegness, and T. Newborough, 1686.

Thomas, Lowell, *India: Land of the Black Pagoda*, London: Hutchinson & Co., 1931.

Tod, James, *Travels in Western India*, London, 1839.

Trautmann, Thomas, *Aryans and British India*, Berkeley: University of California Press, 1997.

Trevithick, Alan, "British Archaeologists, Hindu Abbots, and Burmese Buddhists: The Mahabodhi Temple at Bodh Gaya, 1811–1877", *Modern Asian Studies*, vol. 33, no. 3, 1999, 635–56.

Tripathi, Alok, *The Ancient Monuments and Archaeological Sites and Remains Act, 1958 (with Rules, Amendments, Notifications and Orders)*, Delhi: Sundeep Prakashan, 2007.

Turner, George E., "The Making of *Gunga Din*", *American Cinematographer*, vol. 63, 1982, 895–7.

Turner, Sarah Victoria, "The 'Essential Quality of Things': E.B. Havell, Ananda Coomaraswamy, Indian Art and Sculpture in Britain, *c.* 1910–14", *Visual Culture in Britain*, vol. 11, no. 2, 239–64.

Vogel, J.P., "Notes by Dr Vogel on the Rearrangement of Circles and Redistribution of Work and Possibilities of Economy Arising Therefrom", *The Conference of Orientalists Including Museums and Archaeology Conference held at Simla, July 1911*, Simla: Government Central Branch Press, 1912.

Vogel, J. Ph., "The Preservation of Ancient Monuments in India", *Journal of the East Indian Association*, vol. 12, no. 1, 1921, 32–69.

Waghorne, Joanne Punzo, *Diaspora of the Gods: Modern Hindu Temples in an Urban Middle-Class World*, New York: Oxford University Press, 2004.

Weiss, Richard W., *The Emergence of Modern Hinduism: Religion on the Margins of Colonialism*, Berkeley: University of California Press, 2019.

White, Daniel E., *From Little London to Little Bengal: Religion, Print, and Modernity in Early British India, 1793–1835*, Baltimore: Johns Hopkins University Press, 2013.

Willis, Michael, *The Archaeology of Hindu Ritual: Temples and the Establishment of the Gods*, Cambridge, 2009.

Willson, A. Leslie, *A Mythical Image: The Ideal of India in German Romanticism*, Durham, 1964.

Wilson, H.H., *A Glossary of Judicial and Revenue Terms and of Useful Words Occurring in Official Documents Relating to the Administration of the Government of British India, from the Arabic, Persian, Hindustani, Sanskrit, Hindi, Bengali, Uriya, Marathi, Guzarathi, Telugu, Karnata, Tamil, Malayalam and Other Languages*, London: W.H. Allen, 1855.

Wodehouse, P.G., *Ring for Jeeves*, 1954; rpntd London: Arrow, 2008.

Younghusband, Francis, "Opening Address in 'Photographic Exhibition of Indian Art'", *Indian Art and Letters*, new series, vol. 14, no. 2, 1940, 114–16.

Zeffri, G.G., *A Manual of the Historical Development of Art. Pre-historic, Ancient, Classic, Early Christian*, London: Hardwicke & Bogue, 1876.

Index

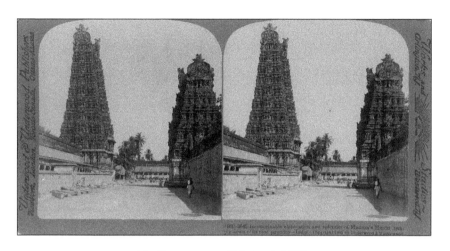

i.1: Stereoscope of Madurai, 1903.

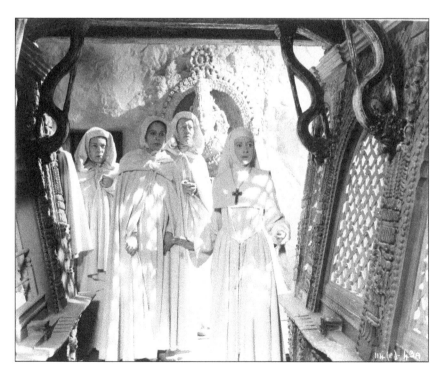

i.3: Still from *Black Narcissus*, film by Powell and
Pressburger, 1947.

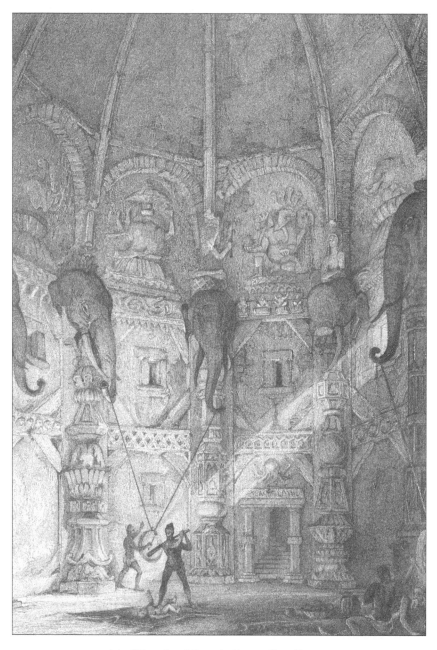

i.2: "Temple of Ganesh, Benares", in Bacon,
The Oriental Annual.

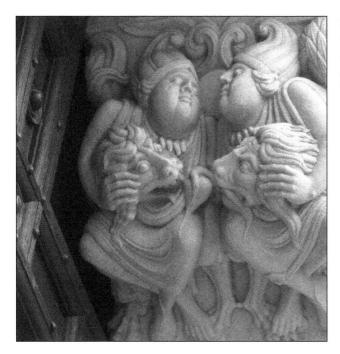

i.4: Carvings on the southern door of the Basilica of Saint-Sernin in Toulouse.

1.1: "Plan of the Famous Pagoda of Seringham Near Trichonopoly Drawn by a Gentoo", Commissioned by Colin Mackenzie.

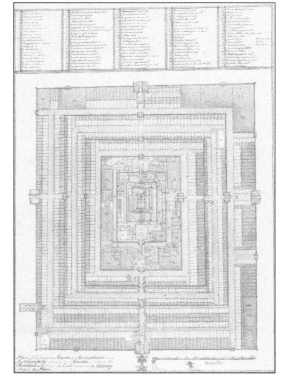

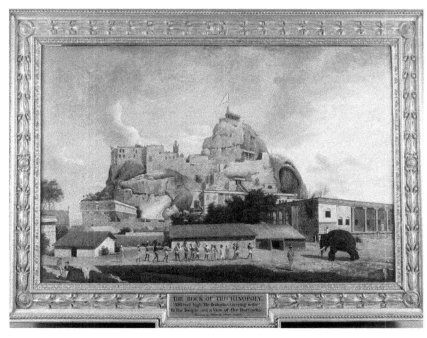

1.2: "The Rock at Trichinopoly, Madras, with the Barracks", 1772–3.

2.1: Thomas Daniell, "The Great Bull, an Hindoo Idol, at Tanjore", July 1798, in Daniell, *Oriental Scenery*.

2.2: "A Five-Storey Gopuram", in Ram Raz, "Essay on the
Architecture of the Hindus".

2.3, 2.4, and 2.5: Diagrams from G.G. Zeffri,
A Manual of the Historical Development of Art.

2.6: "The Hindu Corinthian Pillar", in Fergusson,
History of Indian and Eastern Architecture.

2.7: "Ajunta: Exterior of Chaitya Cave No. 19", by T.C. Dibdin,
in Fergusson, *Illustrations of the Rock-Cut Temples of India.*

2.8: R.F. Chisholm's Drawing of Dharmaraja Ratha, in Fergusson, *History of Indian and Eastern Architecture.*

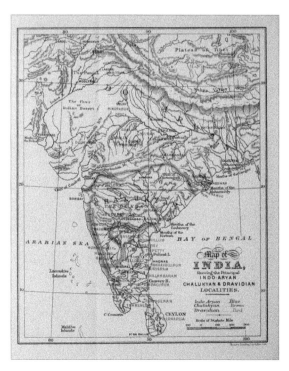

2.9: Map of Indo-Aryan, Chalukyan, and Dravidian Schools of Architecture in Fergusson, *History of Indian Architecture*, vol. I, second edition, 1910.

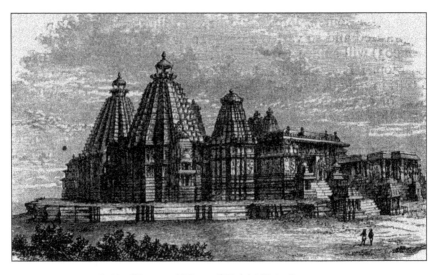

2.10: "Restored View of Halebid", in Fergusson, *History of Indian and Eastern Architecture.*

2.11: "Perforated Stone Panel from a Temple in Unkal, Dharwar", in Cousens, "Chalukyan Temples".

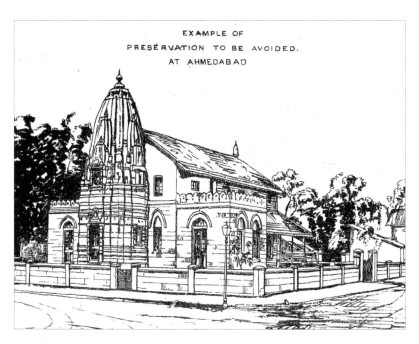

3.1: "Example of Preservation to be Avoided", 5 July 1881, Preliminary Report, in Cole, *Preservation of National Monuments, Bombay Presidency.*

3.2: Contemporary Example of "Blanks" in Restoration, Baskareshwara Temple, Bhubaneswar.

2. The following diagram, which makes no pretence at topographical accuracy, illustrates the position :-

Existing Mosque, N↑ Sadhu's encroachments

Kucha ┌─────────┐
 │ Town │
gabil Attar │ Hall │ Kucha Natwan
 └─────────┘

C h a n d n i C h o w k

5.1: "Plan of Queen's Gardens Showing Masjid Nawab Said-ud-Doula and Shiv Mandir".

6.1: Stella Kramrisch as a young woman, probably in pre-War Vienna.

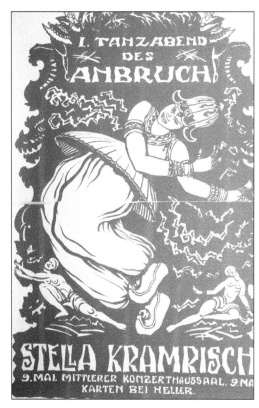

6.2: Poster advertising a pre-War dance
performance by Stella Kramrisch in Vienna.

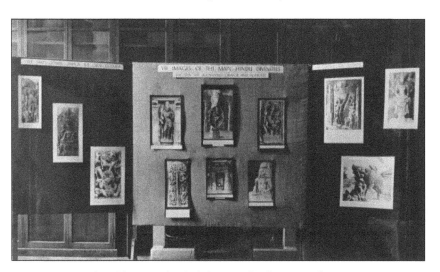

6.3: Photographic Exhibition of Indian Art, photo,
Warburg Institute, London.

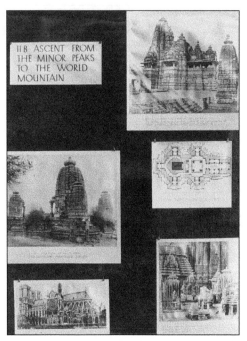

6.4: Ascent from the Minor Peaks to the World Mountain, 1940, photo, Warburg Institute, London.

6.5 Apsara au miroir, Temple de Rajarani, Bhuvaneshvara, douzième siècle, Raymond Burnier, *Visage de L'Inde médiévale*, Paris: La Palme, 1950.

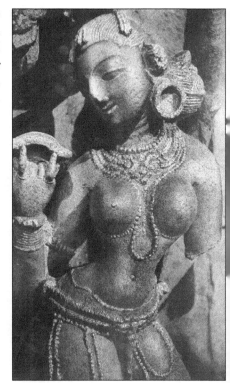